Reinhold Heller

# Hildegard Auer

A Yearning for Art

Simultaneously published as *Hildegard Auer: Ein Verlangen nach Kunst*
© 1987 Belser Verlag, Stuttgart/Zürich

Published by
Associated Faculty Press, Inc.
Millwood, N.Y.

Library of Congress Cataloging-in-Publication Data

Heller, Reinhold.
Hildegard Auer, a yearning for art.

Bibliography: p.
1. Auer, Hildegard, 1929–Catalogues raisonnés. 2. Primitivism in art–Germany (West)–Catalogs. 3. Painting, German–Germany (West)–Catalogs. 4. Painting, Modern–20th century–Germany (West)–Catalogs. I. Title.
ND588.A9A4   1987   759.3   87-979
ISBN 0-8046-9409-5

The paper in this book meets the guidelines for permanence and durability of the Committee of Production Guidelines for Book Longevity of the Council on Library Resources.

# Table of Contents

Without the generous aid and friendly cooperation of Hildegard Auer, this book could not have taken on its present form. She gave freely of her time to answer numerous queries about her art and life in order to make a presentation of her work possible. To her I owe my greatest thanks. Eva Maria Worthington kindly introduced me to both Hildegard Auer and her art, thereby starting the process from which this book resulted.

Vivian Heller and our two sons, Frederik and Erik, patiently watched as massive portions of my time were absorbed in working on the manuscript. To them, as ever, my deepest gratitude.

Peter and Eugen Eisenmann and their colleagues cooperated in various phases of this book's creation. Similarly the editors of Belser Verlag and Associated Faculty Press deserve credit for their contributions.

Finally, I must thank the University of Chicago, for releasing me from my teaching duties during the time this book was being researched and written.

Chicago, 1987

# Introduction

Modern art has existed for some one hundred years. It has been identified almost exclusively in the form-oriented art of modernism by critics and historians, who also posited the development of an avant-garde through which a pattern of increasing independence from the appearance of external reality and from society was traced. The exclusive investigation of this art historical pattern necessarily has caused many of the paintings created since 1880 to be ignored. As a result, the history of twentieth-century art is less an objective study of the works of art created during a fixed period of time than it is the history of a particular taste in art and aesthetics. Although art historians today study such phenomena as academic art, trivial art, popular imagery, salon art, and even kitsch which fall outside the grand stylistic development leading from Delacroix to Impressionism, Gauguin, Seurat, Van Gogh, and Cézanne, in the study of twentieth-century art, a "closed concept of art" continues to reign,[1] based on either the precepts of modernism or on those of socialist realism, rejecting all else as invalid.[2]

Hidden within the aesthetic and political ideologies that remain operative in the histories of this century's art is the belief that only an artist "ahead of the times," whether in formal vocabulary or class consciousness, deserves to be the subject of art historical concern. Artists who fail to fulfill these vague futuristic criteria, or whose work seeks to address a wider public than that attuned to avant-garde or progressive "high art," are ignored. From time to time, one of these artists, working as a rule in a figurative mode and using traditional media, such as oils or watercolor, will achieve public recognition—Andrew Wyeth, Lucien Freud, or Horst Janssen come to mind as examples—but nonetheless studies devoted to the art created since 1945 continue either to totally ignore them, or to isolate them, simply to dismiss them as reactionary and behind the times.[4]

That modernism—and more recently, so-called post-modernism—addresses itself to a limited and relatively small portion of the general public is indisputable. It is unlikely that the art of a time has previously ever been so vehemently rejected or even hated by the general audience of that time as is the case with modern art, even with works created more than seventy years ago. At least since Julius Meier-Graefe's argumentative tract, *Wohin treiben wir?* (Where are we heading?) was published in 1913, serious questions have been raised about modern art's legitimacy by knowledgeable, even sympathetic, art critics and historians, as well as by politically and ideologically motivated opponents—Nazism, Stalinism, or Congressman George Dondero—whose antagonism exists quite apart from concerns of art.

Among the most recent critics of modern art is Ephraim Kishon, a satirist also trained as an art historian, who wrote as "spokesman of the largest and most silent majority of our century":

"I wish to be the mouthpiece of the general public that cannot relate to the creations of its own time and cannot understand its artists. . . . It seems as if modern art is created exclusively for two creatures: the art critic and the art dealer.
For the public, for the simple folk of this earth, among whom I number myself, this art is a technicolor abracadabra. For several generations now, the common—I almost said, normal—man has not dared to protest

even a little against the mountains of trash and the flood of smearings that fill the galleries, exhibitions and museums."[5]

As in most of the antimodern tracts preceding it, Kishon's essay mixes mockery and outrage with comparisons to Renaissance art that make it possible to reject modern art as "a total fraud," the result of a plot hatched by art critics and art dealers.

In Kishon's essay, as in other writings devoted to rejecting the nonillusionistic art of this century, numerous misunderstandings and factual errors abound, so that it is easy to reject them as the products of bourgeois Philistinism or ignorance, but such a rejection fails to bring one any closer to an understanding of the long-lived opposition to the work of the modern avant-garde. Indeed, both positions—whether that of the supporters or the detractors of what is know as modern art—are founded on a feeling of superiority and, at least, aesthetic self-righteousness, as a result of which the respective opposing arguments are never taken into consideration.

The opponents of modernism refuse to recognize that the radical manifestations of twentieth-century art have altered the essence and function of art, and they thus continue to judge modern art according to norms of mimesis and classical decorum; justified by these inapplicable criteria, their judgments on modern art's quality or aesthetic sincerity cannot but be condemnatory. Analogously, the advocates of artistic progress and experimentation refuse to recognize the continuing existence of an art of narrative content and pleasing appearance that—as the presistent popularity of naive art seems to testify—apparently speaks to con-

temporary needs and demands that have not been met by the formal, intellectual, or ironic explorations and variation of this century's experimental art. In fact, what few surveys have been conducted on this issue confirm that more than 90 percent of the public considers modern art as totally incomprehensible, something to be rejected or simply viewed with indifference.[6]

Marxist critics have argued that Western contemporary art is the manifestation of a late bourgeois society in which art has degenerated to the status of commercial product, novelty is confused with quality, and content is replaced by a feverish search for new styles. In this view, modern art has intensified and expanded human aesthetic experience at the cost of impoverishing the experiential powers of humanity in accordance with the demands of late imperialism. Whether judged statistically, however, or in accordance with Marxist analysis, modern art is characterized by an ever-increasing esotericism and elitism which has led to a radical, unprecedented divorce of progressive art from a large majority of the public. It therefore does not seem incorrect to speak of a crisis in art, or certainly in the audience for art, that demands some sort of resolution, even if this resolution consists of no more than critical attention being paid to the vast area of artistic production that exists between the extremes of avant-garde and kitsch. In order to arrive at a true historical comprehension of this century's art, an analysis of non-avant-garde art must come into being. It is the purpose of this book to document at least a small portion of that art which continues to live.

I must emphasize that in this look at an aspect of alternatives to so-called high art, no

attempt has been made to deny the validity or value of the latter. Rather this monograph serves to emphasize a radical plurality in the art of this century, best labeled perhaps with Vassily Kandinsky's 1910 formulations of a "great abstraction" and a "pure realism"—or "great realism"—that exist less in antagonism than in a dialectic of mutual commentary.[7] Implicit in this book is the principle that the case of Hildegard Auer is not unique.

Kandinsky cited Henri Rousseau, Arnold Schoenberg, and Gabriele Münter as examples of "pure realism": the first, a naive painter; the second, a layman or amateur; the third, a professional artist.[8] The criteria for this selection are accordingly not to be sought in the degree of artistic training, but rather in the way in which these artists viewed and visually depicted the exterior world. Kandinsky identified them as "antipodes" to his own abstraction, but also recognized that they "grew from the same root" and sought related goals. It would thus also be incorrect to emphasize too greatly the apparent dichotomy between nonrepresentational or abstract art and representational or object-oriented art, even if this seems to describe the most apparent differences in the two classifications.

Kandinsky thus accents the common origins of the two approaches as more significant than their differences; and postulates an equality between his own abstract paintings, rooted in "dematerialization and the romantic-mystical tone," and "fantasy in most substantial matter," that depicts "things as they are and as they sound within themselves."[9] He views abstraction as having its inspiration within the artist; there is no necessary relationship with—but also no necessary rejection—of the external, visible world and its material objects and things. In contrast "fantasy in most substantial matter" originates in a visual object, whose inner world the artist subjectively investigates. This object and its separation from other objects, as well as its existence in itself, become the pictorial inspiration. One view of art has its sources internally, the other externally, but in both the artist's willful accentuation of a personal insightful view in response to the surrounding world is seen as the primal source of art. There can be admixtures of the two modalities, or one extreme can influence the other, so that the distinguishing qualities of the forms created by the two remain fluid and interchangeable.

From a different point of view, Kandinsky saw abstraction as the experimental aspect of contemporary art through which the professional artist tests and overcomes the intellectual, formal-pictorial, and material limits of art. The "artists of pure realism" are, however, less experimental in their formal vocabulary and technique; they often base their works on the untaught traditions of pre-Renaissance art or the "non-historical" art of children, naives, peasants, "primitives," or the mentally disturbed: art that, according to Kandinsky's criteria, is not yet corrupted through the "practical-purposeful" aspects of taught art practices or the rules of high art and thus has preserved a direct innocence in seeing and depicting.

Kandinsky's concept largely corresponds to the one that was developed thirty-five years later by Jean Dubuffet as *art brut,* an art that is raw, spontaneous, and direct, that represents art in the process of becoming and is not subordinated to the refinements

of Western concepts of art.[10] These Western concepts and their institutions—among which museums, art dealers, art critics, intellectuals, and patrons of contemporary avant-garde art must be numbered—are manifestations of a culture that can be compared to a dead language, but that has lost all contact with the living, common verbal exchange of the time:

"This culture drifts further and further away from daily life. It is confined to dead coteries like a culture of mandarins. I aspire to an art which would branch out directly from our daily life, an art which arises directly from this daily life, which would be a direct emanation from our real life and our real moods."[11]

What Dubuffet and Kandinsky recognized was the possibility of having modern art's experimentation interact with *art brut* and "pure realism" to gain a means of access to a wider public. Whether this remains a possibility today is doubtful, but the links of the artists of this "realism" to the dominant professional, class, family, and other institutions of contemporary society remain. Be-

cause of this closeness, the content of such art also mirrors more closely, both consciously and unconsciously, the openly discussed and secretly maintained feelings and concerns of its society and time, not the more esoteric world of the art professional or of enforced innovation.

In the art and vision of Hildegard Auer, which are presented in this book, I believe we see a far better reflection of the demands made on art by the West German— and in all probability by other Western nations also—art public as well as its concerns in life than can be identified in the works of the current avant-garde. But there is also no absolute separation of the two, and perhaps it is only in these associations and similarities, to which in this book reference has been made only glancingly, that the criteria of lasting values as well as of today's social and artistic purposes can be discerned. Between the alternatives of the political and artistic Right and Left, Hildegard Auer's "pure realism" is a personally shaped path on which numerous others are walking.

# I End and Beginning

Hildegard Auer is an autodidact as artist, never having received or sought technical training from master teachers, academies, or art schools. Self-taught, she manifests a significant and continuing strain of thought that has accompanied the development and variation of modern art throughout this century. Writing in the almanach *Der Blaue Reiter,* in which he with Franz Marc collected texts and images to present in 1912 "the newest movements of painting in France, Germany and Russia, and to show the fine threads that tie them to the Gothic and to the Primitives, to Africa and the great Orient, and with folk and children's art, which is so rich in expression and so primeval in power," Vassily Kandinsky saw the relationship of art schools to developing artists as that of a "threatening frost" to "budding blossoms:"[1]

"Even a very great, extremely strong talent will be held back, more or less, by the academies. Lesser talents are annihilated by the hundreds. . . . Academically trained, averagely talented persons distinguish themselves by learning practical technical expediencies, and in the process lose the ability to hear the inner sound emanating from the visible world. Such a person will make a 'correct' drawing of an object, but it will lack life.

If a person, who has obtained no instructions in art, and therefore is free of technically objective knowledge as artist, depicts something, the result is never hollow appearance. In this we recognize an example of that inner strength at work that is susceptible only to a *general* knowledge of practical technical usages. . . . The result is never dead, but always something alive."[2]

In the same way, Arnold Schoenberg and Henri Rousseau—the one a musician and composer by training, the other a customs inspector by profession—were recognized by Kandinsky as painters in their own right, artists who retained something of a child's lack of inhibition and undisguised innocence; they continued to seek an object's "inner sound," rather than pursue a search for technical proficiency. The artist without the limitations imposed by formal training, Kandinsky concluded, is able to create more readily and immediately a powerful image corresponding to a personal vision than is a tutored, technically sophisticated artist.

In discussing the work of the untutored artist, Kandinsky singled out Rousseau and Schoenberg because of their attachment to an object-oriented art. Had he instead considered them as representatives of artists who have turned from the practice of another profession to that of painting, he might well have identified numerous others, including himself—a former scholar of law and economics who left Russia in 1896 to study art in Munich. Among the artists active in Expressionist Germany, he might similarly have recognized the founders of *Die Brücke*—Fritz Bleyl, Erich Heckel, Ernst Ludwig Kirchner, and Karl Schmidt-Rottluff—who abandoned architectural training to enter a communal autodidactic development as painters; similarly, among Kandinsky's associates in the *Neue Künstlervereinigung* in Munich were Vladimir Bechtejeff and Alexei Jawlensky, both former Russian army officers who had foresaken their military careers and joined Kandinsky in Munich to pursue the art of painting. To these and other artists, Paul Gauguin appeared as the major exemplar of a man,

who having succeeded in a conventional career, abondoned it to embrace the practice of painting, loudly announcing, "From now on, I will paint every day."[3]

Gauguin is, above all, the artist from whose life a pattern can be traced that was later to be repeated numerous times by individuals rejecting their careers in commerce, trade, or industry to seek the satisfactions of independent artistic creation. Like Gauguin, they frequently already had an amateur's interest in art instilled early in their lives by parents, friends, or colleagues. Gauguin himself first began to paint and to be interested in art through the encouragement of his guardian, Gustave Arosa, a stockbroker who was also a passionate patron and collector of art. He further followed Arosa's example after he, too, became a successful stockbroker and independent investor by forming one of the major early collections of Impressionism during the 1870s. Hard work, ambition, and determination marked Gauguin's ten-year career in the French financial world, and he extended its promise of monetary security and material comfort to his family, which by 1883 consisted of his wife and five children. Successful in his career, stable in his personal life, Gauguin also gained the free time that his successful bourgeois existence granted as one of its rewards; he spent his free Sundays painting. Gauguin, the Sunday painter, became sufficiently proficient in his hobby to submit a landscape to the Salon of 1876, and with this action broke the usual isolation and privacy that characterizes the amateur painter. The determined competitiveness that had marked his financial rise was thus transferred to his painting, as he sought to find opportunities for its public presentation in which it would be pitted against that of professional artists. Once his financial means permitted, Gauguin more and more increased his pre-occupation with painting; he rented a studio, befriended artists, spent his summer holidays painting, and displayed his work in the Impressionist exhibitions of 1880–82.[2] It was in January 1883 that his conversion from stockbroker to professional artist became complete. Gauguin gave up his position, which paid some 40,000 francs a year, and made his bold announcement, "From now on, I will paint every day." The decision had not been made carelessly, however, but with the stockbroker's speculative instinct that argued for temporary dependence on existing savings and investments until his own art could provide support for himself, his wife and children.

Gauguin's calculation of his successful activity as an artist failed and his life was transformed into the dramatic and traumatic pilgrimage which has served to form the romantically miserable and ardent legend of a "noble savage." Before that failure, however, Gauguin's life presents an archetypal example of those artists who develop after abandoning a more or less lucrative career–the amateurs who become professional painters usually between the ages of forty and sixty. The basic components of such archetypes can be identified as a strong and determined personality, a socially conventional career successfully practiced, the existence of sufficient leisure time, a lingering interest in art that has led to the formation of an art collection and tentative attempts at creation itself often under the informal tutelage of admired artists, the boldness both to place their paintings in a professional exhibition and to vie with others in that milieu and finally, the determina-

tion to abandon the career pursued previously in order to "paint every day." In accordance with the other aspects of these artist's dual lives, the last decision is often not an impassioned leap into a world of Bohemian excess and deprivation, but rather a measured risk permitted by savings, investments, pensions, and—infrequently—the support of a patron. To the ranks of followers of Gauguin's dream of independent artistic fulfillment and Kandinsky's yearning for an artist with childlike vision, Hildegard Auer is a comparatively recent recruit, someone intent on "painting every day;" striving for an art which is "never dead, but always something alive."

Hildegard Auer's decision to "paint every day" was made in 1977, after she had spent thirty years pursuing a remarkable and extraordinary business career that initially began as a typist and stenographer and ended as director of an expanding engineering firm. For a woman of limited formal education to achieve so successful a career pattern in the German Federal Republic during the 1950s and 1960s was virtually unique, and would certainly have been equally so elsewhere as well, being an outstanding example of an unswerving determination to overcome personal and social obstacles in an overwhelming effort to succeed within the norms of a male-dominated, capitalist society. An effort of such dimensions required the subordination of personal and private concerns to those of an industrial collective whole that functioned in a manner somewhat analogous to an artist's absolute submission to the creation of art objects. Like a corpus of paintings or sculpture, the firm and its products combine into an extra-personal reality, seemingly independent of the life and existence of the in-

dividuals creating it. In a process of self-abnegation, the efforts of the individual are transformed into a totally depersonalized presence. Like Gauguin, Kandinsky, and others before her, Hildegard Auer transferred the quality and norm of her efforts from bourgeois society's institutions and economic measure to the context of art, where these were irrelevant but where the sublimation of self in the manufacture of an impersonal product remained relevant. There is a significant distinction, however: in her art, Hildegard Auer determines the nature of the products of her labor herself; as employee of a firm, she had to submit to externally imposed and determined demands and suprapersonal ends. For Hildegard Auer, as for other artists who reject the successful careers in business or industry they once energetically pursued, the decision to be an artist provides release from the psychological conflict that necessarily arises when strong self-determination finds expression through externally imposed goals. If art and industry could be merged in Hildegard Auer's personal psychology as both focused on an extra-personal result, nonetheless art provides a freedom in determining this result such as the engineering firm could never provide.

Freedom of choice, at times sublimated into the form of apparent submission, is a constantly recurring theme in Hildegard Auer's strivings, whether it be in her art, business career, or personal life. Auer's yearning for freedom and independence makes noteworthy an early life otherwise relatively unremarkable, although punctuated by the requisite amount of unusual incidents that highlight any normal life's development. She was born close to midnight in Stuttgart during the night of July 31—August 1, 1929, the

elder child—another daughter would be born almost a decade later—of an employee of the German National Railroad, a civil-service position which he was able to keep throughout the ensuing years of economic, political, and military upheaval that characterized Germany for nearly two decades after his daughter's birth.

There were no significant political involvements or other major concerns to orient the family to ideals extending beyond the limits of mutual protection and survival. Particularly for young Hildegard Auer, her father became the dominant, overpowering figure beside whom all others shrank in significance. In her eyes, her father was handsome, her mother plain, this latter playing her greatest role by recognizing her husband's masculine beauty—the daughter once witnessed her father standing erect before a mirror, primping and patting his deeply black hair, and reiterating over and over, "Am I not handsome? Tell me, am I not handsome? Have you ever seen such beautiful black hair before? Or teeth so white?"

This anecdote about her father is one of the very few childhood memories that the artist will relate today. Hers was, she continuously observes, an ordinary and normal childhood with no unusual or noteworthy incidents. Certainly from her present perspective, that is the case. Every aspect of her childhood, when she was totally dependent on and subordinate to the will of her parents, she has relegated to the realm of the forgotten, forgettable past. In that past, her mother is subsumed as the childhood relationship of mother and daughter melts into thoughts and feelings of competition for recognition from the father and for

domination of the one woman over the other. Only the figure of Hildegard Auer's father takes on shape as she purposively selects and annotates her recollections and memories. She first painted her memory's image of her father ten years after his death. In *Main Train Station* (1980, p. 104), he stands in the midst of train tracks in the yard of Stuttgart's terminal. At the back of the imposing structure with its monumental tower, Herr Auer has paused in his task of directing trains entering the station to look up at his daughter, to smile broadly and wave. The gesture gives recognition of the father-daughter relationship and the ability of the parental relationship to supersede other aspects of life, but there is also an overtone of remembered authority, of the monumental stature granted by a daughter to a father who dominates over trains and station house. Auer has surrounded his figure with overtly male symbols, ranging from the trains themselves to the phallic emblem of the station's tower looming behind the father's left shoulder. Her presentation of paternal virility is tempered, however, by a body whose proportions are more those of a woman than those of a man and that displays breast-like protrusions pushing against the heavy blue jacket. As an androgynous figure, Auer's father seems more to her than the man who salutes her with welcoming hand. He assumes also a maternal image that in Auer's childhood memories has supplanted her biological mother, and thus become a self-projection, a male-female preexistence that in art also promises immortality. Life-generating, life-giving, life-commanding, life-preserving, life-nourishing, and life-determining, Auer's father has in her memory been transformed into her sole parent, a parent moreover who merges with her self. The father is a lightly disguised

self-portrait in which the artist proclaims, a decade after his death, her true independence from past parental control and discipline, and a perception of self with which she supplants the father's generative authority with her own.

The home seen by the daughter as an emanation of her father's persona was, as she recalls it, typical of the lower middle class. The family struggled during years of financial insecurity on the wages of a minor railroad employee. His civil-servant status granted him a certain security even while the worldwide economic depression of 1929 quickly gave rise to massive unemployment throughout Germany, caused the failure of banks, the collapse of the stock market, bankruptcies, and ever-increasing political instability. Unemployment in Germany in early 1929 had already reached the figure of three million; during the next three years it more than doubled. In Stuttgart, a city with a population of 375,000 in 1929, unemployment rose from 19,000 in 1930, to 31,000 in 1931, to 41,500 in February 1933, even after major industries had reduced the per capita work week by as much as ten hours in an effort to retain a greater number of trained workers—a practice that helped to keep Stuttgart's unemployment rate lower than that in most of Germany. It was a time, as Käthe Kollwitz noted in her diary in 1932, of an "unspeakably difficult general situation. The general misery. People sliding into dark distress. The disgusting political incitement."[4] It was the time, too, when Hitler and the National Socialist Party moved decisively forward toward gaining power; in December 1931, Hitler's followers received their first representation in the Stuttgart city council, and twenty-three of them entered the Württemberg *Landtag.*

Nonetheless, Hitler's support in Stuttgart and the surrounding Swabian countryside remained significantly lower than in most German states. In the presidential elections of 1932, when Hitler received 36.8 percent of the German vote, in Stuttgart and the remaining state of Württemberg only 29 percent of the electorate gave him its vote. The relative resistance to the Führer's apparent spell is concentrated in an anecdote that tells of a speech which he delivered in Stuttgart shortly after he came to power on 30 January 1933: a few sentences into his lengthy address, his broadcast to the German nation suddenly ended when the stroke of an axe severed the cable transmitting the broadcast.

Stuttgart, however, ultimately aligned itself with the rest of Germany, whether willingly or not. The civil-servant status that had given the Auer family a semblance of security during the years of unemployment and depression now enforced the family's earlier political silence. If Herr Auer practiced politic silence, however, he also did not bring the dominant ideology of the state and its omnipresent symbols into the home. The uniform of either the Hitler Youth or its junior organizations never became the young Hildegard's customary dress, as it did for too many other children entrapped in the enthusiasm of a nation being prepared for war. But the euphoric optimism that characterized most Germans as the economy recovered—in Stuttgart, the number of unemployed fell from 42,000 to 18,000 between February 1933 and February 1934, and to 1,800 in 1937—is probably reflected also in the birth of the second Auer child.

The arrival of her younger sister marked a major break in Hildegard Auer's life, bring-

ing competition for her father's concern and attention and reducing her own freedom accordingly. Auer today tells of no scenes where she cradles, rocks, and comforts her baby sister. She remembers instead inventing stories for her, writing them down, and collecting them in books, which she illustrated with drawings done in colored pencil. It was by illustrating these self-invented fairy tales that Auer made her first efforts at art, an isolated involvement with visual images that she would not again repeat for thirty years. Her parents may have admired these drawings by the ten- or twelve-year-old Hildegard, but they did not encourage her to make more of them, and the drawings themselves have long since disappeared beneath the rubble of time.

The drawings similarly had no impact on Auer's schooling, as the attention that might have been given to a child's artistic efforts in a normal pedagogical process were focused instead on teaching her and her classmates how to roll bandages for Hitler's troops as part of the German national war effort. Perhaps, too, the turmoil of the war years prevented truly deep affection from developing between the two sisters so disparate in age, while in Auer the desire to maintain dominance in her father's affections certainly generated a conflicted attitude toward her sister, so that the drawings might well have functioned to provide her parents with an illusory visual testimony of her appropriate sisterly feelings. In the relationship between the sisters, the drawings acted to demonstrate love as well, but also placed the younger in a dependent relationship to the older, who was thereby assured superiority.

The dreams of art that may have been embodied in the fairytale drawings were soon replaced by the facts of war. In the fall of 1939, the German soldiers for whom Hildegard Auer and her school companions were taught to roll bandages marched first to triumph, then into defeat. Civilian life was transformed by ration cards, restricted movement, and nocturnal blackouts. Herr Auer was sent to the conquered nation of Belgium to aid in rebuilding railroads needed for the German war effort. This forced separation from her father, shortly after her sister's birth, brought to an abrupt end Hildegard Auer's ability to monopolize his attention and affection. He lost reality for her and was transformed into a memory to be reshaped by her as she sought her independence. War introduced her adolescence.

Stuttgart, its population expanded to 450,000 and its industry augmented by an airplane factory, began to feel the full fury of war when one hundred Allied planes mounted the first major aerial attack on the city in 1943. The bombardment reached its greatest intensity in July 1944 during three nocturnal attacks that left 150,000 people homeless, destroyed more than 7,000 buildings, and transformed most of the city into ruins. Among the destroyed homes was that of the Auer family. Hildegard Auer, however, had been evacuated from the city along with other schoolchildren in 1943 after the first airraids. The evacuation was the third of the series of consecutive interruptions in her life that marked the abrupt end of her childhood. She was sent into the region of the towns Heidenheim and Giengen/Brenz, east of Stuttgart in the Swabian Alb. For the development of her persona, the evacuation would be the most significant factor trans-

forming her from dependent daughter to independent adult.

The son of the family to whom Hildegard Auer was assigned was at the front; in their overriding concern for him, the family found little time for appropriate supervision of the young evacuee. School too met less and less regularly during the two years that the war continued, encompassed ever more of German life and territory, and finally brought total defeat. This traumatic time of Nazi Germany's collapse freed Hildegard Auer of all supervision and external guidance. The period of her evacuation formed her person and attitudes, above all her need for independence and freedom from externally imposed authority. These were purchased, however, with an enforced isolation in which no substitute for the anchoring figure of her father could emerge. If she found in her independence a value she would never again relinquish willingly, she also inaugurated a search, which continues to this day, for a father substitute.

When Auer returned to her native city about the time of her sixteenth birthday, Stuttgart lay in ruins. The French troops that occupied it during the night of 21–22 April 1945 were replaced during July by American occupation forces. Of the city's 63,000 buildings, only 3 percent showed no sign of significant damage. The population, which had dropped to 266,000 by the end of the war, was swelled by 100,000 refugees and returnees, including the schoolchildren.

With its home bombed out, the Auer family was reunited in temporary shelter. For the oldest daughter the reunion seemed as much forced upon her as the prior evacuation and separation had been. The freedom and independence she found during the war, she now sought to regain as she recognized in the anarchic situation of the society surrounding her in a defeated Germany the justification for her own continuing demands for liberation from family ties and supervision.

Ironically, the practices of family tradition brought her the next confirmation of the end of childhood. Despite the limitations of the post-war days, she began to receive instructions for her confirmation according to the rites of the Lutheran Church. It was a sign of religious duty and responsibility, but also of religious maturity and thus a formal recognition of approaching adulthood. However, when Hildegard Auer recalls her lessons today, it is not religious doctrine that she remembers, but rather the numerous pictures of scenes from the Old and New Testaments, the lives of saints and the portraits of Reformation heroes that hung on the walls of the Parish rectory. They formed her first major experience with art. These cheap prints and reproductions revealed to her art's capacity to overcome the events and circumstances of the mundane and to transform the chaos of time into a continuing order.

The influence of religion yet further contributed to the break between her prewar childhood and postwar attainment of adulthood, between psychological dependence and independence. When she returned, her mother was undergoing a renewed intense influence from Christian fundamentalist preachers, to whose teaching she had previously been highly attracted. Various pietistic sects frequently found enthusiastic reception in the Swabian countryside surrounding Stuttgart, and they these now had a powerful

resurgence after persecution under the Nazi regime. Preachers of doom, damnation, and repentance, as well as advocates of intensive scriptural reading and contemplation, naturally appealed to a people humiliated by defeat, impoverished, and with no apparent hope of a brighter future. From the depressing realities surrounding her, Mrs. Auer turned more and more to visions of apocalyptic divine intervention, which the events of the time seemed to her to portend, and sought daily confirmation of her chiliastic pessimism in the temporary meeting halls and churches of the pietistic missionaries. Into her psychopathic religious world, she drew her husband as well. But Hildegard rejected with unprecedented vehemence the frighteningly nightmarish visions of doom and damnation. Her "evil ways" and her rejection of pietistic extremism further alienated Hildegard Auer from her family, but also established her as independent and no longer submissive to the authorities of childhood. She possessed a new solid strength in her position that mirrored the ideal role she had once accorded her father.

If the authority of family was cut from Auer's life by the events of war and its aftermath, so too was the pedagogical authority found in school. During the final years of the war, at the evacuation site in Heidenheim, her schooling was erratic and capricious, disrupted as it was by air raids and increasingly incompetent teachers, who replaced those conscripted into the armed forces and who substituted fanatic party loyalty for knowledge. After she returned to Stuttgart, Auer no longer continued her formal general education, which therefore basically ended at the age of fourteen. In her intellectual and cultural development, she

thus was forced to become an autodidact, and she herself freely selected those elements of education and culture that she would make her own. What she learned and mastered, she sought and acquired independently, later to test it against those whose education had followed more normal institutional routes, a process foreshadowing her later training in art as well.

Auer herself wished for additional formal education. Once German schools reopened her initial intent had been to obtain training in graphic design, but her father decided that she should seek employment to supplement the family's reduced income. Through a member of the secretarial staff of the re-formed city government, she was put in touch with the Stuttgart municipal authorities and was hired as a stenographer. Clerical work in an office did not particularly appeal to her, but a civil-service position provided a measure of safety and assurance for both a career and position amid the continuing turmoil and uncertainty of German postwar society. In 1948, when Auer first began working in her newly acquired secretarial position, Stuttgart remained in large part a city of ruins with an expanded population of 423,500 but with only 45 percent of its prewar housing available, with continuing severe food rationing, and with a flourishing black market that was the sole source of otherwise rare and limited commodities, ranging from meat and butter to coffee and tea, shoes and coal, and using as currency American cigarettes, a single one of which cost five German marks before the new monetary system was finally introduced in June. Only slowly did the city then proceed to rebuild, and life resume a semblence of the normalcy that had been absent for more than a decade.

Auer's work in the bombed and patched-up offices of the city should have been uneventful, even in the unusual circumstances of a city governed more by Allied occupation officials than by its own crippled government. For her, however, this was not to be the case. Her ambition and thoroughness quickly brought increasing responsibilities to her, but she also viewed her fellow civil servants critically. The independence of thought and action she had painfully gained during the time of her evacuation from the city remained dominant, even if out of necessity she had to submit to her father's demand that she seek employment rather than further her own education. She perceived continuations of Nazilike attitudes in her superiors, despite a veneer from de-Nazification programs, and rather than appearing to continue to support these with her own work, she shortly resigned her position.

As she searched for new employment, what she discovered was the surreal life of a despondent and defeated society that lacked new standards and material means to overcome its desperate condition. Her youthful idealism was challenged by a salesman who offered her a position as his secretary and took her to a partially destroyed building in which a number of rooms with boarded-up windows served as his office and home. After bringing her into the blackness of a windowless room, he locked the door and began an eloquent but hysterical speech filled with bizarre, frightening visions of an impending apocalypse, of Stuttgart once again engulfed in flames, and of the destruction of the world. Without promise of a golden millenium or even of the Second Coming, his deranged prophecies of burning and exploding iniquitous cities and

towns were alleviated only by scenes of barren snow-bedecked landscapes scarred by charred crosses. For over an hour, dressed in his bathrobe, Auer's new employer raged forth his projections of burning buildings, red and yellow flames, and smoke-filled skies, then suddenly unlocked the door and left with a promise to return shortly. Once the door had closed behind him, the terrified Hildegard rushed out, fearful she would meet him on the way, and escaped home. Nightmares and horrified dreams resulted from this delerious interview; they were nurtured by the fantasy life within her which lacked any other form of outlet, now that fairy tales had been replaced by religious tracts in her home. Her experience of entrapment and threatened harm would not be externalized until thirty years later when she painted *The Tyrant,* showing the dour, mustached, bathrobed salesman surrounded by the horror of his psychotic and senseless rage (Oeuvre catalogue, No. 73).

Another interview was more successful, and Auer became the personal secretary of a lawyer, one of the many nourished by the legal confusion besetting German life. Initially these working conditions were satisfactory; then her employer erupted periodically into terrifying fits of destructive rage in which he regularly smashed whatever furnishings were at hand. She discovered that he was a morphine addict. After three months, she fled his employ almost as hastily as she had the demented prophet of doom. Subdued and personally defeated, she was able to resume working for the city when the postwar revocery suddenly gained momentum as the wartime Allies finally split into two antagonistic camps, war broke out in Korea, and the rebuilding

of Western Germany became a political priority.

Auer continued working for the city for another year and a half, then in 1951, she once again resigned in anger and frustration. The capacity to subordinate herself to men whose basic life perceptions she could neither support nor condone was totally lacking in her. She now found herself in a labor market that had weakened following its rapid expansion during the two previous years, and a short period of economic stagnation characterized Stuttgart's industrially based economy. Although the unemployed numbered only 4,500 in the Stuttgart area, while the total number of employed persons approached 300,000, many firms had cut back the hours of their work week after the Korean crisis had caused a scarcity of raw materials and rising prices resulted in reduced markets. Although the unemployment rate in Stuttgart remained significantly less than in other areas of the recently formed German Federal Republic (in February, 1952: 2.2 percent vs. 12.4 percent), for nearly 3,000 unemployed women, finding a new position was particularly difficult in the stagnant labor market. Auer, twenty-one years old and with only a brief work record that seemed to demonstrate some lack of reliability as she had changed jobs three times in less than four years, was unable to find work. For more than two months, she devised a complex system to hide from her parents the fact that she had once more resigned from the position her father advocated because of its certainty and safety in an uncertain world. Each morning she left her home as if going to her secretarial position, and then spent most of the day in city parks between visits to the employment bureau. The feigned employment was less an

effort to hide from her family the supposed shame of her unemployment, however, than to maintain the independence that job and salary had given her even while she remained in her parent's home. The persistently pietistic religious atmosphere continued to alienate her; working and sharing her wages with her family gave Auer a status more that of boarder than daughter, someone living a life independent of family authority in spite of living with the family; the charade of working days and working hours prevented a reversal of this free posture.

After living the pretense of employment for more than sixty days, Hildegard Auer found a position as a stenographer in a recently established engineering and machine design firm, one of the more than 5,000 new businesses organized in Stuttgart during 1951. Again Auer discovered that the offices of the firm were in the rooms where the founder, Eugen Eisenmann, both lived and worked, but this time the traumatic experience of her earlier search for a job was not repeated. Eisenmann, trained as an engineer prior to the war, had spent part of the postwar years carving coats of arms and wooden figurines, which he sold to American troops. Now, in 1951, he had established his firm with the aid of one employee, hoping to sell his machine designs and lease out their manufacture. To bring order to the stacks of papers and drawings scattered about his living room, as well as to keep watch over his business-home while he sought customers, he needed a secretary. Auer enthusiastically accepted the position, although she had no knowledge whatsoever of machine-design processes and the newness of the customerless firm did little to bring the assurance of a certain

future, as her civil-service jobs had done. The very uncertainty appealed to her, however, and the position promised novelty as well as little supervision so that her need for independence would be maintained. Soon she also demonstrated that whatever limitations were built into a secretarial position did not apply to her, and that whatever bounds were placed on women in the business world she would be able to break. While her new employer was out seeking sales, she used what knowledge of machine-design terminology and functions she had absorbed during her brief time at the minuscule firm to make the firm's very first sale.

Auer's embrace of the firm and its uncertainty as well as its unstructured manner of operation represented a rejection of her father's control over her life and of her willing submission to his wishes. Her need for a father figure she projected onto the firm, to a degree even onto Eisenmann, its founder, whose willingness to take risks corresponded more with her own attitude than did her father's concern with safety and certainty. The altered allegiance was expressed by her when, immediately after being hired, she moved out of her parent's home despite her family's objections and rented rooms for herself. To decorate the walls of her rooms, she bought reproductions of paintings by Lyonel Feininger and Franz Marc, artists declared to be degenerate by Hitler but in postwar Germany returned to their status as popular pioneers of modern art and praised as defenders of an antiauthoritarian individualism.

The choice of Feininger and Marc as her favorite painters defines Auer's aesthetic outlook in 1951, insofar as she thought

about art at all. Her knowledge of art was extraordinarilly limited. Since she saw the paintings and reproductions hanging in her priest's rectory at the time of her confirmation, she had had no direct exposure to art of any significance. Her schooling had totally neglected it, whether as practice or appreciation, although it is likely that some aspect of the Third Reich's condemnation of modernist tendencies and its celebration of idealized classicism and realism would have been known to her, if only through the reproductions in newpapers and magazines.

The collapse of the Third Reich had also meant the collapse of its aesthetic, so that after twelve years of Nazi art policement, German artists as well as German audiences had reached their zero hour, analogous to that occurring in the German society and economy of 1945. Efforts were then undertaken to establish renewed contact with German innovative modern art, but most examples of it in museums and public collections had been removed, confiscated, sold, or destroyed. Surviving artists, such as Erich Heckel and Karl Schmidt-Rottluff who were among the founders of the Expressionist group *Die Brücke* in 1905, were appointed to professorships in German art academies; in Stuttgart, Willi Baumeister, a student of Adolf Hoelzel and before the war a major advocate of an abstract constructivist art, was called to the Academy in 1946. Periodicals that had survived the war, such as the popular *Die Kunst und das schöne Heim* (Art and the beautiful home), and even more recent ones, such as *Das Kunstwerk* (The work of art) or *Kunst unserer Zeit* (Art of our time), also turned their attention to the works of the previously condemned, pre-World War II painters. Art galleries and museums likewise displayed

whatever could still be obtained. The aesthetics of modernism had been propagated as early as 1946 when an exhibition of twentieth-century French art, a first overview of abstract painting bearing the title *Extreme Malerei* (extreme painting), traveled to Freiburg, Munich, and Berlin, and to Stuttgart in 1947.

As the political divisions between East and West Germany grew and hardened, notably after 1948, modern art was also more and more interpreted as being specifically antitotalitarian and contemporary abstract painting above all as being expressive of the new West German anti-Communist political and social order. Auer's appreciation of Feininger and Marc reflected the popularization of this institutionalization of the avant-garde and its historical predecessors. The artists she chose had both taken part in the revolutionary artistic movements of the 1910s, but they had also retained an easily recognizable subject matter on which they superimposed elements of Cubist-derived semigeometric linear patterns. Usually neither abstract in their form nor strident in their content, the paintings of Marc and Feininger lent themselves to an untutored taste wishing to gain modified entry to the risks inherent in modern art and its overt proclamations of an existential individualism posited in personal freedom. Like the late works of Emil Nolde, the paintings by Marc and Feininger remained seemingly easily accessible and possessed an aura combining a slight sentimentalism with a desire for daring.

The firm which Auer joined prospered with "the economic miracle" of the 1950s. A factory was set up, additional employees were hired, branch offices were established, and

a new factory with offices, which would employ more than five hundred people, was constructed in the town of Böblingen, near Stuttgart. International markets were developed, and the Eisenmann firm came to specialize in high technology designs that emphasized conservation of materials and energy and environmental protection systems. Auer meanwhile had taught herself skills of interpreting and presenting the machine designs of the firm and permitted this to absorb all her energies, both personal and professional. Her working days frequently lasted until midnight and encompassed all seven days of the week. She had never consciously set out to become a career woman, but her remarkable skills and energy quickly resulted in transferring her duties from stenography to management. She became the only woman on the firm's directorial staff, as well as the only person lacking appropriate formal training and schooling, her knowledge and skill remaining totally autodidactic. In 1970, when Eugen Eisenmann retired from the management of the company he had founded, he selected Hildegard Auer to head the firm, a position which she held until April 1977.

In the Eisenmann firm, Auer found and created a reality to substitute for that of her family. Pietistic fanaticism was exchanged for goal-oriented dedication, an absorption of her own individuality into the collective persona of the company, and with this dedication she subsumed her demand for personal independence. In guiding, forming, and promoting her, the firm became a depersonalized father whose characteristics she adopted until she served in a paternal role herself, only then to reinaugurate her search for a model and guide to which she could subordinate her individuality while ful-

filling it. By 1977, the firm could no longer fulfill that function, and she turned instead to painting, which since the beginning of her business career with the company had taken on increasingly important significance.

Once she had acquired the reproductions of the paintings of Feininger and Marc, it was through the Eisenmann firm that Auer's concern with art was fostered. Significantly, the interest in art latent since childhood—and which certainly attracted her to a company which produced drawings as part of its design process—received a paternal approbation previously denied her. Prior to World War II, Eugen Eisenmann had collected primitive African art during mountain-climbing expeditions in Africa. His intended career as mountain climber ended with the outbreak of World War II, and during that war, his art collection was destroyed. When in the 1950s his firm began more and more to prosper, he once again began to collect but now concentrated on the works of the German Expressionists, particularly the paintings and drawings by the artists of Munich's *Der Blaue Reiter*. As it developed, the collection increasingly focused on the work of Gabriele Münter, then little known except as Kandinsky's companion who had donated her collection to the city of Munich in 1957, which was also when the first book devoted to her work was published. Eisenmann's collection is now the largest private holding of Münter's work in existence.

In time, Auer herself began to buy Expressionist paintings, and more particularly those of Gabriele Münter. These works became the source of her own artistic awareness and self-identification, establishing an aesthetic strongly rooted in the images and ideas of the pre-World War I Munich avant-garde. In the appreciation of this art and in the process of developing an increasing identification with the figure of Gabriele Münter, Auer constructed for herself an alternate identity free of her professional position but one that both depended on and was justified by it. The firm and Eisenmann's own collecting activities provided a paternal blessing.

Inspired by the interest of the *Blaue Reiter* group in folk and primitive art, Eisenmann also began to buy examples of Bavarian peasant painting on glass—*Hinterglasmalerei*—including examples from Münter's own collection, and works of such untutored, naive painters as Henri Rousseau and Adalbert Trillhaase. For relaxation, he himself also began to paint during sailing holidays on the Bodensee, and he encouraged his employees to do the same. During such a holiday on the Bodensee, Auer was given some watercolors while on a cruise with Eisenmann and two other managers from the firm, all of whom were engaged in more or less amateurish attempts at rendering the scenic sub-Alpine landscape surrounding them. "I was ordered to paint," Auer now maintains, recollecting also that she had wagered Eisenmann that she was more talented than he and would be more successful in her efforts at painting. Thus, while her career neared its unexpected apogee and she would be named a director of the company, she risked painting. To risk painting reflects her earlier decision to join the fledgling firm when it, too, was without a certain future and presented only a modicum of security but did represent both competition with and rejection of her father's authority, the substitution of herself in the paternal role while she reconstructed an authority

deserving willing submission in the firm itself. For the stacks of cards and papers scattered in the two rooms serving Eisenmann as office and home in 1951, she was now to substitute her total lack of technical knowledge in the practice of art.

Armed with paper, brush, and watercolors placed into her willing-unwilling hands on the sailboat, she struggled for hours in the effort to produce an image and ended with an awkward representation of a few individual blades of grass, filling only a few square centimeters of the paper. The landscape totally eluded her as, with the critical expectations of someone knowledgeable and perceptive of the formal criteria of painting as she had learned them in her absorption with paintings by Gabriele Münter and other members of the *Blaue Reiter* group of artists, she was critical of her own efforts to the point of immobility. The knowledge of her eye immeasurably exceeded the ability of her hand. As with the Eisenmann firm, the risk appeared greater than the promise, but Auer persisted.

In 1962, Eugen Eisenmann, called for an open exhibition of his firm's Sunday painters. To encourage others, he not only exhibited his own amateur efforts but also insisted that the managerial staff "set an example" by submitting whatever paintings they had already created, or alternatively create paintings especially for the exhibition. Auer complied.

Limited to employees of the Eisenmann firm, the exhibition had the character of a hothouse plant, unique and lacking contact with a wider, more competitive existence. The context changed, however, as the exhibition became an annual event open to all

amateurs and Sunday painters throughout Germany, and a system of awards was instituted with juries composed of art critics and museum professionals, in conjunction with representatives of the Eisenmann firm. As publicity and knowledge of the annual Eisenmann exhibitions of naive painters, Sunday painters, and "creative outsiders" spread, and Eisenmann himself began to form a new collection deriving from these exhibitions of contemporary naive art, the compass of the shows altered dramatically. In 1983, at the last of the series of twenty-two exhibitions, more than a thousand artists in various stages of nonprofessional status submitted more than 2,500 works, of which 350 were selected for display.

Auer, too, changed in her art as it was confronted with the inspiration of nationwide competition. From directionless experimentation limited to watercolors, haphazardly practiced during vacations and holidays, she switched to oils and in deliberate emulation of Gabriele Münter to painting on glass, creating new *Hinterglasmalerei* based on motifs of circus performers, or, on cardboard, scenes recalled from vacations spent sailing in Scandinavia during the mid-1960s. In the environment of naive and amateur painting, her works also began consistently to win prizes and be selected for purchase by the exhibition juries. Emboldened, she worked in an ever-increasing scale and on canvas, until in format and ambition her work broke free of the context of other naive art, and she was given a semiseparate status as "creative outsider" at the 1982 exhibition where she displayed her triptych, *Alaska Festival* (p. 116–119).

Having decided in 1977, when she retired from the Eisenmann firm to emulate Gau-

guin in his statement, "From now on, I will paint every day," Auer's ambitions and achievements moved beyond the limits of Sunday painter, amateur, and nonprofessional artist. As some of her paintings reached the dimensions of more than 200 centimeters in height and nearly 400 centimeters in width, she proclaimed herself to be in competition with the traditions and current practices of twentieth-century "serious" art, and it is in this competition that she now continues toward its unpredictable conclusions. This is now the risk. Museums have purchased her work—*The Tyrant* (1978, Oeuvre cat., No. 73), and *Sleepwalker*

(1980, Oeuvre cat., No. 98); she has had gallery exhibitions devoted to her work; and she has fostered internationally a group of collectors seeking to acquire her work. The mechanisms of her self-proclaimed competition are firmly in place. The outcome remains in its beginnings as she charts a path between the vociferous gestures of post-modernism's Neo-Expressionists and the hesitant private touches of the naive amateur. In her beginnings can be discerned Auer's goals: a personal combination of the pattern of rebellion and submissions, rejection and acceptance, which has shaped her life.

# II  The Past Made Present

Hildegard Auer achieved the formulation of her art during an "apprenticeship" in the Eisenmann collections of Expressionist, naive and amateur painting. Eclectically she formed her own personal vision by submitting, first mentally and then in practice, to the discipline presented by the art she knew most intimately, discerning its values and methods, emulating its forms, and thus restructuring it into her own perception. Not forced to submit to the laws and rules disseminated by art school or master, lacking externally imposed preconceptions and predefined problems, she possessed a freedom to achieve an art independent of the styles and fashions prevalent in the 1960s—pop art, op art, minimal art, hard edge, happenings, concept art, and their various mutations. Mutually contradictory in approach and form, the diverse tendencies of that period did possess a common root in their antagonism to manifestations of gestural abstraction that dominated the late 1940s and 1950s as Tachisme, Art informel and Abstract Expressionism. As Auer limited the freedom she possessed by adapting criteria derived from the figurative works of Expressionist and naive painters, she too participated in this effort to deny the continuing validity of modernist abstraction.

During the 1930s—notably after 1936—the governmental actions against modern art effectively disrupted Germany's attachment to its own earlier contributions to the development of twentieth-century art. When World War II ended in 1945, German artists were surrounded by a wasteland of bombed cities and destroyed aesthetic ideologies, the inheritors of the twelve-year-long defamation of modern art as well as of the victor's new defamation of the art of the Third Reich. With all values called into question, there was an artistic vacuum, which could only be filled by attachment to the currents of art remaining alive outside Germany, and the increasing political tensions and division after 1947 accordingly saw German artists, whether of East or West, attaching their art to the respective ethos of Soviet socialist realism or of the various modes of Western progressive modernism.

While some artists continued to produce apparently nonpolitical landscapes and portraits according to the norms of the Third Reich's eclectic idealism and found patrons for these, painters in the French, British, and American occupation zones sought alternatives to the denounced aesthetic of Nazism initially in semirealistic modes of surrealism and magic verism focused largely on allegorical themes. This was soon superseded, however, as West German artists followed the example of such expatriate painters as Hans Hartung or Wols in Paris and Hans Hofmann in New York, and evolved forms of gestural abstract painting. Accordingly, the attitude toward Germany's modernist past also shifted.

Although the contributions to representational modes of modernism as provided by most Expressionist painters received early and continuing homage through exhibitions, beginning in Hamburg in 1946 with the Galerie Bock's *Wegbereiter der modernen Kunst* (Pioneers of modern art), the evolutionary significance of this art in the emergence of abstraction was more and more emphasized, and Vassily Kandinsky's inauguration of a subjective, nonmimetic mode of painting was increasingly heralded as the farsighted prediction of the necessary development of abstraction into the

present. Gestural abstraction represented the undeniable triumph of modern art's desire for an intrinsic vocabulary that would guarantee the artists a maximum of personal freedom in their expression.

In one of its earliest issues, the newly founded periodical *Das Kunstwerk,* dedicated to proselytizing the postwar avant-garde, dogmatically announced, "The era of mimesis is over; everywhere the will to abstract art has become dominant."[1] The pronouncement coincided with Stuttgart's first postwar exhibition of French abstract art, *Extreme Malerei,* and also with two other extensive major overviews of contemporary art. In 1948 the *Grosse Ausstellung französischer abstrakter Malerei* (Great exhibition of French abstract painting) was seen in virtually every major city of Western Germany—Stuttgart, Munich, Düsseldorf, Hannover, Frankfurt, Kassel, Wuppertal, and Hamburg—while simultaneously Karlsruhe, Mannheim, and Düsseldorf hosted an exhibition of fifty-four paintings from the collection of Peggy Guggenheim under the title *Gegenstandslose Malerei in Amerika* (Nonobjective painting in America). These grandly extensive shows clearly established abstraction as the artistic vocabulary of the triumphant Western allies and of the future.

Such a clear association of the "will to abstract art" with the West incontrovertibly placed it in the ideological context of the emerging Cold War. Abstract art, in the words of the American Abstract Expressionist Robert Motherwell, was "related to the problem of the modern individual's freedom,"[2] and to deny the validity of abstraction was either a reactionary position or, more significantly, a denial of individual human rights under the dictates of the Stalin-

ist Soviet Union. Figurative painters, even those whose reputations had been firmly established prior to the rise of Nazism, such as Carl Hofer, found it more and more difficult to exhibit. In the visual language of gestural abstraction, Western artists and critics proclaimed the identity of an artistic principle of freedom intrinsically antagonistic to all totalitarianism, whether Fascist or Communist.

The free flow of colors, lines, and shapes in an open compositional arrangement subjectively achieved was also identified in abstraction's dogma as a uniquely universal human language capable of transcending international boundaries. As early as 1944, Jackson Pollock in New York had announced that national schools of art were an absurdity, and that "the basic problems of modern painting are independent of any one country."[3] Similar stress on international interdependence attended the founding of the United Nations Organization, but by the late 1940s such ideals were embodied more in groupings of mutual defense organizations, such as NATO or the Warsaw Pact, and in local economic communities exemplified by the European Coal and Steel Community.

West German artists' adherence to the practices of abstract art corresponded to political and economic efforts to integrate the new Federal Republic of Germany as a coequal participant in the Western European community of nations. The corrosive nationalism of their past was to be denied and replaced by visions of Western European cooperation and integration. Guiding the German effort, Konrad Adenauer predicted a change in "the entire manner of thinking and political feeling of Europeans," which

would lead them "out of the confines of their national state existence. . . . [to] give the life of the individual greater and richer meaning."[4] Only by breaking fully and categorically with the nationalism of the German past, he concluded, would "people whose feelings in our time were still determined by suspicion, the desire for advantage, and resentment. . . . become neighbors and friends." Abstract art, too, functioned in the economy of generating a nationless future, and it was hailed as "the fundamental support of worldwide human interaction" by Werner Haftmann in the preface to the catalogue of the 1959 Documenta Exhibition:

"During the past decade, a pan-human consciousness has been generated by modern art to overcome all limitations inherent to the distinguishing qualities of language, custom, history, racial consciousness, and folklore. . . . From Europe to the Americas, to Africa and Asia and the distant Far East, [abstract art] has been able to give rise to a sense of inner agreement, and has embodied this agreement in a form of language that facilitates immediate communication. It can be recognized as the first product of a world culture."[5]

Haftmann's grandiose vision of a world culture based in abstract art manifested itself at the 1959 Documenta, which was organized to celebrate the definitive triumph of abstraction in art. The first Documenta exhibition, which took place in Kassel in 1955, had already proclaimed Germany's integration into the international stream of modernism by highlighting German contributions to pre-1933 modernist developments; similarly in 1955, the success of the German Federal Republic's artists in the process of internationalization and normalization was announced when René Drouin organized the exhibition *Nonfigurative Painting in Germany* for Paris's Cercle Volney. By 1959, it was no longer necessary either to question or to defend German adherence to the Western dogma of abstract art; instead abstract art itself could be presented as the universal product of democratic values and freedom:

"If in the seemingly confusing panorama of contemporary art we attempt to discover the principle components, we determine surprisingly quickly that the overly fullsome richness of arguments, propositions, and experiments that has accompanied the evolution and the appearance of modern art can be concentrated into a few guiding principles, like light rays in the center of a concave mirror. One thing we can conclude immediately: that the entire grand domain which confronted visual reality with optically illusionistic images today only displays minimal signs of life. Art has become abstract."[6]

This triumph and victory for abstract art was not, however, as complete or dominant as Haftmann and its other advocates argued. Resistance to it had been constant since 1945, and not only among the political extremes of Left and Right. In his book, *Verlust der Mitte,* published in 1948, the art historian Hans Sedlmayr advanced the argument that in modern art, and notably in abstract art, there was a "loss of center," a lack of attachment to the humanistic and theological values of Western civilization, indicative of a "disturbed relationship to God." Even such an earlier vocal advocate of modern art as Wilhelm Hausenstein protested in his book *Was bedeutet die moderne Kunst?* (What does modern art mean?)

published in 1949, that nonobjective art manifested a kind of nihilism:

"I dare to maintain that abstract art is the expression of a world in which the destruction of the objective has already become reality. Terrible enough in itself: but in fact it is no longer necessary to say even that abstract art confirms the collapse of the objective world in an exemplary fashion. . . . [It is an art] that no longer senses, comprehends or thankfully accepts the wonder of reality which for the visual artist should be the true wonder, the wonder in fully specific terms; [it is an art] that under the vague collective term "abstract art," not bound by any norms, becomes no more than a formalistic game with some sort of pleasant relationships of color, curves, and surfaces, that is, a purely subjective presentation. . . ."[7]

Although remarkable examples of abstract art were placed by the newly prosperous West Germany into diverse public buildings, ranging from museums to churches to governmental offices and factories, abstract art failed to gain the loyalty or acceptance of much of the public. An aesthetic elite was frequently postulated as controlling the manifestations of modern art, and of destroying art's ties to the broader aspects of society. In 1958, the popular periodical *Der Stern* argued that a "dictatorship of modern art dealers" had replaced the "art-terror of the totalitarian state" and that Hitler-like fanaticism "now condemns every artist in whose paintings remains discernible even a slight remnant of the forms of nature."[8] A survey showed the rejection of modern art to be even more widespread as only 6 percent of the respondents accepted "painting in a Picasso-style," while 32 percent reject-

ed it, 11 percent were undecided, and 51 percent had never heard of it. Had the question been directed toward abstract painting, the rate of acceptance would presumably have been reduced even further.[9] The triumph of the abstract in art had clearly been an ephemeral one.

By 1960, gestural lyrical abstraction was also being rejected by younger artists. Artists of the *Gruppe Zero* practiced a constructivist-kinetic aesthetic, which they conceived of as "a zone of silence before the new beginning," but their intellectualized abstractions failed to meet continuing demands for an imagistic art, whether from "the masses" or from artistically more educated persons who proudly began to collect woodcuts and lithographs by Ernst Ludwig Kirchner or Erich Heckel, by the artists of classical German modernism. The major private collections of Expressionist art in West Germany came into being precisely as Haftmann announced the victory of gestural abstraction and as avant-garde artists turned more and more to increasingly esoteric paintings or to the experimental activities of happenings.

Eugen Eisenmann, for example, once the profits of his engineering firm started to permit him to form a collection of art, turned not to the contemporary work of Ernst Wilhelm Nay, Willi Baumeister, or Georg Meistermann, but rather to paintings by Emil Nolde, Ernst Ludwig Kirchner, and Gabriele Münter. The choice represented several motivations. Certainly Eisenmann rejected the monumental paintings of the 1950 abstractionists, if not catagorically, then as components of his milieu, the objects of his daily vision. Simultaneously, however, the Expressionists represented an acceptance

of modern art and of the antitotalitarian ideology it was deemed to represent, but it was also a modern art already tested and appealing in its reference to a former, seemingly more innocent time. Finally in the desire to collect German Expressionism, there was an element of national pride that countered the broader silence and rejection dominating attitudes toward the German past and German national identity. To the internationalism of lyrical abstract painting was countered the national presence and acceptance of German Expressionism, an affirmation rather than a negation of the German past and character. Nor was Eisenmann an isolated instance.

The 1955 Documenta, as we have seen, was the first systematic attempt to display Expressionism as the German contribution to the artistic revolution of 1910–1925. In 1959 in West Berlin, Leopold Reidemeister presented the German artists as exemplars of a wider European movement, as recipients of a Western European artistic tendency that they had developed in a uniquely German fashion, in *Triumph der Farbe: Die europäischen Fauves* (The triumph of color: the European Fauves); another exhibition, *Masterpieces of German Expressionism,* traveled to numerous German cities and to Holland in 1960; and at the Archives of German Literature in Marbach, near Stuttgart, the display of *Expressionismus. Literatur und Kunst, 1910–1923* (Expressionism: literature and art, 1910–1923) not only presented a rich documentary reconstruction of the movement but also saw it as permeating all products of German culture so that Expressionism was presented as a peculiarly German form of consciousness and artistic awareness. As such a typical German manifestation, Expressionism was

doubly valued, moreover, because it had been so dramatically denounced by Hitler, and by his condemnation was exonerated from the suspicion and guilty associations haunting much of the German past. The "renewed interest" in German Expressionism announced in Holland by the *Duitse Kroniek* in 1959 was also indicative of a renewed interest in affirming a German identity that would complement the "miracle" of the postwar economic revival which by 1960 transformed Western Germany into the third-ranking economic power in the world. While the reminiscences of still-living participants in the Expressionist movement were collected and more and more of their art was seen in museums and exhibitions, the former Expressionist poet Kasimir Edschmid saw Expressionism as still very much alive, *Lebendiger Expressionismus* (Living expressionism), through its continuing significance for contemporary Germany, its closeness to the true German soul and character. At this time, too, Werner Haftmann, now the director of the new National Gallery in West Berlin, praised Expressionism as "the unique identity of German modern art":

"In German Expressionist paintings, we discovered a particular restlessness and distress of the pictorial architecture that corresponded to a particular deepening in the range of content, in a style of keen Romanticism filled with intense nature worship and poetically emphatic meaning. . . . We can conclude: if France presented to the new European style its formal power and clarity, then German painting added to it its ideational depth." [10]

If Haftmann's characterization sounds overly much like the cliche of Germany as the "land of poets and thinkers," this is ulti-

mately less significant than that he should emphasize uniquely German qualities in art in a lecture delivered in 1964 at the German House in Paris. It was the "Germanness" in German painting that was heralded and proclaimed, not Expressionism as part of an international mode of early modernism.

By the late 1950s, in exhibitions, in publications, and in newly formed private collections, Expressionism was therefore very much alive once again, and frequently its enthusiastic audiences recognized it as an alternative—poetic, meaningful, and purposefully German—to the abstract paintings and seemingly esoteric manifestations of contemporary avant-garde artists, who were judged to be part of an elitist monopoly of cultural legitimacy, of art entrepreneurs dismissive of the tastes of the diffuse art public and its needs. The thirst for an authentic twentieth-century German art was thus directed to a large extent to the art of the past but to art that also claimed legitimacy as a representative of progressive modernism. The aesthetics of Expressionism were promulgated, moreoever not only by its art, but also in newly published anthologies of Expressionist writings, such as Paul Pörtner's *Literatur-Revolution 1910–1925, Dokumente-Manifeste-Programme* (Literature revolution, 1910–1925: documents, manifestoes, programs), published in 1960–61, which made available once again the historic texts defending and defining the ideals of German Expressionism. The reprinted books, moreover, frequently attained a significant popularity, so that the almanac *Der Blaue Reiter,* for example, sold 21,000 copies during the first two years of its republication. The tenets of Expressionism took on a new relevance in their renewed circulation among an art-hungry but abstraction-weary

art public that, nonetheless, sought to own samples of an art truly "modern" but visually pleasing and which could function as an accepted sign of new-found prosperity in the revived West German economy. (German art audiences largely derive from the upper-middle and upper classes, and their makeup would most likely be similar to that of French museum visitors who, in a 1966 survey, were found to consist of 1 percent farmers; 4 percent workers; 5 percent craftsmen and shopkeepers; 18 percent professional employees and managers; 46 percent upper class).[11] With its varied associations, Expressionist art achieved an unprecedented popular acceptance.

Much the same audience and market, which supported the resurgency of Expressionism, also generated an extended revival of naive art, a revival marked in 1961 by the exhibition *Das naive Bild der Welt* (The naive image of the world), which originated in Baden-Baden and traveled to numerous other German museums. In the two following decades, significant shows of art by naive and untutored artists proliferated in the Bundesrepublik and other West European lands. During the 1950s, isolated instances of exhibitions of naive art took place, but nothing that was on the scale of the Baden-Baden show in comprehension or comparable in quantity to the seventy-seven exhibitions of naive art recorded in 1965.[12] Like Expressionism, during the 1960s and 1970s, naive art became "a sort of goal and point of escape for all those who mistrusted the further developments of "high art," the critic Juliane Roh observed in 1974:

"Because, as contemporary "high art" shakes the aesthetic foundations and wish-

es to replace them with other values (banal, social-critical, conceptual), the quality of the aesthetic remains of high value to the naives, indeed is even the motivating force of their creativity, even if there continue to exist those who would deny the status of art work to the work of the naives.

If the claim is made today that creativity is a universal quality which is totally dissociated from traditional aesthetic criteria, then the naives continue to convince us of the opposite. In the situation of art today, they rise almost to the status of being guardians of the grail, of that concept of art that continued to be unimpeachable until the recent "death of modern art" (of which youth today speaks continually). . . ."[13]

To critics and art audiences schooled in the traditional criteria of art and in the aesthetics of prewar modernism, the naive artist appeared as a bulwark against mounting post-modernist attacks as they intensified after 1960 and promised a "dematerialization of the art object,"[14] while proclaiming the death of paintings and other concrete, stable manifestations of art. An ephemeral art lacking commercial commodity value was espoused, a "detachment of art's energy from the craft of tedious object production," according to the artist Robert Morris:

"What is being attacked. . . . is something more than art as icon. Under attack is the rationalistic notion that art is a form of work that results in a finished product. . . . What art now has in its hands is mutable stuff which need not arrive at the point of being finalized with respect to either time or space. The notion that work is an irreversible process ending in a static icon-object

no longer has much relevance. . . . (From such a point of view, the concern with "quality" in art can only be another form of consumer research—a conservative concern involved with comparisons between static, similar objects within closed sets)."[15]

Similar antagonism to an aesthetic of art objects and the process of individual creation was voiced in Germany by George Maciunas, one of the founders of Fluxus, which was, he argued, "strictly against the art object as functionless and destined only to be sold and provide the artist with an income. At most it can have the pedagogic function of making clear to people how superfluous art is and how superfluous the object itself is. . . . [Fluxus] tends towards the spirit of the collective, to anonymity and ANTI-INDIVIDUALISM."[16]

The intellectualism and leftist political sloganeering of anti-object art further disoriented and increasingly alienated large segments of the Bundesrepublik's audience for art, which saw its long-voiced demands for a renewal of figurative art denied. The emanations of American pop art gained a significant following among German collectors and museums, and in 1965 the exhibition of drawings by Horst Janssen at the Kestner Gesellschaft in Hannover, which previously had been a constant supporter of the avant-garde, inaugurated the popular reputation of his formally traditional graphic art with its sensual orchestration of such established motifs as the still life, the landscape and the human figure. If such artists as Janssen or Paul Wunderlich were "modernist" substitutes for the "post-modern" avant-garde, the works of nonprofessional naive painters appeared even more as a last refuge of pictorial invention and fanta-

cy. In distinct ways, the naive artist and the neo-traditionalist draftsmen appealed to the identical reaction against the hermeticism of the 1960s "high art" and provided the public with collectible objects whose style and content fused contemporaneity with established aesthetic values and a reverent recognition of the past. "Naive painting," wrote the French art historian Georges Schmits, also functions as ". . . a flight towards a golden age which has passed and a return to childhood, as a response to the depersonalization and the inhuman speed of the contemporary world. It is what supplies a measure of authenticity, stability, and contemplative distance, a measured slowness, a return to endearing anecdote, but above all [to] a simplified perception and its associated ability for synthesis. . . . The naives are our pastoral writers."[17]

Restoring pictorial order and invention, presenting a comprehensible synthetic view of a world largely derived from nostalgic remembrances of the variedly distant past, justified by the testimony of Expressionism as parallel seekers for painterly truth, naive artists became a desperately sought alternative for a public alienated from the avant-garde it once espoused as the manifestation of a free postwar society.

The exhibitions of Sunday painters and of naive artists inaugurated by the Eisenmann firm in 1962 found their motivation in this perceived bankruptcy and irrelevance of the avant-garde. They also represented an effort to regain aspects of the idealism which had characterized modern art during the previous decades of the century as they continued to express their faith in the humanistic utopianism of the Enlightenment and Romanticism, art that has a primary function in the "aesthetic education of man" and through beauty should implant in him a "harmonious character." This the apparent noncommunicative attitudes of abstraction and the anti-aesthetic stance of the newer avant-garde failed to fulfill. As Eugen Eisenmann encouraged his employees to confess to the value of their artistic creation in public exhibitions, he reaffirmed the desire for an art which would communicate aesthetic worth; he also reiterated the related faith that from untutored and uncorrupted talent would emerge "instinctively a type of work whose innocence and wonderful simplicity [would put to shame] those of their contemporaries caught up in the hypertrophy of the mind."[18] The universal value of art was emphasized as well when he displayed the paintings in the factory dining hall, where it was accessible to all, whether worker or manager, upper or lower class. The exhibitions thus fulfilled the function of proclaiming to all social factions of the German public an alternative to both the decried esotericism of the avant-garde and the tastelessness of popular kitsch. In time, the exhibitions should also demonstrate the innate nature of artistic talent and its need to develop free of academic or institutional or intellectual coercion in the total freedom of annual shows, where a receptive public could judge. From the exhibitions, too, a collection of works could be formed which might compete with the art of the past in its emphasis on imagery and aesthetic beauty while denying the lasting validity of contemporary "high art" activity.

More than any other individual included in the various Eisenmann exhibitions since 1962, Hildegard Auer fulfilled the unwritten and perhaps unconscious program that motivated Eugen Eisenmann's sponsorship:

untrained in the making of art, she dared to test her talent. Constantly struggling with the rudiments of technique which were hers, she developed a personal visual vocabulary, figurative and harmonious, by fusing elements of naive and Expressionist practices. Largely isolated and removed from other professional artists, she works now in her own artistic realm outside the limits of both the naive and the avant-garde.

Her earliest works, of 1962 or 1963, Auer no longer recognizes as relevant or significant. Totally amateurish, they displayed little other than a fundamental ignorance of the techniques of oil or watercolor painting. Blind in technique, she nonetheless formed a personal aesthetic according to which to judge her work. Her own inadequate images accordingly were seen in the light of her ten year's absorption in the Expressionist and naive paintings of Eugen Eisenmann's collection and in her own similar but smaller selection of German Expressionist and South German folk art. In their aesthetic she found her own. In their aesthetic she tested herself. To their aesthetic she matched herself.

The artist with whom Auer has developed the greatest affinity is Gabriele Münter, but in the search for a formal vocabulary in which to clothe her first significant painting. *The Funeral Procession* (1964, Oeuvre cat., No. 1), Auer turned to another *Blaue Reiter* painter, August Macke. Macke's technique and style she studied carefully and expertly so that today she continues to demonstrate a keen recognition of his particular qualities and to manifest a strong attraction to the simplicity of conception and means found in his scenes of contemplative figures in parks, outside shop windows, or in city streets. Although not related thematically to Macke's work, the small painting of a funeral cortege seen during a summer in Stockholm does take up Macke's recurring motif of figures grouped in a formal park setting. This admixture of direct kinship and dissociation apparent in the subject matter's relationship to Auer's artistic model is reflected in the formal qualities of the painting as well. In her composition with the strong diagonal of the path a central organizational element, Auer depends on a frequent device of Macke's works, but most closely approximates his *Sunny Path* (1913, Comparative ill., No. 5). Macke's exaggerated perspective which paradoxically flattens the space, his slight deviance from naturalistic color, his generalizations of figures into types, his suppression of a sense of volume in his forms, and even such a device as his denial of individual facial characteristics were all emulated by Auer, but in her recollection of Macke she failed to achieve his ease of movement or sophistication of color harmony.

Auer's brushstrokes are tentative, applied in small swirling touches or testy longer strokes that mix the various limited shades of green, yellow, red, blue, violet, and black on the prepared canvas. The result is a small range of individual hues dark and opaque, rather than brightly translucent as in Macke. But the somber tone and nonreflective surface, regularly interrupted by the repeated rhythms of red, orange, and green wreaths as well as the orange-yellow faces and the white-blue shirt fronts effectively render the sense of picturesque funereal grief, made poignant by the apparent awkwardness of rendering, the stiffness of the figures, and the almost childlike depiction of hieratically ordered trees and mourners in

top hats. Qualities of the amateur intermingle with those of the sophisticate as Auer's knowledge of an artist's production was not matched by her knowledge of the means of visual creation. This fundamental dichotomy in which she failed to understand the limitations of her ability or the particular nature of what she could achieve remained the inescapable obstacle to her efforts throughout most of the first decade of her artistic development.

Auer's ability to paint was extraordinarilly limited during this period, not only in terms of her technical knowledge but also in terms of the time she had to spend on it. Increasing demands at the firm persistently prescribed the amount of time available for other activities. She painted, as a result, almost solely when on holiday, largely as a means of relaxation, although the potential for competition remained constant as her fellow employees likewise painted, and she painted specifically for the annual exhibitions of Sunday painters the firm sponsored. The tension between pleasurable activity late in the evening after a day's work or on summer vacations and the pressure of having to produce finished works for the factory exhibition resounds in the stylistic indecisiveness which is manifest in the paintings of the 1960s, where self-indulgent experiments in paint are persistently masked by her emulation of other artists, their style, technique and subject matter. From one painting to the next, Auer shifted her model so that Macke was immediately replaced by Alexei Jawlensky, Ernst Ludwig Kirchner, Emil Nolde, or Gabriele Münter, as Auers painterly mode was switched according to the artist she most associated with the subject matter and format of a particular painting. Stylistically, as a result, no unity was

achieved nor was a personal style attained as Auer's painting underwent chameleon-like transformations with each individual work.

In 1965, her shifting artistic allegiance turned to Jawlensky for *The Party Dress (Woman with Hat, Oeuvre cat., No. 2),* whose compositional arrangement with the bust-length representation of a woman seen totally frontally easily resurrects Jawlensky's paintings of women's heads of 1912–13 (Comparative ill., No. 3). From these Expressionist paintings, Auer not only borrowed the compositional arrangement, but also the intensity of color–the reds, blues, pinks, violets, browns, and flesh tones delineated in heavy black and set against a bordering solid violet background. The comparatively heavy application of paint and the tracks left in it by Auer's small brushes also echo Jawlesnky's practice as does the constant repetition of rounded shapes–breasts, necklace beads, cheeks, eyes, head, hat, and flowers–which generates a restless rhythm throughout the painting. With that restlessness, she departs from Jawlensky, as she also does in the strict ironic frontality that pushes the figure stiffly into the center of the almost square field.

The stiffness and harsh frontality combined with the heavy outlining of nose and chin as well as the stylized emphasis on the breasts seem to form a deliberate reflection of practices characteristic of naive painters, just as do the insistent detailing of floral patterns, of beads and earrings, and of strands of hair. Unlike the truly naive artist, however, Auer does not find her painterly qualities in a process of matching her untutored skills against the demand for an illusion of nature, a practice that frequently

leads the naive painter to seek to capture every visible detail and to ensure the shapes of objects by providing them with surely enclosing outlines. Auer's practice was, instead, to emulate consciously the effects of naive painting, much as in a more fluid manner Jawlensky had already done fifty years earlier. Totally unlike the truly naive artist, Auer intended to create paintings that adapted the practices of past art, whether Expressionist or naive, as hommage to the art she most admired.

The concept of what constitutes naive art remains a fluid one with no full agreement as to how its features might be recognized. Nonetheless, certain dominating characteristics, in addition to a lack of formal technical training in art, repeatedly appear among artists termed naive. Fundamental among these is a basic lack of stylistic development but rather, once technical matters are sufficiently mastered, a stylistic stasis in which each new work reconfirms the formal qualities of its predecessors. As the catalogue of the pioneering 1961 exhibition *Das naive Bild der Welt* proclaimed:

"In contrast to his not-naive colleagues, the naive master seems not to have the need to concern himself analytically with the style of his art. He need not come to terms with the stylistic formation of his contemporaries or of his precursors. He possesses his own formal reality in which he must seek to unfold and improve."[19]

In their mode of representation, there is, for example, little to distinguish an early painting of the Douanier Rousseau's and the last one executed in 1910. Thematic and compositional changes occur, but the essential manner of painting remains identical, largely because the process of measuring his own art against that of past or present masters and adjusting it according to changing stylistic demands was never entered into by Rousseau, as he himself confirmed: "I cannot now change my style, which I acquired, as you can imagine, by dint of stubborn labor."[20] The motivation for change is lacking in naive art and the "stubborn labor" of achieving any visual expression provides strong motivation for stylistic consistency. Auer's art, with its persistent stylistic shifts and experimentation, breaks with the dominant naive attitude, even when she sets out to emulate select qualities of naive painting in her own work. The appearance of naive art is emulated by her, but she herself adopts and maintains an eclectic attitude which permits her to dip into the vocabulary of past art to apply it to her own work at will.

If the attitudes manifested by Auer therefore contrast categorically with the attitudes of a naive artist, the surface appearance she lent her art did not. *Chestnut Blossoms* of 1966 (Oeuvre cat., No. 3), in comparison to her two earlier paintings, displays a far more overtly naive style, or perhaps even more strongly, recalls the art of children. The perspectival manipulations of *The Funeral Procession* and the expressive decorativeness of *The Party Dress* are totally lacking, although the painterly facture of the latter was retained, but in a looser, less-controlled style that piled layers of wet paint one atop another and mixed them into a viscously murky surface. All shapes are viewed frontally and flattened without distinction, whether they be the massive chestnut-like color of the staring woman, the violet path, or the rounded green circles of trees. As all the forms tend toward geomet-

ric shapes, above all the repeated circle of trees, breasts, and face, set next to each other without transitions as distinct rather than organically connected shapes, the painting functions as a deliberate quotation of the hallmarks of a young adolescent's art. The formal characteristics of a teenaged girl's imagery is seconded by the assertive emphasis on sexual features: the broadly rounded breasts that dominate the painting's center, the massive shape of the aproned abdomen with its indications of pregnancy, and the sexual symbolism inherent in such elements as the rounded trees with their vertical pink blossoms or the oral emphasis on the woman's slitlike brown-red mouth. It is as if Auer, recalling the illustrations she had made for her little sister almost thirty years before, was deliberately reconstructing the art of her own adolescence.

Auer herself has confirmed that *Chestnut Blossoms* constitutes a conscious emulation of naive art, and that in her other works of 1966–67 she quickly moved her art through a heightened process of further eclectic emulation of both naive and professional artists. A trip to Oslo and the Munch Museum there caused her to adopt the composition of his paintings of children, particularly *Four Girls at Aasgardstrand* (1902, Comparative ill., No. 4), a painting with which she was already familiar from the Staatsgalerie in Stuttgart, for her own representation of children she had seen during a cruise to Denmark. In *Children at the Sea* (1967, Oeuvre cat., No. 6), as in Munch's painting, the children are positioned frontally in a single row, gazing out at the viewer from a generalized landscape setting. Auer also attempted to emulate certain aspects of Munch's rapid brushwork and transluscent paint applica-

tion, but for this her technical ability failed to meet her demands, and as a result the swirling sea surrounding the children seated on a pier appears coarsely overworked. Munch was a revelation; his brooding psychology permeated her own paintings. In this work, however, she also apprenticed herself to Gabriele Münter's color orchestrations. The deep Prussian blues, redbrowns, pinks, yellows, violets, and white, as well as the practice of setting off the light-colored figures against a somberly dark ground are akin less to Munch than to such seemingly unrelated works by Münter (in terms of motif) as the *Still Life with Sunflowers* (ca. 1910, Comparative ill., No. 1), whose peaked diagonal compositional order and color seem almost superimposed onto Munch's painting of the four Norwegian children. Similarly the generalized facial features, already used by Auer in her Macke-derived *The Funeral Procession*, show the blank but seeing round eyes and pursed mouths often used by Münter as well. If some of the qualities of an adolescent's art remain in this painting of children, and may possibly be formal devices deliberately maintained to emphasize the subject matter, Auer has also placed herself under a self-imposed apprenticeship to artists of the past with a consistency and determination not apparent in her previous works. Painting had ceased for her to be solely a way of passing the time and a means of relaxation. There was now a seriousness of purpose and earnestness as well as ambition not present earlier.

Gabriele Münter likewise inspired a series of paintings on the motif of the circus (1967), some of which were done in the technique of the glass painting which the *Blaue Reiter* artists had in turn learned from Bavarian folk art. Münter had already translated this

folk-art technique usually reserved for devotional religious imagery into the context of circus scenes, but Auer's composition retains a particular closeness to Münter's Madonnas, who iconically dominate a composition and spread their mantle protectively over their worshippers, much as Auer's woman acrobat (Oeuvre cat., No. 7) seems to embrace in her sweep the animals of the circus.

These paintings consequently bespeak not only of Auers own love of the circus but also of an effort to absorb, through the work of a fellow artist who had done so previously, the formal criteria of folk art with its lengthy traditions that preceded the emergence of naive painting in the nineteenth century. There is in this experimentation with the styles of Munch, Münter, folk art, naive art, and other models a desire to reexperience the practices of the past and also to translate into her own world the artistic sensibility of particularly significant moments or objects. Thus a visit to the house once inhabited in Davos by Ernst Ludwig Kirchner resulted in Auer's purchase of a tapestry designed by him, and in the extraordinarilly Kirchneresque painting *Davos in Winter* (1968, Oeuvre cat., No. 14). More than in any other of her works, in this painting Auer copies technique, color, composition, and motif to such an extent as virtually to lose her own identity.

The submission and surrender to Kirchner's authority was, however, swiftly rejected. In no later painting did the overwhelming influence of the former *Brücke* painter manifest itself as Auer more and more recognized the limits within which her own talent could freely unfold. In further testing of herself against selected prototypes, Auer tended to move between the instinctive vocabularies of naive and folk art and variants of the *Blaue Reiter* artist's early formal practices, until her own fully personal style was achieved on the basis of these ingredients.

The selection of models is significant. Certainly ever since Auer purchased her reproductions of paintings by Marc and Feininger, she retained a consistent interest in such artists of the Expressionist period whose aesthetics and imagery gained a relatively widespread acceptance among German audiences even during these artists' own lifetimes. The reasons for this—at least superficially—are not difficult to discern, particularly in the case of Franz Marc. Of all the artists of the pre-World War I avant-garde in Germany, he was the one who overtly remained most attached to certain German Romantic perceptions that had been popularized and, to a degree, trivialized during the late nineteenth and early twentieth century. Thus, in spite of the abandonment of naturalism in his forms and colors, his glorification of animals bespoke a sentimentalized panentheism that viewed animals as innocent and true reflections of a divine consciousness; even without such metaphysical signification, moreover, Marc continued the nineteenth-century genre of animal painting in which deer, horses, or dogs take on quasi-human characteristics and participate in dramatic, melodramatic, or comical enactments, thus inviting an empathetic response from beholders. Marc's overlay of a modernist style on top of this subject matter succeeded in giving his art an aura of contemporaneity without destroying its popular viability. The myth surrounding the artist that arose as a result of his early death in battle further contributed to the general acceptance of his work.

Marc was, in many ways, the prototype of a popularly acceptable modern German artist: deeply rooted in German tradition, retaining recognizable subject matter in most of his works, and a martyr for his national identity. (Significantly, the same degree of popularity has not been gained by August Macke, who shared virtually all Marc's characteristics except the animal motifs in his paintings). When Auer turned to Marc and other *Blaue Reiter* artists for her prototypes, therefore, she also selected models among those pre-World War II painters who corresponded to a widespread perception of what constituted a modern German artist; a conscious concern for this identifiable Germanic quality–a Germaness untainted by association with the Third Reich, and in fact rejected by it–formed a conspicuous component of her selection.

It is possible to perceive the other major support of her art–the painting of the naives and their folk-art predecessors–as a similar attachment to identifiably German aesthetic and ideological values through which she would mark her own work. The appreciation of naive and folk-art, as well as the art of children, by the *Blaue Reiter* circle, and beyond them, by Expressionist artists and patrons in general, has already been cited here as a major precedent and justification for the interest in naive art that emerged during the 1950s and 1960s. Among the artists, Kandinsky and, even more, Gabriele Münter frequently emulated the formal vocabulary and subject matter of Bavarian folk painting, creating independent compositions in the style of Bavarian glass painting, actually copying folk paintings, and hanging examples of such painting as equals among their own work.

Their appreciation of folk, primitive, children's, and naive art had its origins in Romanticism's recognition of an innocent human nature–whether that of the child, the uncivilized, or the untutored–as a subjective spiritual existence which gives rise to a "concept of a pure and free energy, an integrity, an infinity" that is moving to the beholder, according to Friedrich von Schiller. This was also what attracted Kandinsky when he identified children's art with folk art, and saw in naive artists the capacity to maintain the superior qualities of these, causing him to exclaim: "There in an unconscious, enormous power in a child. . . that elevates the child's work to the level of an adult's works (and often much higher!). . . . The artist who, during his entire life, remains like a child in many way can often arrive at the inner sound of things much more easily than others."[21]

The Expressionist discovery of such art projected it into the German artistic consciousness; even if one disregards the naive painters, artists emulating their formal features have consistently been present throughout the decades until the present. The formal characteristics of naive art, of children's art, and of folk art (as well as of the art of the mentally disturbed) were deemed to exist outside the discipline imposed on, and limiting, the professionally trained artist. Considered timeless in their manifestations, they were shown to possess certain fundamental qualities in common: imposing frontality, hieratic composition, disregard for conventional proportions, an often wooden stiffness and apparent awkwardness in the figures, a detailed delineation of objects and their components, a limited color spectrum, a predilection for rhythmic patterning, a strong simplification

of organization, a rejection of perspectival illusion, a denial of volume, and a sense of dream and magic in the presence of objects or figures. All were "the manner in which primitive formal powers are made manifest."[22]

The universal manifestation of "primitive formal powers" was, moreover, granted a particularly German cast when critics discovered similar qualities to be present in a wide selection of German artists chronologically distributed from the Gothic Middle Ages to Lucas Cranach during the Reformation and on to Philipp Otto Runge at the beginning of the nineteenth century. A specifically German sensibility seemed to emerge from the "primitive" and "childlike" aspects of these artist's works and their emulation became a means of affirming the German identity of a painter after World War I. Participants in the 1920s New Objectivity, committed frequently to proclaiming a national manner of image making, modeled technique as well as form on those German artists whose "primitiveness" seemed above all to testify to their national identity. Otto Dix and Max Beckmann were among these emulators of the naive, but the same emulation, if less radical in form, could be found among painters whose political ideology conclusively affirmed Nazism; the bond between the groups was therefore not ideological identity, but within antagonistic political attitudes to affirm the identical features of German art. Nor did this dependence on the formal characteristics of nonprofessional art cease in 1945 with the Nazi defeat. When a new realism reemerged during the 1960s, as yet another component of the complicated challenge to the hegemony of gestural abstraction as the avant-garde vocabulary, German "super realists" such as Peter Na-

gel were once again unique in granting their images overtones of the naive. The German attachment to qualities of the untutored painter, the artistic amateur, the aesthetic innocent, was thus reiterated yet again to continue this century's persistent echo of the Sunday painter's voice and vision.

In the early works that testify to her efforts to find a personal expression, Hildegard Auer predictably also turned to the discerned stylistic signs of the artistic naive, and in that affirmed her attachment to identifiably German traditions as much as when she modeled her work on the Expressionists. Deliberate naivism, unmixed with the Expressionist practices that colored her works of 1962–67, emerges in her first planned painting, one which is not the unpremeditated product of a late evening's desire to relax or of the Eisenmann exhibition's annual needs for submissions by the firm's staff. *Cows at the Tanja River* (1968, p. 78) derives from a scene witnessed by Auer during a tour of Norwegian Lapland in the summer of 1968. The cows resting near the cold river amidst the opulent green of the Nordic summer were sketched by her, then, half a year later, during the Christmas holidays spent on a Bavarian farm, she created the painting. In the disposition of forms and in compositional arrangement, in the limited color spectrum and in spacial conception, and finally in terms of the motif itself, this painting marks a significant break with Auer's prior images. It represents in an essential fashion her first independent work, one created without the deliberate citation of the practices, so archetypal for her, of Münter, Jawlensky, Macke, Kirchner, or Munch. It can be identified as the first painting truly by Hildegard Auer.

After the intense reds of *The Party Dress,* the somber tonality of *Children at the Sea,* and the unresolved coloristic mix of *The Circus,* this painting of reclining Lapland cow's shows an unexpected subtlety in color usage. The palette is simple, limited to pastel tones of blue, green, yellow, brown, and pink, along with white. The soft colors and their limited range suggest a sense of tranquility, which is augmented by the general simplicity of the painting's conception and composition. The shapes of seven white-pink cows provide the essential form whose contours are echoed in all the other major areas of the scene, so that the protrusions of land on which the cattle are resting take on the same semirectangular, slightly humped outline as the animals themselves. The repeated mirroring of similar shapes reduces the spacial quality of the scene, and this flatness is enhanced by the general lack of modeling in the forms and by the almost embroidered decorative patterning of the bushes and trees in the background. Even more responsible for the anti-illusionistic tone of the painting, however, is that the traditional gradation from dark to light, and from the lower (foreground) edge of the painting to the upper (aerial) edge has been reversed so that a pale, ethereal blue appears below while the densely patterned, affirmatively brushed heavier area of the green and yellow forest closes off the upper edge. It is aerial perspective transformed into its antithesis. The means of thus achieving a spatial flatness are composed of truly naive practices—nonmodeled forms, outlines, ornamental patterning and repetition of similar configurations—but these are imperceptibly and skillfully fused with a sophisticated manipulation of illusionistic practices and techniques. There is evidenced a consciousness of

means alien to most amateur and naive artists, and the painting itself is transformed into a self-conscious commentary on the language of naiveté. It is a painting in dialogue with its own ancestry.

Identifying the sources, other than Auer's own personal experience of the cows in the sub-Arctic landscape, is more difficult than the deceptive simplicity of the painting might seem to suggest. Animals are a frequent motif in naive art, whether the lions and apes of Henri Rousseau's tropical jungles, the zoological variety in Edward Hicks's Peaceable Kingdoms, the farmyards with oxen and roosters or the forests with symmetrically ordered deer often populating paintings of the Yugoslavian colony of primitive artists at Hlebine, or the portraits of domestic dogs and cats by the Swiss woodsman and lumberjack Adolf Dietrich. Stylistically none of these relate to Auer's *Cows at the Tanja River.* Instead, the eclectic capacity of her vision seems to have constructed a vocabulary that is formed from recognizably naive but nonindividual devices, such as the simplification of flattened and outlined forms, the tendency toward characteristic and repeated silhouettes, the love of patterning. Rather than modeling herself on a particular painter, Auer abstracted the principles of naive painting in order to produce a personal style in her work. Moreover, a kinship less with naive art than with the animal paintings of Franz Marc also seems to posit itself strongly. She has obviously not emulated Marc's Cubist and Futurist inspired style as in his *Fates of Animals,* (1913, Comparative ill., No. 7) but rather sought her prototypes in the transluscent minimally modeled forms of horses or cows in blues, yellows, and whites of 1910–11. From Marc she also bor-

rowed the practice of dividing the landscape into discreet color areas, which are juxtaposed to one another, and finally the structure of the painting in which the horizon line, upon which naive artists generally place great emphasis, as well as the area of the sky are completely absent, thereby again enhancing the image's antinaturalistic flatness. The practice of melding aspects of *Blaue Reiter* art and the painting of the naives, which can be discerned in Auer's work almost from the start is here carried into a more mature, assertively self-defined image, projected as an alternative to the contemporary avant-garde in a process that makes the past present, that reattaches itself to the ideals and styles of early German modernism without duplicating it or seeking to supersede it.

Auer's style was not fixed, however, after she completed *Cows at the Tanja River,* nor did the seriousness of purpose that marked this painting continue. For the next two years, her paintings continued to demonstrate indecision and stylistic vacillation, and the process of imitation again became far more overt in character. The foliage of Henri Rousseau's jungles thus clearly served as the model for the trees and bushes in *Bear in Autumn* (1968, Oeuvre cat., No. 8) while *Happy Birthday* (1969, Oeuvre cat., No. 15) transplants the coloristic tumult of Seraphine Louis's trees and bushes into a more muted Swabian context, complete with quasi-folklike figurines, imitations of those that Gabriele Münter might have included in her paintings. Quite probably this small painting also had as models some of the still-life paintings then being sent to the Eisenmann exhibitions by Ida Bock, a housewife living outside Stuttgart at Sindelfingen-Maichingen. A comparison of Auer's painting to Bock's *Bouquet of Flowers with Pewter Pitcher* (1964, Comparative ill., No. 8) clearly shows the same emphasis on placing the main motif iconically into the center of the painting, painstaking rendering of each floral petal individually, and the tilted a-perspectival presentation of the various objects in their setting. Bock, however, felt the need to render each object discrete from those bordering on it, so that the plate of fruit, the coffee cup, the pewter coffee cannister, and the vase of flowers each maintain their conceptually defining form without being superimposed on one another, and each is depicted completely. Bock's vision was indubitably that of a naive or amateur painter who focused on the object seen and was then psychologically challenged to represent the objects as hieroglyphs of themselves, totally identified by sharply drawn characteristic silhouette. Auer's picture represents a greater artistic daring, a risk engendered through her continuing absorption in the principles distilled from the art that surrounded her in the intimacy of her home or personalized the institution of the Eisenmann offices. Rather than set her floral composition into a defining background of flat color—as Bock had—she pushed it over the edges of her support. The result is a monumentalization of the image and the generation of spatial ambiguity as the precise placement of the bouquet becomes disguised, both pushing toward picture plane and remaining placed, particularly through its pewter pitcher, into the apparent continuity of distance within the painting. The spatial organization of the composition is likewise denied clarity by the placement of the figurines in such a fashion that their heads either cut into the floral forms or abut against them, so that the male bearded head and the red-cheeked

woman's face appear almost as continuations of the red, orange, white-yellow, and violet of the flowers. The precision of location is disrupted as well by the cut oval of the green, violet and yellow tablecloth, which tilts upward and refuses to function as a fixed base, its colors echoing and augmenting those of the flowers above it. The distance implied by the superimposition of one form on another is denied by placement and the flattened rendition. Scale relationships, too, are disrupted. Shapes, apparently human shrink in relationship to the flowers dominant above them, and beneath them the oval form of the tablecloth shifts perceived reality between table top and floor covering. The confusion is lifted once the man and women are recognized as figurines, and the relationships of the objects to one another can similarly be granted a naturalistic logic; the visual ambiguity, however, is never totally removed and constantly demands new deciphering. The painting becomes a visual game that has as its protagonists its visual fact and the reality of human experience and memory. The simple clarity and precision characterizing the naive are totally lacking even as their appearance is conjured forth.

Like *Happy Birthday,* other paintings of 1968–69 are manneristically naive. Working in a deliberately plagiaristic naive style, Auer nonetheless demonstrated an inability or unwillingness to limit herself to what she was imitating. The pictures are dishonest, she has stated, as they were created to function as items in the Eisenmann annual exhibitions of Sunday painters and denied her own reality. The images present a certain quasi-naive charm, even prettiness in their form; and in their content there is a lack of narrative but simultaneously a regressive reference to a saccharine past in the use of folk and quasifolk art objects. In the structure revealed by the paintings, however, and in its repeated ambiguities, Auer denied the painting's apparent simplicity. Whether consciously or not, she subverted her own subordination in the act of advertising it. The freedom she demanded for herself was ironically retained, albeit in disguised fashion, even as she painted amid the managerial family of the Eisenmann firm celebrating its holidays at the Ratzenberg farmyard.

The years of the 1960s represent the time of Auers painterly formation during which she worked in an almost totally eclectic manner, deriving her stylistic vocabulary erratically from diverse sources, but primarilly from the *Blaue Reiter* artists and from naive painting. For the work of postwar artists she developed no sympathy, and abstract art she found too limited in the ability to communicate a readable content. The models she sought out for her own work attached themselves rather to the modernism manifest prior to World War I. This reflects, certainly, a subjective personal taste—both her own and that of Eugen Eisenmann as manifested in their collections—but it also forms a deliberate effort to bridge over twentieth century Germany's most problematic years and to seek an identity within a seemingly more innocent time when the products of German culture bore none of the guilt that necessarily adhered to them later. The indecision of Auer's amateur efforts in art during the 1960s reflects a greater social lack of identity—a lack of a constant referential to being oneself and a constant participation in certain group-specific characteristics, according to Erik H. Erikson,[23] that manifested itself in the Bundesre-

publik as it found itself economically prosperous while the international encampment of Anti-Communism to which it belonged decreased in cohesion. The issue of a German political and cultural identity remained unanswered as the various ideals of internationalism, ranging from the United Nations to NATO and the Common Market, likewise lost the immediate promise they seemed to bring during the 1950s. In 1966, Karl Jaspers summarized in his book *Wohin treibt die Bundesrepublik?* (Where is the Federal Republic heading?): "It has been said that there is a vacuum in our political consciousness. Indeed, we do lack a political goal that is rooted in our hearts. We are not standing on foundations created consciously by us. We do not take flight with our will to freedom. . . . For us, there still is no political origin, no political ideal, no awareness of the past, no deliberate goal for our future. In fact there is hardly awareness of the present except in the will to private property, to living well, and to security."[24]

Jaspers's pessimism was perhaps exaggerated, but nonetheless the contemporary neurotic inability to establish a German identity beyond that of economic and political security became a vexing problem during the 1960s, to judge from the number of publications devoted to the subject.[25] Willi Brandt's independent *Ostpolitik,* the rise of radical student organizations, and, in art, the beginnings in Berlin of a new subjective-expressive school of painting, with Georg Baselitz, Eugen Schönebeck, Karl Heinz Hödicke, Bernd Koberling, and Markus Lüpertz among its propenents, are symptomatic of a confused but vocal search for a way out of the German dilemma. Under totally different and frequently

antagonistic manifestations, these artists shared not only a will to an identity but also an attachment, conscious and deliberate, to values or particular manifestations of Germany's pre-Nazi cultural and political past, an era equally innocent of Nazism's crimes and of West Germany's material wealth born of the Cold War. Auer's efforts, outside the noisy spectacles of the avant-garde and of the spectrum of political activeness, are in communion with the same desire for identity, for an attachment to a past that lacked the potential condemnation of the present.

The isolated, unrepeated example of *Cows on the Tanja River* provided Auer with a model for her future paintings, setting them into a stylistic amalgalm of the naive and of sophisticated modernism as practiced by the *Blaue Reiter* artists. The formula, with its overtones of being a particularly German mode, was taken up again in 1970, and then consistently exploited by her. *The White Stag* (1970, p. 81), identifies Auer's new-found certainty and her willingness to move beyond the surface naivism with its flower bouquets and folk figurines that marked her work during the last two years of the 1960s. Her reasserted independence, not surprisingly, coincided with Auer's appointment as managing director of the Eisenmann firm. For the painting, Auer turned to a dream she had early in December, to a totally private realm in which a world of conscious external control was denied and whose truth could be questioned by no one. In it, Auer as never before took on the role of being her own authority.

The new painting quickly makes apparent formal similarities to its 1968 precursor: the colors are muted, with white dominant and mixed with all the other colors; the volume

of forms is denied; a system of repeated patterning knits the surface together with echoing visual rhythms; and space is flattened, not only by the rejection of perspective, but even more as the background is compositionally pulled into the foreground, thereby rendering the spatial organization ambiguous. In its centralized symmetry and its aperspectival rendering, the image maintains Auer's continuous dialogue with naive art, as it does by monumentalizing the form of the stag in the doorway, isolating it and bestowing on it a supernatural, mysterious aura, the quality of a magical apparition. The farmhouse interior, the bird perched atop a chair, the tall clock with its eyelike face, and the stag in the winter landscape engage in a conversation of the absurd in their juxtaposition, but attachment to the naive's assertion of the experience of reality prevents it from becoming engulfed in the artifice and morphetic delirium of Surrealist visions or the projections of such contemporary Viennese phantasists as Rudolf Hausner or Ernst Fuchs. Auer's vision involves, not the detailed rendering of an irrational world inducing anxiety in its hyperrealistic illusionism, but a simple and uncomplicated statement of ideogramatic facts: trees, bushes, fence, snow, deer, doorway, panelled wall, tiled floor, chair, bird, clock. It is an additive perception that itemizes in order to present the narrative by setting its protagonists simply next to each other in symbolic, not veristic, presences.

Auer's stag—the red deer identified as *Rotwild* or *Edelwild* (noble deer) in Germany and zoologically identified as *cervus elaphus*—is denied its characteristic red-brown coat to appear ghostlike in snowy albino form with large staring gold-red eyes. Its pose, with head turned sharply as if listening to a sudden noise, body in profile, and legs stretching the animal into alert tenseness, is borrowed from popular wildlife photography, a "nature pose" artificial in its determination to reveal as much of the animal's majestic presence as possible and identical to the poses in which prize farm animals—horses, cattle, or goats—are also presented in their portraits. The photographed image can serve multiple purposes for animal husbandry, for hunters, and nature lovers, with each reading the content of their disperate experience into it, each seeing the nobility of the stag with different perceptions. Auer reproduced the deer's pose from memory, probably not even consciously basing it on its photographic precedents. However, the white stag's ability to recall the popular images of photography with their ambivalence does enrich the connotative functions of Auer's painting, and it is in a dialogue with this image that she gains an independent meaning. The nature scene of a deer suddenly pausing in a forest clearing was subverted by her and its banality was inverted when she projected it into the context of an uninhabited domestic interior. The juxtaposition demands interpretation and necessitates the denial of previous animal paintings, whether the naturalist studies of Ferdinand von Rayski or the metaphysical compositions of Franz Marc. Auer's picture emerges from deliberate fusions of dream memories, artistic precedent, and popular imagery to generate multivalent associations for her art's audience, which at the annual Eisenmann art exhibitions continued to be attuned to the directness of Sunday painters and of the naive. Auer's process, which involves a conscious manipulation and synthesis of diverse sources of style and image, denies the naive or amateur attitudes, however, and sig-

nifies an effort to construct a unique and independent art.

*The White Stag* demonstrates characteristics in style and attitude that Auer now maintained, with slight variations, until the end of the 1970s. Once she became the managing director of the firm and also moved into a house in Sindelfingen-Maichingen, Auer also developed the resolve to establish and develop her own artistic persona from the interplay of naive and early modernist tendencies with which she had experimented without achieving resolution during the previous ten years.

She ventured, as well, to work in a somewhat larger format than that of 40 by 50 centimeters, which had previously been the size she favored in her canvases. In the smaller format, she had been able to work with speed during the limited periods of time available to her, and to attain relatively complex images while using small, tentative brushstrokes. The result most frequently was an image that proclaimed the limits of its size and a certain precious quality that tended toward the decorative, the surfaces filled by small flat forms densely abutting one against another, their colors contained within the subdivided shapes. In this, Auer remained attached to the limitation frequently present in naive and amateur art, where the artist tends to work in a small format because of limited material means, lack of vision or lack of daring, and a technique too rudimentary to take on the ambitious project of a large canvas. *Cows at the Tanja River* and *The White Stag* embodied efforts by her to overcome the limitations of format and technique. She gained through her animals a greater sense of monumentality, but nonetheless the painting's small-

ness constantly interferes with her intentions, making a fully satisfactory solution impossible.

During the 1970s, much of Auer's work involved the effort to overcome these limitations of technique, with her first solution consisting ironically of increasing the patterning of the picture. *At the White Wall* (1971, Oeuvre cat., No. 18), set in the garden of her new house, therefore shows an intensified sense of color combined with even greater flattening of forms and space than occurred in her previous works. As the colors adhere to the surface, they are presented in discreet areas like pieces of a puzzle fit together and with virtually no modulation. Scalloped shapes echo each other and contrast to the vertical and horizontal striping that is dominant in the central figure. But in the expansive dimensions and distinguishing color patterns, as well as in the linearly geometric delineation of her clothing, this woman is lifted out of the context of garden wall and vegetation surrounding her. Thereby she achieves a sense of monumental presence as no prior figure by Auer had. The ability to give her figures, whether animals or humans, a sense of conscious presence with which they dominate their image and the environment around them was Auer's major achievement in the early 1970s. It bespoke the role she had acquired in her professional life, but was also indicative of the ambitions and efforts she placed into her art even at this time.

The naive artist's practice of situating a figure frontally and thus iconically in the center of a composition was retained by Auer and became an almost signatory device for her. She enhanced this primary figure's sig-

nificance by subordinating to it a screenlike environment which now began to function as a means of augmenting the narrative or representational content of her paintings, whereas in previous canvases, such as *Chestnut Blossoms,* the figure acted more as personification of the landscape setting. In contrast, the landscape of *The Morning When the White Wolf Came* (1972, p. 80) reveals the causes of the horse's uneasy state of attention and accentuates its precarious existence. The trees function not only as a naturalistic setting; they are more: both a fragile source of enclosing protection and a cage-like container preventing escape. Disembodied wolves' heads, appearing like hallucinations among the bushes of the background, palpably make present the sounds of their baying while also personifying the lurking, watching danger. The screen of tree trunks, the rhythmic repetition of the dark canine heads, the patterned indication of a snowy landscape, the icy plane of sky and clouds—all these function to enliven systematically the canvas area surrounding the central figure of the horse while also clarifying the event depicted. Auer's presentation has its sources, although not consciously, in the history of visionary paintings that frequently represented a thought, dream, or divine appearance by depicting it as if actually present. She portrays the sound of the wolves much as Henry Fuseli, for example, represented the demons of a nightmare plaguing a sleeping woman; the mental images of baying wolves surround the horse, so that their presence becomes inescapable, visually analogous to the sound that encircles the frightened animal. But more than the ghostly apparitions of the wolves, the landscape with its encaging tree trunks and impenetrable, insurmountable wall of bushes and

cloud-filled sky functions as an extension of the horse's fears and anxieties. The landscape setting acts as a symbolic statement of the central mood; landscape is given life as a function of mind and emotions so that it is an extension of the figure which it surrounds, no longer incidental but an essential component of a total pictorial narrative.

The landscape gained increasing significance as a symbolic entity in Auer's paintings of the 1970s as it provided a more expansive setting for the action depicted. A sense of irreality is frequently fostered, whether in the snowy barrenness embracing *Mrs. Kortuma* (1975, Oeuvre cat., No. 43), the Franz Marc-like colorations of *North Station Street* (1977, p. 95) or the moonlit lakeside wilderness in *The Sleepwalker* (1980, p. 115). More and more, as in the last of these, the landscape forms were simplified and granted a crystalline structure with few individualizing details. The shapes and the colors, granted individual and a-naturalistic properties, take on an anthropomorphic aspect, coming to life in strange, suggestive configurations as they vie in significance with the central figure. As it contributed to the communication of her art's content, moreover the attention paid to background also enabled Auer to compose in the larger scale of her newer works, to fill the canvas with structured forms.

The size of Auer's paintings is ultimately limited by the space in which she works. The relatively low ceilings of her bungalow studio prevent her from using formats greater than about two meters in height, as also befits an art whose total tone is one of essential intimacy, of privacy rather than of public posture. It is an art of and for the middle class and it remains at home in a

domestic interior, not in the anonymity of vast, white-walled gallery spaces and under the glare of track lighting. There is in this a statement of rejection in regard to contemporary high-art practice, just as the meticulously placed, a-sensual brushstrokes in her paintings are a denial of the painterly bravura of both postwar gestural abstraction and contemporary "vehement painting". The scale of her paintings can read as validly as a denial of Third Reich monumentalism as it can of the avant-garde's pseudo-murals, while it also finds itself in kinship with the practices of *Blaue Reiter* artists who rarely moved beyond similar dimensions. Painting size is a statement of her sources and attachments, in effect, and also posits the desire to create works that would maintain their legitimacy on the walls of living rooms and libraries as private, more than public, art.

As she evolved the method of placing the protagonists of her pictures into spatially and conceptually expansive settings that serve as enframing subtexts, in several smaller paintings Auer also created paintings whose massive figures threaten to push past the boundaries of her canvas while simultaneously being compressed within them. *The Protector* (1976, p. 89) virtually eliminates all setting for the two harshly frontally posed figures who fill all but a small area shaped like an inverted L, and that pushes them vise-like toward and against the opposite edge, depriving them of potential movement except such as will press them even further together. The colors, which in her other paintings of the time tended toward deep reds, yellows, blues, and greens in a luminous interplay, are somber with the black-coated form of the man dominant and all others darkened by their admixture with quantities of black. The psychological impact of the colors and composition, as the form of the man seems to hover over and engulf the smaller one of the woman, is joined by hints of futile movement. Eyes gaze simultaneously in different directions, mouths and facial planes shift from frontal to somewhat sideways presentation, and the woman's entire left side appears pulled into the encroaching shape of the man, but the sense of entrapment is never overcome. In coloration and spatial as well as compositional concept, the painting clearly departs from Auer's prior exemplars among naive and *Blaue Reiter* painters and points most directly to Max Beckmann. As Auer now sought to create a viable art outside the confines of high institutionalized art, she significantly turned to many of the same models as the representatives of the new *Heftige Malerei*—identified by American critics as Neo-Expressionists—did; they, too, sought to create a new identifiably national mode of painting. Stylistically and ideologically antagonistic, in the motivation of their art they share similar concerns.

The injection of elements derived from Max Beckmann into her own work signaled a complex of changes in Auer's art during the later 1970s—immediately before and after her retirement from the Eisenmann firm. Dreams of her own death accompanied the drastic shift in her life as after twenty-five years of service she let go of the firm's overt presence and protection. With the risk of her newly restored independence, however, also came a surge in her creative activity, and she painted a dozen pictures during the summer, fall, and winter of 1977. More than previously, she turned to themes derived from her own life prior to its identifica-

tion with the engineering firm, intermingling these with recollections from the summers in Canada and Alaska as well as with psychological allegories.

*Death in Alaska* (1978, p. 99) is exemplary. Unlike the compositions of her earlier work, the principal figure is placed, not in the center to function iconically, but to one side. As a result, the central area of the canvas is occupied by the movement of the landscape perspective into depth. No objects or figures prevent that visual movement, but in the sharply contoured landscape of mountains and river, animals are placed in such a way as to deny the landscape's perspective by their relative size. The process of simultaneously affirming and rejecting illusion, present in many of Auer's earlier works, received new impetus in this disjuncture of scale. To this she now added a new vocabulary of brushstrokes. As is the case with many naive or untutored artists, Auer previously paid little attention to the consistency of facture. Most frequently, the tactile appearance of the object—the multiple layering of flower petals, the laciness of a dress, the smoothness of skin—determined the type of brushstroke she applied, whether small discrete dabs, curving commas, or broadly and evenly modeled planes of paint. *Death in Alaska* introduces a constantly flickering brushwork through which Auer endowed the painting with a cohesion of surface that her previous work had lacked. Somewhat akin to the informal touches of Impressionist painting, the web of brushstrokes lends the picture's forms a quality almost of insubstantiality or of a loosely woven fabric that directly contradicts the defining, sharply drawn edges of their shapes. The painting is thus constructed out of a quantity of anti-

thetical components—naiveté and sophistication, illusion and denial of illusion, three-dimensional and surface accentuation, fluid brushstrokes and linear structure, among others—which achieve cohesion through Auer's orchestration. Overtly simple, Auer's art disguised an increasing complexity of conception and execution.

The increasing intricacy of Auer's paintings after 1977 also manifested itself in her effort to create multifigured compositions. This was by no means a new concern. One of her first paintings, *The Funeral Procession* (1964, Oeuvre cat., No. 1) had depicted a large group of people, but failed to provide a precedent with which Auer could continue. More productive for her was *Children at the Sea* (Oeuvre cat., No. 6) painted in 1967 in emulation of Edvard Munch's paintings of groups of children. In 1981, she repeated the composition in *The Brothers,* (Oeuvre cat., No. 113), but placed the boys more in the foreground so that they appear monumental against remnants of the seashore setting; by also reducing the coloristic complexity, Auer now attained an image that reflected Munch's psychological and artistic concerns more closely while melding these into the context of her own pictorial world.

The frieze-like arrangement of figures in the foreground was similarly employed in the Alaskan scenes, *Whales in the Bay* (1978, Oeuvre cat., No. 71) and *At the Sea* (1980, p. 107). The contrast between the two demonstrates the continuing changes in Auer's work and in her comprehension of the artists she was emulating. In the 1978 painting, the figures appear bunched together stiffly posed, lacking all interaction; in the later painting, they shift and move in their arrangement across the foreground so that a

continuous rhythm is visually established. In her colors and their function, Auer had changed as well. *At the Sea* has reduced the coloristic mix into a series of tonalities of browns, blues, and yellows, shading being achieved by mixing white or black into the base color. For this somber tonality, Max Beckmann is the source. It is likely, too, that it was Beckmann who served as the model for Auer's formulation, beginning in 1980, of multifigured allegorical works into triptychs, emulating the format that Beckmann had successfully used during the 1930s and 1940s.

Despite its repeated secularization during the nineteenth and twentieth centuries, the triptych format has retained remnants of its original religious aura; artists continue to use it to communicate, if not religious, then broadly philosophical, moral, or allegorical commentaries. Max Beckmann's expansive statements on the human condition, as they emerged in response to Fascism, war, and their aftermath, demonstrate the most profound exploitation of the triptych format and its ethos; but artists as diverse as Erich Heckel and Ellsworth Kelly, Otto Dix and Mark Rothko have likewise valued the format's ability to pronounce a supranatural content. Auer, too, has projected an allegorical motif into each of her three triptychs:

*Morning-Noon-Evening* (1980, p. 100), *Alaska Festival* (1982, p. 116), and *The Power of Music* (1983, p. 132). The format, with its three separate but interrelated canvases, made it also possible for her to work on a grand scale. Her lately developed dexterity, with which she had attained the ability to create a unified surface and to maintain a personal style throughout a painting, were similarly appropriate to the larger format

with no more adjustment than the extension to three images, not solely one.

Devices now consistently used by Auer thus functioned to create a sense of cohesion within each separate field and also to unify the three paintings into a single compositional organization. *The Day* employs Auer's recently discovered practice of opening the centers of her compositions as figures act to enframe a perspectival spatial recession, or are placed below the spatial recession, to appear as contrasting screening elements in both side panels, *Morning* and *Evening;* the middle panel, *Noon,* activates a variation, the center of which is indeed filled by the yellow-eyed head of a white horse, but the horizontal expanse of the surrounding landscape as well as the animal's pale color prevents it from becoming the blocking, heavy iconic presence so frequent in Auer's previous paintings. The triptych then repeats the organizational principles of its components so that *Morning* and *Evening* with their echoing figure arrangements and similar deep coloration act as repoussoir to *Noon.* The openness of the center is gained by orchestrating the combination of the format's horizontal directional movement with its expansive connotations and the central panel's pale, receding color schema. In this her first triptych, Auer demonstrates a sensitivity to the signifying powers of the formal properties that rejects obvious complexity while retaining the simplicity characteristic of the best naive painting.

The three triptychs provide a clear account of Auer's transformation as a painter while she gained self-assurance in the practice of her art but lost the impetus formed by the motifs of the first works she created after

her retirement in 1977 from a career as executive manager, motifs many of which reflected concerns which her business life had masked and repressed, and which emerged almost explosively and obsessively as soon as she found in art the ability to release them. In the triptychs, the motifs of the late 1970s remained, and perhaps found their most synthetic expression. Formally, they display an increasing concern with movement, both explicit in the figures and implicit in the composition.

*Morning-Noon-Evening* despite its presentation in a fashion that suggested movement from the left to the right panel, from darkness and expectation to light and awareness to darkness and protective enclosure, remained static in its overall quality, with the figures immobile and incapable of motion and with time frozen in each of the three interacting images. Auer injected movement into *At the Sea* (1980), but did so hesitatingly and tentatively, turning the figures' heads and placing them into poses that suggest ongoing activity. In contrast, *Alaska Festival* (1982) uses motion as its major unifying principle: bears dance, caribou prance, men and women embrace, run, and dance. The effect of perpetual movement is heightened, too, by constantly accentuated diagonals formed in the three canvases by mountains, seashore, clouds, rocks, trees, and undulating blue-white carpeting, all moving toward the center where sudden horizontals push insistently forward, stopping the movement with a tense counter movement.

*The Power of Music* (1983), which is directly focused on the theme of dance, proceeds differently. The rush of perspectival diagonals and the staccato of discrete forms isolated in contrasting lights and darks are abandoned for colors muted in a nocturnal blue-green and continuously undulating rhythms of lines that move across all three fields. Wavelike undulation, subtle accentuation of shaded tones, and the dancing or music-making poses of the figures generate a movement totally different in character from the exhilaration of *Alaska Festival*. During the intervening years, Auer's figures had gained in the weight of their presence as well; an illusion of volume has been reintroduced and the number of figures filling the canvas reduced, giving each greater space and a more dominant role, while the background forms become increasingly stylized and flattened.

The spatial openness of Auer's paintings in the late 1970s and early 1980s has again been rejected in favor of a more tapestry-like appearance, a shallow space that repeats in its movement around the figure groupings the undulating motion of the dancers and landscape forms. There is an increased naturalism in terms of the rendering of volume, but this has been combined with a more emphatic stylization of figures and features, so that feet, hands, facial characteristics, and bodies gain a repetitive sameness that enhances their artificiality but also reduces the diversity present in earlier paintings. Within these larger and more ambitious paintings, a regression to practices more akin to naive art than were found during the five years after 1977 takes place, thus increasing the monumental impact through greater simplicity and patterning, repetition, and reduced color contrast.

The same qualities are apparent in Auer's most ambitious single painting, *Walpurgisnight* (1984, p. 127), its expanse filling one

entire wall of Auer's bungalow studio, from floor to ceiling and from corner to window. Figures crowd the foreground; the center is blocked; the landscape appears as a stylized flat backdrop of repeated mountainous shapes; color is muted and limited in range, and a centripetal motion visually paraphrases the dance motif in conjunction with the irregularly modeled dancing figures themselves.

Other paintings at this time both share and reject aspects of this vocabulary. Auer's colors changed significantly at this time; the deep greens and blues with little modulation, sharply delineated against one another, give *Hurrying Angel* (1984, Oeuvre cat., No. 140) a dark monotone into which the bright yellow cuts decisively. *Still Life with Figures* (1985, p. 124) likewise reduces the color range, largely to blue–greens and pink–violets applied to a limited number of shapes, each clearly set off against the other. Violet in mixed tones became one of Auer's most frequently used colors, intermingling with others in a painting, or as in her large *Still Life with Hunting Trophies* (1985, p. 139) embodied in a dominant foreground form which influences all those surrounding it.

These still-life paintings finally reflect a manipulation of space and volume that perhaps signals most clearly Auer's distancing of herself from the naive and amateur painters in whose company she began her artistic life. Quotations appear, perhaps in part because of the still-life motif, less from Expressionist or naive painter's than from Cubist-like experiments in spatial organization, possibly due to a newly found admiration for Picasso but even more reflecting practices apparent in Gabriele Münter's still

lives. Like most of Auer's new still lives, Gabriele Münter's *Still Life with Sunflowers* (1910, Comparative ill., No.1) displayed a similar preference for planes of flat color, outlined two-dimensional forms that nonetheless have a sense of volume, exaggerated perspective with a view of the surface on which the still-life objects rest, and even the contrasts of purple and yellow.

Despite all simplification, there remains a spacial complexity in Münter's painting that emerges again, in different terms and with different devices, in Auer's *Still Life with Ship's Figurehead: "Forward"* (1985, p. 146), where the tilted table top shifts backward into a series of frames to provide a manneristic play between illusionistic depth and surface, between a background that encroaches on the space of the foreground and a foreground that pierces into the background plane.

In Auer's recent still lives, but also in her self-portraits and allegorical works as well as infrequent landscapes–or more correctly, townscapes such as *In the North* (1984, Oeuvre cat., No. 141), Auer consciously returned to the sources from which her art originally sprang. Münter's delicate Expressionism was reinterpreted, melded with practices that Auer had made her own after nearly ten years of constant artistic activity. Her rejection, in her own work, of the examples of contemporary artists continued as she sought instead an identity in the German past.

Her work personifies an effort to carry on where early modernism left off, to practice an artistic vocabulary recognizing the existence of a national artistic past, and to provide a commentary on modernism's failure

to establish the means of a supranational, universally transcendent, human art. Internationalism in art is rejected, and Auer in her art seems to speak in her native tongue, perhaps even a local dialect of the Swabian countryside, but it is a dialect used to depict the animals and life of Alaskan villages. The nationalism postulates a historically unique reflectiveness, which neither denies nor adulates the past or the specifics of German life, but maintains a fundamental cynicism and relativity that lacks faith in absolute national values. The style and practice of her art, after he successful career as part of the business life of Germany's "economic miracle", seek to make present the past, to renew it in the vision of the present. As in the works of Josef Beuys, Horst Janssen, and numerous Neo-Expressionists—all different and in various ways antagonistic to each other—with whom Auer shares little else, art transforms the past in the conscious light of the present.

# III  The Dream of Animals

Only rarely does Hildegard Auer talk about her art. In her home and in her studio, as well as in the offices of the Eisenmann firm in Böblingen where she formerly worked, her paintings surround her and extend her presence. Personal extensions of herself, they are an alternate visual world whose content and form she is able totally to control, an antidote to the reality outside her command.

Questions about one or another of her works, she frequently counters by the flat statement: "I have no narratives to weave around my paintings." Her art, she says, is simple and direct without hidden sophistication. The kinship with the paintings of naive, folk, and—to a lesser degree—Sunday painters is unbroken. In its simplicity such work "is the expression of heart and soul, uncomplicated by mind, and thus akin to the wisdom of nature, to the universal pulse, to the music of the spheres," argued Wilhelm Uhde early in this century, and concluded that the true content of such painters' work "is the emotional richness of their lives."[1] Perhaps Auer would deny herself aspects of Uhde's description; nonetheless, in her art she, too, seeks not intellectual dissection but intuitive appreciation. It is grounded in an instinct for art, a compulsion to paint and thereby to satisfy her own intense desire to express in painterly terms her own vision and insights. Auer admits to only one motivation: the overpowering sense, never to be denied, of "I have to paint this" as she confronts a scene, motif, or pictorial concept. "I have to paint this" is the compulsive justification for her art.

The classical naive artists, such as Henri Rousseau, Louis Vivin, Camille Bombois, André Bauchant, and Seraphine Louis, whom Uhde identified as "Painters with Dedicated Hearts" when he first exhibited their work at the Paris Galérie des Quatre Chemins in 1928, painted "what their hearts, rather than tradition or teachers, taught them to paint."[2] Auer argues similarly for herself. For her, too, the psychodynamics of creativity originated in the subjectivity of her responses to memories or dreams. Making visible what she refuses to verbalize, the paintings speak for their creator, revealing thoughts and feelings that she otherwise cautiously or modestly keeps to herself. In this way, they also negate the repressive and sublimating tendencies dominant in her life until 1977. Essentially, her art denies her previous professional existence and livelihood, much as her entering the employ of the fledgling Eisenmann firm in 1951 acted to deny her childhood home, its authority, and its near-psychotic religiosity.

Now her art, the total environment she has personally shaped through her pictures, again counters what previously existed, making her prior professional career fade behind an anthology of images derived from her life before 1951 and after 1977, or from the world which for her has become an alternative to modernized mechanization and depersonalization: the world of animals and of the virtually uninhabited subarctic wilderness of northern Norway, Canada, and Alaska.

Although seldom truly autobiographical or confessional in the sense of revealing hidden moments in her life—thus depriving them of their intrinsic privacy—Auer's paintings consist of instinctive exhibitions of her own private personality as it is made manifest in moments, events, or scenes experienced intensely by her. Her art has contin-

ued to display the Romantics' insistence, formulated by Caspar David Friedrich, that the artist should "revere every pure movement of [his] spirit, revere every gentle presentiment, because this is art in us! During an inspired hour, it then takes on visible form, and your painting is this form."[3] The first painting that Auer truly created from such an "inner drive of the heart",[4] rising from the impulse of "I have to paint this" in response to a personal experience, was *Cows at the Tanja River* (1968, p. 78).

This painting, *Cows at the Tanja River,* originated during the summer of 1968 when Auer went on a cruise of Scandinavia under the aegis of Eugen Eisenmann along with other members of his firm. The trip alternated between experiences of outdoor sport—fishing and hunting—and appreciation of art, particularly of Edvard Munch. Eugen Eisenmann had long admired Munch as one of the major masters of modern art, although he had never invested in any of his work. In addition to Eisenmann's enthusiasm, the principal source of prior knowledge about Munch's art among the members of Auer's group was the scattering of Munch paintings in German museums, including the Stuttgart Staatsgalerie. The Munch paintings in the Oslo museum were of a quite different nature, however. Most Munch paintings in German collections derived from the period during the 1890s and early 1900s, when he either was living in Germany or was closely associated with German artists. The Munch collection of paintings in Oslo focused on the works he created during the three and a half decades that followed his return to Norway in 1909. Less obsessively concerned with themes of sexuality and mortality that dominated his earlier works, these tend to focus

on Munch's perceptions of the Norwegian landscape and on peasants, workers, and fishermen rendered in an awkwardly monumental style frequently touching the naive in effect. For Auer, these works painted by the aging artist during a "second career" following that of his membership in Europe's radical bohemian and antinaturalist avant-garde became the most vivid experience of the summer. Totally unrelated to Munch's art in motif, *Cows at the Tanja River* inaugurated her efforts, still continuing, to absorb the Norwegian masters' intense example.

The Tanja River flows northward toward the narrow fingers of the Tanjafjord in the Finnmark area of Norway, bordering in the west onto Nordkapp, Europe's northernmost extent several hundred miles north of the Arctic Circle. The landscape is desolate and deserted, marked by naked, massive gray rocks that form the seashore and the mountains rising sheer and vertical immediately behind it, unprotected from the lashing waves of the Arctic Sea. Small fishing villages, consisting of precariously constructed wooden huts in protected inlets of the fjord, provide the sole population other than semi-nomadic Lapp farmers who inhabit wind-blown plateaus further inland, where they raise reindeer and cattle on lands irrigated by the Tanja River as it flows near the Finno-Norwegian border.

Vast deserts of stone shape much of the region, giving it a barren impression whose starkness is accentuated by the winter months of virtually total darkness. During the two and a half months of summer, however, the sun never sets, only approaching the horizon to tint the sky and landscape with multitudinous shades of red,

purple, and gold. The glory of sunlight is met by the sudden emergence of vegetation which intersperses the gray rocks with rich areas of intense green. It was this summer landscape that Auer experienced, first during days in which almost nothing but barren boulders was to be seen; then one day, walking alone rather than with the other members of her group, she suddenly came upon a bend in the Tanja River, and there was an oasis of life fed by continuous sunlight and the waters of melting glaciers and winter snows. On the pale sandy bank of the river rested—as unexpected as a hallucination—slender white cows, motionless, gazing steadily with large brown eyes into the swelling blue-green water. Away from the grasses and plants that served as their fodder, the cows lay on the reflective silvery sands in order to intensify the warmth of the summer sun, a sun that within weeks would again disappear along with its vitalizing warmth, leaving dark and cold the silvery sands. The sense of life's vitality and warmth—calm, quiet and contained but also threatened, surrounded as it is by rocky grayness and nocturnal darkness—formed the first of Auer's I-have-to-paint-this experiences, as she sat alone and contemplated the idyllic bucolic scene before her.

Animals were to be one of Auer's chief—but not only—subjects during the next ten years. Even when animals do not form the central interest of a painting, moreover, they are often present as an emendation, a form of commentary on human activity. Her vision of animals ocilates between tame domestic dogs, who share their existence with man and whose behavior is regulated by their human owners, and untamed animals existing in a freedom that, while undefined, is threatened by the intrusion of man, whether

as hunter, farmer or builder. Thus the animals become signs for a greater nature, for the Arcadian wilderness Auer saw in Northern Scandinavia and Alaska regions seemingly at the end of the earth where human intrusion and regulation remain rare but in their rarity all the more noticeable. Animals in nature become idyllic substitutes for machines in factories, but the obverse of the idyll for Auer never totally evaporates even in the most sentimental of scenes.

As a genre, animal painting has largely disappeared from the repertoire of artists after the onslaught of modernism's ascetic aesthetic. Franz Marc marks the termination of a lengthy tradition that endures only as sentimentally cute kitsch or as illustrations in popular hunter's and naturalist's magazines and books. The demand of modern art that content be heroic and monumental, or be revealed in form alone, denied validity to the genre of animal painting except incidentally, but modern society, too, has more and more divorced human life from frequent contact with the animal world except through dogs, cats, and other domestic pets who share in the space of human shelter. The horse, certainly the most frequently represented animal in the past and one that dominated the means of man's travel by land, was replaced by mechanical substitutes and quickly lost the attention of artists. However, for Franz Marc, the horse still maintained its symbolic and emblematic dimensions whereby it embodied numerous values ranging from animalistic vitalism to virile spirituality and the pantheistic unity of all nature. Animal painting was thus transformed into metaphysical painting by Marc and animal subject matter was recruited as the most apt means of expression: "I know of no better means for the 'animalization of

art,' (as I would like to name it,) than painting of animals. ... [I seek to intensify] my feeling for the organic rhythm of all things, [to attempt to empathize pantheistically] with the trembling and the movement of blood in nature, in the trees, in the animals, in the air. ..."[5]

Even while Auer intensely admires Marc's work and was certainly influenced by it in the coloration and compositional organization of *Cows at the Tanja River,* for example, she finds his animals too noble in their abstraction, akin to "gods without flaws" rather than living creatures. She rejects the process of intellectual idealization fundamental to Marc's works and advocates instead a more direct process of perception through which she stores an image in her memory, to retrieve its essentials later in her paintings. The process is considered by her as a search for the essential appearance and manner of the animals encountered, revealing their primeval experience of life and existence. In this last aim, she does approach Marc, notably his yearning to "descend into the soul of the animal in order to discover the treasure of images there".[6] Auer, however, portrays a landscape less as an animal might experience it—an imagery for whose appearance she could today refer to innumerable scientific studies that confirm objectively what Marc could only intuit—than to achieve a sense of the animal's life experience, something akin to the animals ego ideal, and to present this in its apparent naturalness and simplicity as an antithesis to the artificiality of human existence.

*Cows at the Tanja River* accordingly, in spite of an organization and even a coloration akin to those of Marc, focuses on the wide-eyed self-awareness of the white cows as they absorb the sun's warmth, conscious of nothing but their own sensual existence at the moment, which becomes eternal. In this effort to experience the animal's experience and to represent it, Auer is actually more closely akin to Edvard Munch than Franz Marc, to Munch's drawings of panthers and bears in the Copenhagen zoo and to his numerous representations of horses grazing, pulling plows, or galloping forward in a snow-filled landscape, thereby becoming a single force of energy around which all else clusters (Comparative ill., No. 6). "The older I become," Munch declared, "the more the distinction between animals and men dissolves for me"[7]; and Auer's animals possess a similar anthropomorphism, not so much that they become substitutes for human beings but that they share humanity's existential experiences. The processes of human existence thus have their equivalents, stripped of all accretions, in those animals that Auer found in their habitats in Northern Scandinavia, Canada, and Alaska.

For her initial efforts at such an existential depiction of an animal—the first grizzly bear seen by her in the wilds during a trip to Canada in 1967—Auer adopted a deliberately naive style of painting (Oeuvre cat., No. 8). Modeling her Canadian wilderness on Henri Rousseau's imaginary jungles, she created a flat plane of separately rendered fronds of golden ash leaves and conical tree trunks, with pale-blue sky and waterline insistently, but within the economy of the composition disturbingly, creating a horizon line. Multitudes of blueberry and cranberry bushes with their berries, each of which is rendered individually as if it were an ideogram of itself, litter the green-leaved fore-

ground with insistent spots of red, blue, or golden yellow. The grizzly bear itself emerges, brown, white, and red, in a similar additive construction as if only when dissected into its component parts could the totality of the animal be comprehended. Thus the body and legs appear in stylized simplified profile; an almost truly circular head is rendered frontally, with the ears stuck on, eyes, nose, and mouth flatly itemized; and the stub of a tail seems virtually pinned to the body's rump. The itemization of components even extends to the margins of the frame, where separate spots of gold and red continue the motif of the picture's berries, which become almost more than the grizzly the primary theme of the painting.

The naive mode, here ably emulated, lends itself to such a picture particularly well, granting not only an insistent gestalt orientation in the rendering of objects, so that they read as hieroglyphic depictions of their essential visual characteristics, but maintaining also some of the sense of innocent awe that the very sight of the agilely lumbering, feeding grizzly engendered in Auer. The bear's presence in the dense forest, its simultaneous dominance of and absolute dependence upon its wild surroundings, take on an archetypal, exemplary quality through the naive rendering, transforming a momentary impression into a timeless, motionless projection. Although painting with the Eisenmann exhibitions in mind, in *Bear in the Fall*, Auer matched her subject and her style with a deliberation not earlier apparent and found thereby a personal content capable of much further exploration.

*Bear in the Fall*, like the conceptually related painting *Dying Elk* (Oeuvre cat., No. 11),

while pointing toward the content of Auer's later work, lacks a personal stylistic commitment as it maintained an artificial adherence to a style copied from the naive art of Wilhelm Uhde's „Painters with Dedicated Hearts". Their colors and forms echo throughout Auer's paintings as they are applied to motifs alien to them. *Cows at the Tanja River* alone merges personal content with a style that, although akin to naive and other precursors, speaks in a personal vocabulary, not one totally derivative. It was the only painting of the 1960s to do so. Not until 1970, in *The White Stag* (p. 81) did Auer again discover this unity.

*The White Stag* is a painting that once again was created during winter holidays at a Bavarian farmyard; the setting of door and foyer with its furnishings derives from there. The hunting activities of the Eisenmann firm's founder, which decorated the farmstead with innumerable trophies of deer antlers, certainly also functioned as the subconscious inspiration for the image of the white stag gazing with golden eyes into an open doorway.

Several weeks before Christmas, in anticipation of her forthcoming trip, Hildegard Auer dreamed one night of the white stag's visit. The dream took place in a fortress, a massive and ancient castle filled with hunting trophies, much like the Bavarian farmhouse but obviously grander in scale. Here hunters were feasting and celebrating the success of their forays when, like the terror-arousing statue of the dead commendatore who in Mozart's *Don Giovanni* interrupts a similar feast to seek either vengeance or repentence, the ghostly apparition of the white stag disrupted the meal, apparently permanently since Auer does not recall any-

thing more of the activities of either the deer or the hunters. Like most dreams, it is a fragmentary memory that focuses on the condensation of its essential elements, here identified as the white stag, the hunters, and the banqueting hall.

Reduced to such an enumeration, the dream lends itself readily to interpretation in Freudian sexual terms, possibly identifying the hall as a representation of the womb, which here protectively encloses the male members of the Eisenmann firm, while the deer, with its phallically symbolic antlers poses an external, male threat. It would not be extraordinary for Auer, whose adult life was largely formed within the protective aegis of the Eisenmann firm, to perceive the company as playing such a fundamentally maternal, nurturing, and guarding role, and perhaps especially as she herself prepared to take on leadership in the predominantly masculine firm, a role that for her might easily give rise to sexual imagery in the unconscious vocabulary of her dreams. In such a context, the intrusive stag might well be less a vengeful vision of the hunter's quarry and more representative of a possible external threat to the firm Auer was increasingly to guide, or if the animal's gostly appearance from the past is accentuated, the memory of a prior male authority whose continuing presence was a threat to Auer's new position.

Such an absolute and exclusive focus on Auer's dream and its possible function in the unconscious life of her psyche, ignores however the painting's existence. The painting of the white stag is not identical with the dream of the white stag; rather, it is a consciously created image whose inspiration resides within the remembrance of the dream. For the painting it had to be transformed. The dream's narrative was condensed; the setting was altered; and the hunters disappeared as Auer translated private dream symbolism into an image that, as a painting, necessarily adopted a public vocabulary. The adaptation of the popular image of a stag in the painting, as already remarked, was similarly part of a process of making the private public, as was the use of elements of a naive style. What Auer in this painting then sought to communicate was a deliberate meaning symbolically expressed, not the signification of her dream. In that intended meaning, the role of both animal and house alters to become a visual commentary on nature and on humanity's interaction and relationship with aspects of nature. The contrast of female and male, apparent in the dream image, remains here, but in a revised fashion.

Underlying this shift in signification from dream to painting is Auer's concern with projecting something of the mental or emotional life of the animals she depicts. The world of the deer—a world of snow, bare trees and bushes only minimally scarred by a fence—is enclosed and entrapped within the confines of a doorway. In its colors and its organic forms, it also appears as the antithesis of the interior; the world of nature and the world devised by man are juxtaposed and contrasted. The *Edelwild's* presence is necessarily an alien one within the regulated, geometrically ordered milieu of painted wooden walls where not the passage of the seasons but the mechanical mechanism of a clock marks the passing of time and life. Even within the old fashioned, "natural" world of the ancient farmhouse, Auer observes, untamed nature is excluded or destroyed, and nature itself made artifi-

cial, much as the scene of the white stag with snowy hills and coves of trees appears more like a woven tapestry or even a projected slide, a controlled representation of nature rather than nature itself. In its confrontation the deer becomes magical, even without the reminiscence of Auer's dream, a premonitory vision insisting on its own continuance, yet in that insistence being subjugated in an atmosphere of man-made artificiality. As in the dream, it is its own ghost, the shadow if its true nature.

Incongruously inside the hunters' lodge, on the back of an old black chair, to one side of the open doorway, a white bird is perched. It shares its coloration and animal existence with the stag, and like it, also stares directly out of the canvas at the viewer. Unlike the apparition of the deer, however, the bird is not out of doors, but sits within and on the artificial constructs of men, sharing their space rather than the space of nature. Auer herself explains this bird—and others that appear after this in her paintings almost like signatures or personal marks—as emblems of herself or, depending on the context, of other women. In this self-projection as an admonitory voice, Auer announces the vision of the stag not so much as a vengeful commendatore of nature but more as a revised vision of Saint Eustace, who finds salvation not through the sign of the crucified Christ but the segments of nature, between the stag's antlers.

The winter landscape outside the doorway is not an untamed segment of nature, however, but rather the well-tended, nursed, and trimmed meadows, hedges, and coves of fir trees surrounding the Eisenmann farmhouse. In Auer's painting, too, this regularized landscape with its cultivated, trimmed forms is the stylized substitute for a wilderness denied. The rolling hillocks, with patches of trees regularly spaced among them appear as well in one of Auer's few landscape paintings, *Hoarfrost at the Ratzenberg,* in 1974 (Oeuvre cat., No. 27). The painting emulates aspects of Gabriele Münter's landscapes, notably those of 1910, which show flattened, individualized forms, each possessing a characterizing silhouette and outline to distinguish it from its surroundings. Auer adopts Münter's amorphous shapes, making them more organic in quality than her predecessor's, but does not compete with Münter's easily brushed, flowing manner of paint application. Instead, frost-tinged, cold shades of green, blue, and brown are applied carefully, letting the brush define each separate branch of trees and bushes and transforming clouds and fields into fantastic, dreamlike forms of solid color lacking all but the merest touch of modulation. The memory of Henri Rousseau's landscapes screened with bushes and trees certainly echoes here in the frost-covered filigree of branches, but Auer also bestows her landscape with a sense of movement, as if the hills were sensuously writhing, which is alien to the Douanier's rigid if playful compositions. This sensuous element dominates Auer's landscape. It ceases to be hills, trees, and sky and becomes something alive, something in its forms overtly female, hinting at a woman's hips, thighs, breasts, without permitting the allusion to become illusion. The linkage of nature with woman, symbolically hinted at in *The White Stag* and already present in such early paintings as *Chestnut Blossom* (1966, Oeuvre cat., No. 3), is subtly asserted by means of the landscape's stylized forms through which the life and forms of woman and those of the earth become equated.

Such an association of woman with the forces of nature has a long history. It is recognized as part of popular thought in such terms as Mother Nature and Mother Earth. Frequently employed in the past to argue for the inferiority of woman to man—the one tied to her biological rhythms and reproductive functions, the other surpassing the limitations of untamed nature and constructing his own self-made order, this anthropological proposition of woman's harmony with the processes of nature has recently been interpreted positively, especially in the writings of the woman's movement.

Biologically participating in the rhythms of the natural world, in an era of conservation woman is seen as one with that world, standing in opposition to the self-destructive activities of man. Auer would not describe herself as a feminist, but in seeking her own identity, her existence as woman became a paramount consideration, and with that recognition a realization that in many ways a woman remains more closely interlocked with nature than does a man. Her paintings as a result reveal a positive identification of woman with nature's forces, particularly in her series of paintings depicting a woman moving easily through a landscape as an essential extension—and not an intrusive destroyer—of it.

In *Goldstream* (1977, p. 88), a woman, clothed in pale brown, is seated in the foreground against a majestic Alaskan mountain landscape through which a gold-tinged stream diagonally meanders. Although the watery stream is intrusively dominant, the woman's imposing presence is the major interest in the canvas. As she sits or perhaps hovers among the mountaintops, she echoes the forms and colors of her sur-

roundings. The rocky, rolling shapes of the landscape take on a form and texture that is repetitive of the brown-gray drapery covering her legs. Her blouse and its collar similarly reflect the more angular shapes of the mountain peaks behind her. Her face—its color more that of the shadowed rocks than of actual flesh—and her auburn hair with its jagged outline also replicates the coloration of the background massed shape of the mountains. What began or was perhaps initiated as a snapshot image of a figure in the impressive setting of a mountain landscape—a tourist's cliche—has become a depiction of woman as nature. She appears as the human extension of the dramatic Alaskan landscape.

This visualization of the concept of woman's identity with nature also emerges in *The Sleepwalker* (1980, p. 115), but here the purport has shifted. Auer once more applies significatory devices—a landscape stylized into fundamentally feminine forms, the sharing of outline and internal detail, the coloristic kinship—but here there is no duplication of the two nor any isolation of the woman within her natural setting. As this woman walks confidently through the landscape, she keeps her eyes firmly closed; her face, unforgettable with the darker skin tones of an Alaskan native, is not the Occidental woman in other Auer paintings. The kinship of the Alaskan landscape to the native Alaskan woman is obvious, and reasserts the equation that Auer postulates. But even more, the painting represents the generation of life, both that of nature and of humankind.

The landscape itself is rocky; icebergs appear on the fingers of ocean in the distance; the moon, not the sun, lights the sky

with its cold light. All these elements serve to depict not life but barrenness, a barrenness in transition to new life. The moonlight of the Arctic winter night is beginning to give way to a deep blue heralding approaching day and approaching spring. In the river, the salmon leap as they swim toward their spawning grounds. In the foreground, a single plant has burst into brilliant white bloom. Blossoming future life envelops the image of the sleepwalking woman as if it were enclosing her in the protective shelter of a nature-wide womb. The woman's lightly folded hands cover her own womb, accentuating that it is the center of her unconscious existence, as she moves, trancelike, in continuing sleep. (Originally Auer depicted her as pregnant in an even more overt affirmation of the painting's theme of emerging life, but suppressed this detail after several of her patrons protested about the woman's obvious pregnancy.) As an emblem of both her own and nature's pregnancy, the sleepwalker moves with certainty through the landscape, needing neither to be awake nor conscious in her essential unity with her womblike surroundings.

The leaping salmon in the background of *The Sleepwalker* were given their own independent composition, *Wedding of the Salmon* (1981, p. 96). Here nine salmon in the foreground, their faces grinning with the joy of life, as do many of Auer's animals, leap toward a narrow passage of water between two fir-lined tongues of land, aiming toward a glacially white mountain range above which is suspended the white orb of a full moon. The scene is one that is frequently admired in Alaskan streams; photographs of salmon racing upstream also invariably appear in the state's publicity brochures.

Such conventions are alien to Auer's art, their message antithetical to it. Transmitting a mood of mysterious, expectant, almost reverent silence, the depiction of the pink-tinged salmons' mating is one of Auer's most lyrical and lighthearted paintings, but one that also projects a meaning beyond its humor. The landscape with flowing river and spreading fingers of land leading to the mountainous realm where fertilization will take place is an overt metaphor for vagina and womb. Combined with the eagerly phallic salmon, the painting not only depicts the merriment of the leaping fish, but functions further as part of Auer's effort to visualize the correlations between the natural world and women. In the guise of the eager salmon, Auer painted an allegory of conception and procreation.

*Encounter* (1978, p. 93), provides an additional representation of woman's unity with nature. The movements of tree-covered hills and steep mountains echo those of the woman in the foreground; the extended bands of white clouds evoke in their formation the rounded suppleness of female forms, ironically almost more so than the flattened, stylized figure of the seated woman. The equation of the landscape with woman and with fertility, whether literal or metaphorical, is made plain as a lake, its waters long recognized as a symbol of the origins of life, emerges oval-shaped between two rounded fingers of tree-lined shore. This visual analogy serves as a backdrop to the scene of two horses coming quietly toward the figure of the seated woman, preparing to nuzzle her gently in a sign of trust and recognition. Just as Auer has previously linked the landscape and the women within it through the reverberations of echoing forms and colors, she now re-

lates the woman's coat to the reddish fur of the nearest horse and the coat's feathery collar to the similarly textured and shaped mane. Again closeness and kinship are announced, a relationship that reaffirms Auer's belief in woman's inherent intuitive capacity to communicate her compassion with nature and its animals.

*Encounter* may reflect an incident during one of Auer's trips to Alaska, but more significantly with *The Sleepwalker* and *Goldstream* it forms part of a trio of commentaries on the relationship of woman to nature painted during 1977–80, each proclaiming the kinship with different accentuations. In their features, the women portrayed in these landscapes can be connected with the artist herself, and the paintings certainly form part of a process of self-exploration and reflection when Auer was about to sever her relationship with the Eisenmann firm. The anxiety engendered by the future separation emerged in dreams of death, as related earlier, while Auer sought to forge a new identity that excluded linkage with the firm that had dominated her life for two and a half decades.

Auer's new dedication to art formed an essential component of her redefined persona, but even more basic was the exploration of her own identity as a woman, through which she now achieved an independence hitherto unprecedented in her life. Reconstructing the non-Eisenmann years of her past shaped the process of her self-exploration, and in her memories a focus was found in vague recollections of her father's mother, the grandmother who had given birth to fifteen children. Under the cloudy vapor of childhood memories, her father's mother became an Earth Mother, a personification of nature in whom the essentials of being a woman were revealed. In 1979, Auer painted a portrait of this grandmother (Oeuvre cat., No. 89), and in the next year the portrait of her father at the Stuttgart train station that melds his existence with that of his daughter and grants him, implicitly, the nurturing qualities of a woman (p. 104). Together the two paintings create a geneology for the emergent new woman-artist.

Shortly after her father's death, Auer made a first effort at depicting him in allegorical terms by showing him in a landscape as virtually no other man is placed in her paintings, alone and the central focus (1973, Oeuvre cat., No. 26). The landscape is that of the Ratzenberg and the snow-covered hills, leafless trees, and dark sky, which seem to absorb the light of the moon, act as metaphors for death, just as do the wilting funeral flowers held in her father's hand. Through the effort to submit the landscape to a process of commentary on the figure and consciously to perceive both as a conceptual unit was inaugurated the process from which Auer's later allegorical paintings of women emanated. Auer worked through her identity with her father by seeking her own reality as woman, moving by way of the discovery of her grandmother, a woman identified through her father, and through her to nature, where an independent identity was found. Having lost both her own father and the substitute paternal authority of the Eisenmann firm, Auer newly affirmed her own authority in her existence as woman.

In both *Encounter* and *The Sleepwalker,* the woman represented is accompanied by animals. *Encounter* includes the horses as part

of an effort to demonstrate a woman's closeness to the life of nature; in *The Sleep-walker,* the canine presence of a wolf or dog, its eyes glowing mysteriously pink, functions more as an extension or alter ego for the woman, much as earlier in *The White Stag,* the bird perched confrontationally on the chair acted as substitute for a woman's presence. In 1977, in a painting based on childhood memories, Auer likewise substituted for herself a canine amalgam similar to that in *The Sleepwalker.*

*North Station Street* (p. 95) is, overpowered by the presence in the center foreground of the monumental golden dog-wolf, which paces purposefully down the white street. Otherwise, the setting of the symmetrically constructed painting consists of two rows of houses framing the street as it recedes treeless in strips of blue, green, red and white into the distant landscape. The animal emerges as the sole living being, encircled by the empty rows of yellow house facades with their tiers of empty windows. The colors and their application in large flat areas recall Franz Marc's paintings, but the grinning presence of the animal alone amid the geometric constructions of men that cut sharply into the landscape and hide it—this is unlike Marc's world which avoids such confrontations of animals with cities and buildings, preferring instead to focus on animals as independent metaphysical realities.

Auer's concern, in contrast, was to accentuate the extreme otherness of the dog-wolf in its surroundings, its appearance of alienation as a representative of nature in a realm of monotone artificiality. The motif, she relates, was inspired by her own memories of the loneliness and rejection she felt as a child as she walked along the North Station Street to school, alone and separate from other children. The dog-wolf in its isolation possesses this connotation of loneliness, but also seems to contradict it and to overcome it through its very presence. In its grand size, which dwarfs the empty houses, in the pronounced vitality of its golden color, and in its unique facial expression, more human than canine, it announces a scene of triumph, not defeat.

Alone in the picture, the dog-wolf walks free between the sameness of the rectangular interlocked houses along a road that emerges from the mountainous landscape and, it is safe to presume, will rejoin it after passing through the faceless town. Auer's substitute self-portrait with its recollection of childhood rejection transforms itself, perhaps subconsciously, into a representation of her existence as a lone woman in the commercial world of men, where only 2 percent of the managerial staff of West Germany's mid- and large-size industrial concerns were women.

In the engineering firm of Eugen Eisenmann, she long remained the sole female employee other than the secretarial staff. It was an isolation only made more manifest when she assumed the role of managing director, a role in which her dissatisfaction constantly increased. The duality of her simultaneous isolation within, and subjection of, the milieu surrounding her is what the dog-wolf in the alien context of the blank-faced houses expresses. Like her canine substitute, however, Auer saw herself leaving the firm which had witnessed her lone triumph to return to an alternative existence in which her truer nature, unhampered and not subordinated, as artist and as woman would reemerge.

*North Station Street* is conceptually related to the 1974 painting *Dogs in the City* (Oeuvre cat., No. 29), which shows in the center foreground, on a tiled street, two dogs whose huge size overpowers the nearby houses. The later painting's sense of alienation is not present, however. Instead, the city—Petersburg, Alaska—with its regular rows of tended fir trees and with lights shining out from the windows of its pristine red, yellow, and white houses tranquilly contains the dogs. At ease, they rest in this colorful man-made world that faces comfortably toward the sea. It is a domesticated world constructed close to nature, not like the scar of injuring houses in *North Station Street;* within this orderly bourgeois domestication, the dogs too quietly but picturesquely recline. The rebellion and rejection of the dog-wolf are absent.

Comfort and domestication mark *Dogs in the City* as the order surrounding them prevents the wildness and unpredictability of nature and also its freedom from intruding. Nature in such a setting is tamed and exiled. The 1976 painting of Auer's English terrier Benno (Oeuvre cat., No. 52) limits the natural world to the view through a window; hampered by the bulging curtains, it seems almost to be pushing to enter the orderly interior where it has been supplanted by a neatly arranged bouquet of cut flowers, contained in a decorative vase, standing on a bureau. Benno himself reclines on a sofa, his head nestled on a cushion. But the comfort of his rest is disturbed as he perks up his ears, listening and cowering beneath the nocturnal view of trees and clouds, and beneath the extended wings of two of Auer's totemic white birds.

A similar motif is seen in the painting *Dog on Blue Rug* (1985, Oeuvre cat., No. 156) which presents a different perspective as the dog Windo lies amid rugs whose dissonant colors and zigzag patterns explode outward from his reclining form. There are no decorative flowers here except those in the pattern on Windo's cushion, and these emerge more like tubular, fleshy growths bursting forth aggressively. The view in the 1974 painting that nature needs containment and is a potential threat has been supplanted by a sense of impending, energetic activity suggested by the overlapping diagonals and restless color combinations of the composition. The animal vitality which in *Benno* is absent and denied has now been recognized as a necessary presence, called forth not by the narrative of a scene as Auer would have done earlier but by the formal means of the painting's organization and coloration.

This 1985 painting demonstrates, therefore, a greater mastery of the vocabulary of technique, and it also manifests an altered perception of the relationship between domesticity and nature. Where in the early 1970s nature was identified as something excluded by the comforts of bourgeois existence, there is a later recognition that the vitalism of nature is only temporarilly contained and that a tension or conflict necessarily exists between the demands of ordered civility and the freedom of nature. The antagonism of the two became visible in *North Station Street,* as Auer proceeded to reconstruct her own persona outside the confines of her professional career, outside the daily man-made milieu of her previous life.

The shift from a celebration of controlled contemporary domesticity presented in the charming narrative mode of a deliberately naive style to a celebration of the unpredictable vitality of nature can also be followed by again contrasting the portraits of Benno, beginning with the first one of 1968 (Oeuvre cat., No. 9), which shows the dog reclining in Auer's office at the Eisenmann firm, and *The Wolves* of 1979 (p. 91). The shift is obviously one from a civilized interior with a tame canine to an Alaskan landscape and a pack of yelping wolves with bared teeth, a shift from comfort and control to majestic animality and unpredictability. The additive composition of the earlier works has been replaced by one in which unity is obtained by permitting forms to echo one another, so that the steady forward drive of the wolf pack is repeated in the landscape formations of massive boulders, lakes, mountains, and spear-like clouds. All of nature is vitalized in the process, and the wolves form an overt component of it.

Transitional between them and documenting the process of change in Auer's perceptions, is *The Guardian* (1978, p. 84). The dog-wolf in *North Station Street,* but now a reddish-brown, again appears, reclining within an arch of trees. Behind this, in glowing reds, golds, and blues is a fragmentary view a window of and a house. The separation between the man-made structure and the massive shapes of the leaves and trees is sharply abrupt, and any transition that there might be between the two is blocked by the glaring canine.

The formal organization of the painting, using a repoussoire device, suggests a continuing process of protection, as does the title. All access to the blue, gold, and red of the house's interior, whose windows appear to be the painting's source of light insofar as it is presented, is barred by "the guardian" and by the two rows of trees that enclose it like an embracing canopy. Nature, including here the reclining animal, appears as a transitory state leading to the geometric structure of civilization in the background, but it also functions as barrier, preventing arrival at the goal of the building, and in this guise needs to be overcome or destroyed. As an allegory of the process of civilization, the painting pessimistically announces the persistent antagonism between nature and the rational structures created by man, even as the two are brought into proximity with each other.

*The Guardian,* however, speaks a more personal language as well, whose meaning parallels the overtly allegorical one and complements it. In *North Station Street,* by her own testimony Auer identified the semitame wolf-dog with herself. It is likely, therefore, that the same animal, now acting as "guardian", is a similar self-projection. Moreover, the central feature of the painting, the blue and gold of the window or perhaps glass door in the house's facade, forms a massive letter H, the initial of Hildegard, so that the house even more overtly functions as Auers self-presentation in the painting. The explanation for her concern with a house image at this time may lie in the alterations being undertaken in her own home and studio, alterations that were to facilitate her activity as artist now that she no longer was active in the Eisenmann firm. Her new identity was granted the testimony of reality in the bricks and mortar of her adjoining bungalows, but *The Guardian* suggests a continuing anxiety about the vulnerability of Auer's altered life, as well as

a conscious determination to protect it. Concerning a conceptually similar painting, *The Barrier* (1978, Oeuvre cat., No. 69), Auer commented that "it is necessary to erect barriers so that not everyone can gain access to you". This theme of barring access is also the content of the contemporary *The Guardian* in which Auer in the persona of the wolf-dog prevents access to intimacy with herself. Having left the Eisenmann firm a year previously, she insisted on both constructing and jealously guarding a new independence found in her embrace of art and—if the dog-wolf is indeed to be seen as a self-projection, and in its closeness to nature as an analogy of woman's existence—her being as woman.

Auer's concern with contrasting the natures of woman and man, and of accentuating woman's continuing instinctive nearness to the natural, attained its most extensive statement in the largest painting she has attempted: *Walpurgis Night* (1984, p. 127). Historically the most famous Walpurgis Night is the one described by Goethe in *Faust,* but ever since medieval times the eve of May with its freely caterwauling, cavorting witches has repeatedly recurred in German painting and literature. It therefore can be said to possess a degree of national identity and in this respect would appeal to Auer. She, however, describes the painting as a "masked emancipation motif".

Set in a nocturnal mountain landscape—the Harz Mountains are the traditional site—*Walpurgis Night* is populated primarily by seven larger than life-size figures of women, the witches who roam free during this magical night. Deemed to have access to magical powers through a pact with Satan, witches were long persecuted in the Christian world;

recently, however they have become recognized as symbols of woman's resistance to the domination of a patriarchal society. Accordingly, the women's movement now views witches as a form of counterculture practiced by women during the centuries of their greatest repression by men. Walpurgis Night is recognized then as a celebration of woman's vitality and natural sexuality, not as a night of satanic dedication.

When Walpurgis Night was depicted by earlier artists—invariably men, notably during the nineteenth century—their paintings showed an opulent crowd of naked women either riding the skies on phallic broomsticks or intimately engaged with the denizens of hell. They were visions of women as sexually prolific and in their overt sensuality in league with Satan. In such sexual fantasies, the witches were anxiety-inducing, and they were seen as threats to the rational order of the social hierarchy, the patriarchy deemed to be the rule of God and nature. The perception of society as necessarily dominated by men was undermined when in his book *The Matriarchy* (1861), Johann Jacob Bachofen argued that human society was originally matriarchal, not patriarchal, in its organization. Denied historical and, implicitly, anthropological justification, the existing patriarchal social order lost its validity as the sole acceptable manner of organizing human life. Bachofens finding's strengthened arguments that woman could no longer be limited to a subordinate role in society in which she existed solely as wife, housewife, and mother. The call for female emancipation increased, and a loosely organized woman's movement emerged in Germany, gaining increasing strength in the twentieth century, only to be suppressed and perverted during the 1930s.

With the resurrection of feminism during the 1960s, calls for a revived matriarchy in varied mutations again emerged. By 1977, they had gained sufficient currency to be used in Günter Grass's novel, *The Flounder,* as a major focus of the narrative. More serious and scholarly in approach, Ernest Bornemann's *The Patriarchy* (1975) denied the superiority of male-dominated societies and praised the virtues of women as models for a future society free of repression:

"Woman as childbearer is the original producer. As nourisher, she is the mother of civilization. Man, in contrast has become the despoiler of nature and the predatory animal par excellence because of thousands of years of occupation as hunter and fisherman. He will need thousands more to arrive at that degree of civilization attained by woman during his years as hunter and fisherman."[8]

The matriarchy which preceded the patriarchal society of hunters and its subjugation of women was hailed as a contrast to the insensitivity and cruelty that have characterized man's agricultural and industrial rape of nature, the environment, and animal life.

Auer does not identify herself with the extremes of feminism, but nonetheless her *Walpurgis Night* revolves around thoughts of emancipation and matriarchy. Her "witches" celebrate their sensuality and sexuality while dancing and singing joyously, some with breasts bared, in a landscape that echoes their forms and rhythms. Two of the women have ceased their dance, however, to minister to two men, smaller in size, who have collapsed in the foreground, two hunters who have succumbed to the artificial stimulus of alcohol on this night

when women, stimulated by nature, reign. Even the devil, included by Auer in accordance with the tradition of Walpurgis Nights, is subordinate to the women; a strangely comical, teddy-bearish creature, he joins their dance, powerless and insignificant, rather than being the overlord of his satanic domain. Nature, the painting proclaims, grants woman a unique existence that links her with the movements and vitality of the earth and cosmos. This is in contrast to man, who is overpowered by nature and responds by seeking to conquer her, to coerce and restrain her in an enslaving logic and uniformity totally lacking in comprehension. Women and nature are triumphant here, their bounty escapes the hunters and finds refuge in glory among the exultant women, and the hunter's dog leads in mocking laughter. While the patriarchy is temporarilly lifted, an instinctive order of sensual celebration, compassion, and unity with nature is established in which humanity and animals both share their dreams of freedom.

Although not as consciously proclaiming a message of woman's emancipation as *Walpurgis Night,* Auer's three other monumental paintings of the early 1980s–the triptychs *Morning–Noon–Evening (1980, p. 100), Alaska Festival* (1982, p. 116) and *The Power of Music* (1983, p. 132)–contain similar assertions of woman's essential coordination with nature's primary movements and of man's need to learn to manifest these in a more harmonious future life and society. The most recent of the three, *The Power of Music,* like *Walpurgis Night,* employs the motif of the dance in an iconography of liberation and released pleasure. In the mysteriously somber light of an Arctic summer night, in the central panel a woman and

man dance in response to the music being played by two women, feminine extensions of nature in their coloration and posture as well as metaphorically as they make aural the rhythms of the land. The man and woman lend their bodies to the process of making visual this harmony, interacting as equals in sensuous mirroring rhythms. In the foreground a dog yelps joyfully. Only the abrupt intrusion in the lower left-hand corner of a man gesturing unnaturally and obscenely disrupts Auer's vision of nature's celebration in a harmony of woman, man, and landscape.

The triptych's two side panels reinforce the content of the central field. On the left, beneath a sheltering tree in a glacial mountain landscape, a man is pensively playing a cello, his eyes closed as he seems to translate the natural sounds surrounding him. Nearby, wide-eyed, is perched a grandiose snowy owl that duplicates the size of the cello (which in turn echoes the body of the dancing woman) in its function as a symbol of nature's melodies. In the right-hand panel, lighter colors herald the brighter tones of a flute and of dawn rising over a mountain lake on which in a boat is a man accompanying a woman with vibrant red hair. She sits broad-breasted, with widely open eyes and mouth at his feet as he plays a flute. Responding to the alluring music, giant fish joyfully leap into the boat, echoing Auer's prior allegories of conception and procreation.

Auer's use of painting to praise the powers of music unites her with Romantic and Expressionist German precedents. Musical analogies and metaphors abound in their writings about the visual arts. Lyonel Feininger, so much admired by Auer at the time

she joined Eisenmann's staff, observed that "music has always been the first influence of my life. . . . Without music I cannot see myself as a painter", and Paul Klee admitted to his diary in 1906, "The parallels between the visual arts and music urge themselves on me ever more."[9]

The appeal of music for these painters lay in music's effectiveness as a means of primordial emotional communication. Music expressed directly the composer's inner life and projected it directly into the soul of the hearer. But it also spoke intuitively of the life of the universe, echoed the music of the spheres, and proclaimed, according to Friedrich Schlegel, the "infinite unity" in which man, nature, and the cosmos are conjoined. When Wilhelm Uhde praised the painters of Dedicated Hearts as reflecting the universal music in their art, he too attributed the ability to do this to a naive innocence that granted insights into nature which science could not provide. Auer's triptych similarly visualizes the Romantic and Expressionist perception, guaranteeing its innocence by setting her allegory in the Alaskan wilderness, in a nature which remains little despoiled.

Music, in the triptych, transforms and informs those who submit to its rhythms and harmonies, permitting them to overcome their individual diversity and to share in a universal unity. The conversion brought about by music is also depicted more humorously in *The Murderer and the Ocean* (1984, Oeuvre cat., No. 142), which depicts a man seen against a rhythmic pattern of ocean waves and shoreline. Essentially comic in effect, it serves as a visual footnote to the triptych, having as its inspiration an anonymous, overly silly quatrain which Auer had learned as a child:

Der Mörder sitzt am Strande
Und lauschet den Akkorden.
Er sieht sich außerstande
Für heute noch zu morden.

The murderer at the seashore sits
and to its rhythms lists.
He sees himself quite out of sorts,
Can find no murder in his thoughts.

The nonsense of the poem is rooted in the Romantic-Expressionist faith in music and nature, which Auer, too, professes, but *The Murderer and the Ocean* is a comical commentary on it, almost a self-parody in its trivialization of her concerns.

Auer has noted that she first introduced motifs of music and dance into her art around 1980 to enliven her compositions and break the silent, hieratic, motionless quality that had heretofore been predominant in them. In her work, however, as in the work of most artists, such a concern reflects a concern with meaning and how best to express it. The rhythmic motion of the dance enabled her to accentuate further the forces and movements in which the diverse apparitions of existence coalesce. Thus in *Alaska Festival* the three panels are united by the motif of dance as men and women, bear, and caribou perform a charged mating ritual under the erotic influence of the Arctic summer night. The triptych also serves to cap Auer's repeated celebrations of Alaska, its wilderness, its animals, and its people.

Auer first visited Alaska in 1971, and thereafter the landscape of North America's "last wilderness" was to be a major concern of her art; it also became the primeval reality substituted by her psychologically for con-

temporary Western Europe with its predominantly urban, industrialized existence. With its expanse of 586,400 acres and a population of only 402,000, more than half of it concentrated around the city of Anchorage, much of Alaska remains virgin wilderness. The Alaskan poet Richard Peter celebrated his state as a final refuge where nature keeps man at bay, preserving her land and wildlife:

"Alaska is not tamed . . .
The wilderness will never yield
In this its last retreat. It will not die
Though humankind in millions takes the field,
Because fierce nature here is queen and will
Not rest again upon her rocky throne
Till there are no more strangers left to kill
And she can truly call this land her own."[10]

The scenic-wildness of Alaska, which Richard Peter depicts, is matched by its scenic beauty, a beauty so intense that in 1899 it caused the chief geographer of the United States Geological Survey to warn:

"There is one word of advice and caution to be given to those intending to visit Alaska for pleasure, for sightseeing. If you are old, go by all means; but if you are young, stay away until you grow older. The scenery of Alaska is so much grander than anything else of the kind in the world that, once beheld, all other scenery becomes flat and insipid. It is not well to dull one's capacity for such enjoyment by seeing the finest first."[11]

The animal life in this "enchanted wilderness" likewise receives descriptions in which superlatives are the writer's primary adjectival form:

"There is a tremendous number of wild animals in Alaska that do not have equals as to power and size in all the world. No grizzly is more fierce than the Alaskan grizzly; none more powerful than the Kodiak bear; nowhere does a moose carry stronger antlers. White wild mountain sheep and silk-furred mountain goats enliven the mountains, uncounted herds of caribou roam the tundra, lynx and wolves live in the woods. Bison pasture in the prairies, musk oxen stand in the Arctic islands and polar bears inhabit the cold shores. Sea otter and walrus splash in the bays, whales plow through the seawaters, and two million fur seals live on the Pribilof Islands. And all these wild animals thrive and multiply."[12]

The actualities of Alaska present problems that such idyllic rhapsodies exclude, but the sense that "you can hardly imagine a country more beautiful, healthier, more re-freshing than Alaska", as the German journalist Hans Otto Meissner contends, remains overpowering. Mixed with memories of the Alaskan stories of Jack London, long popular in Germany, this was the Alaska that Auer saw and wished to see.

During visits to Petersburg, the small town of some two thousand descendants of its Norwegian founders, Eskimos, and Indians located on Mitkoff Island about one hundred miles southeast of Juneau, Auer frequented a small bar and dance hall into whose compressed space dancers and a singer were crowded. Collage-like, her re-construction of the locale presents the dancers of varied races as they move either in ecstatic self-abandon or, like the pregnant woman and man on the right, in a contemplative embrace in response to the music provided by the red-haired singer in the center of the painting. The formal qualities of the painting—the undulating diagonals of the floor, the sharply cut silhouettes of the figures, the compressed space, which have already been discussed (see Chapter 2)—orchestrate and intensify the mood of sensual expectation, sexual tension, and expansive movement inherent in the scene.

The combination of this dance-hall activity with the two views of glacier-surrounded waters at whose shores animals feed and also dance with their mates suggests that the Petersburg couples form part of a universality which extends from the smoky interior into the crystalline air of nature and the cosmos. As the triptych format proclaims the intent of metaphysical content, the juxtaposition of animals and humans inexplicably within the unity of the three panels—and also within the central panel where a monumental American eagle overlooks the scene and a dog grins demonstratively out at the viewer—generates a tone of mystery in Auer's celebration of Alaska's primitive purity and of the regeneration of life both animal and human.

The theme of courtship and mating depicted in *Alaska Festival* emerges again in *At the Sea* (1980, p. 107), but with a sinister overtone totally absent from the triptych. The painting's sombre tonality with its grayed whites, browns, blues, and yellows contributes to this effect, as do the sea-shore and the houses glowing poisonously yellow in the light of an off-shore beacon. Rather than the joyous dancing of couples, here there is a confrontation between men and women as the two approach each other in the dim light. Munch's crowds of anxiety-ridden anonymous people are the ancestors of these Alaskans; antagonism

overrides any attraction that might register on these faces with their clenched teeth, suspicious eyes, and forced smiles. In the foreground a man and woman collide, the space between them cut sharply into shape by the edges of their arms and shoulders. The man reaches crudely for the woman's breasts. She bristles, her raised left hand becoming a claw aimed at the eyes of her confronter. It is the ominous dimension of the contrast between men and women that Auer paints as she identifies the women with the sea and the men with the sickly yellow houses intruding into the dark landscape. Even the animals are ensnared in this nightmarish net as puffin-like birds join the three women and a black sea gull, accustomed to feeding on the detritus cast away by men, glares among their antagonists.

The first of Auer's triptychs, *Morning–Noon–Evening* (1980), portrays the interaction of animals and humankind in a more optimistic fashion. If *Alaska Festival* is an ode to the unity recognizable within the differences of women, men, animals, and nature, then this triptych is a similar laudatory poem to the animals that share in human life. Living in the company of men, women, and children, the horses, dogs, and birds in this triptych work for, comfort, or guard them. Here the animals join in human dreams and waking experiences in a mutually beneficial partnership in the setting of impartial nature.

Presenting this message of mutuality, the triptych makes use of the thematic tradition of the times of day which has served artists for centuries as a vehicle for expressing thoughts about the meaning of life. Possibly the best known is Philipp Otto Runge, who

planned a series of paintings devoted to using the divisions of the day in a complex iconographic program revealing diverse temporal realities ranging from the fundamental temporal passage of a single symbolically universal day, to the divisions of a human life, to the eon-long unfolding of God's plan of divine salvation. Auer's triptych is less synthetic and ambitious, its content more apparent and readable in a seminaive fashion.

Morning, noon, and night are readily recognized in the three landscapes. The scenes of human and animal activity correspond to their temporal settings. Thus, *Morning,* the first panel of the triptych, shows a couple and a child waking, a dog barking its welcome to the rising sun, and a bird flying upward toward the golden glow in the sky. *Evening,* the third or right-hand panel, more complexly presents a sleeping woman holding a baby while a boy reclines near her, a large red-brown dog guarding them, and a mysteriously draped older woman, awake and holding close to her a sheltering womblike form in which a white bird seems to glow. The significance of this dark shape is difficult to determine, and Auer has provided no clues. From the figure's color and form which mirror those of the landscape, it seems likely that this is a personification of nature's beneficial presence.

The landscapes in each of the three panels in the triptych further enhance the ability of the images to project meaning. In *Morning,* the shoreline seems to move in a configuration akin to that of the waking couple; behind this, the rocks and mountains, semianthropomorphic in shape, push upward, rising toward the dawning day as does the totemic bird. Similarly, *Evening's* dark enshrouded hills press downward be-

neath the descending maroon striations of the twilight sky, becoming bedlike as the Arctic nativity scene unfolds beneath it. *Noon,* the central panel, shares in this manipulation of landscape as tall, solid land formations are intended to suggest broad supportive pelvic forms absorbing the sun's warmth. This central panel departs from the two which complement it in that its primary focus is not on human figures engaged in an appropriate activity, but on a white horse gazing out of the canvas with glowing golden eyes while other horses are glimpsed swimming gently in the fjord behind it. The human beings in the composition are divided into two groups: the first, composed of three men and a woman passing singlefile, partially submerged in the suits and uniforms of their professions, oblivious to the visions surrounding them; the second, limited to a single, crouching, adolescent girl, her head tilted, gazing pensively upward into a private world of dreams.

The girl's vision is the painting's central content, a crystalline vision of strong contrasts in which adults play a significant but colorless and incomprehensible role. In color and placement the golden-eyed horse recalls the deer of *The White Stag;* it, too, is more a mental projection than a reality. The vitalistic sensuality and sexual symbolism of a horse become notably applicable in the context of Eskimo folk tales in which a common device is for animals to take on human form and for human brings conversely to appear as animals, the two moving freely back and forth between their respective worlds so that they become undistinguishable. More than a priapic presence, however, the mystical horse is a second intimation of the girl's growing self-awareness, her awakening consciousness of her own sexual powers and alluring appearance that will supplant her huddled, dark present. Auer's own adolescence, as we have seen, marked a major transformation in her life, and she recognizes the significant subdivisions of all human existence as childhood, adolescence, and adulthood. *Morning–Noon–Evening* depicts such a view of the movement in temporal life. The central panel is a vision of animals, a vision of self, the dream of a different future.

# Illustrations

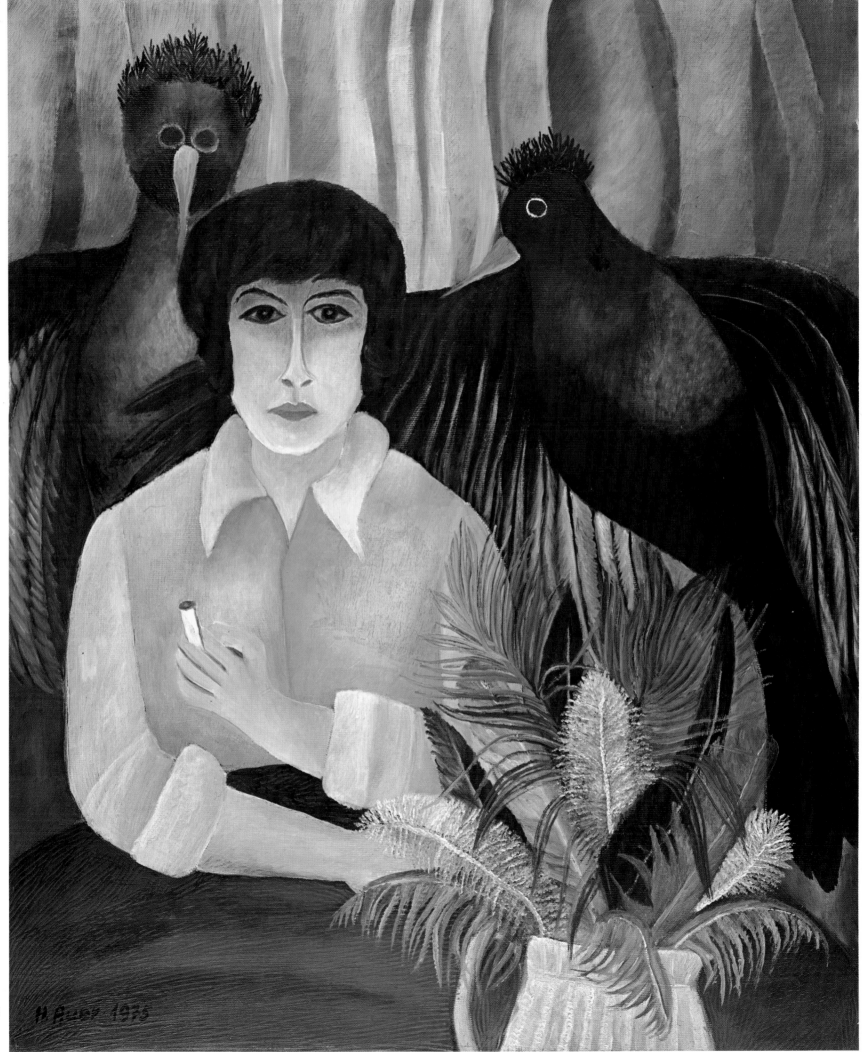

Self Portrait, 1975
oil on cardboard
60 by 50 cm

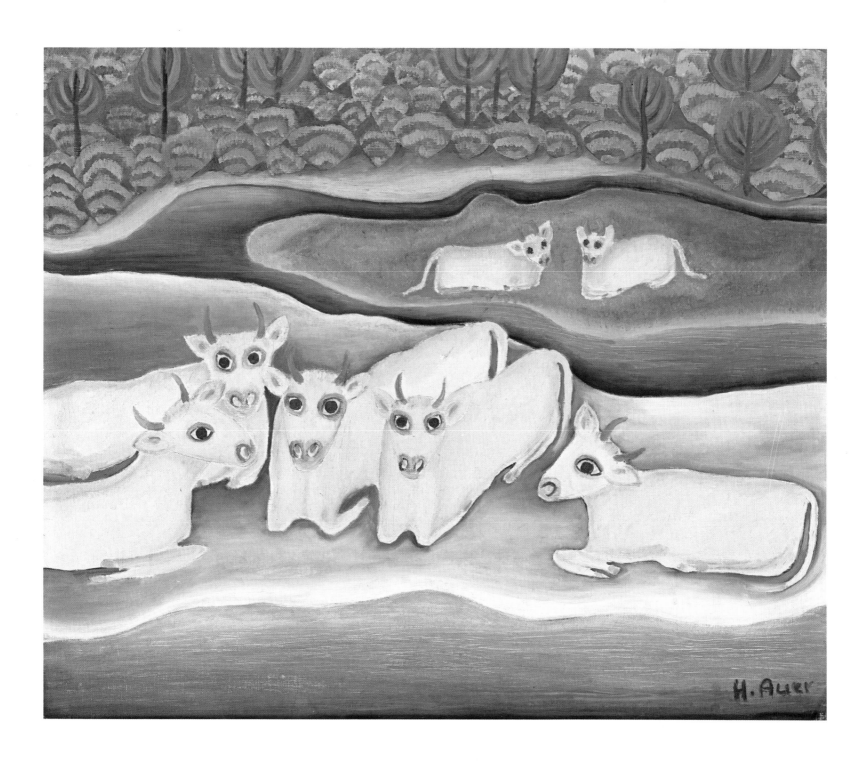

Cows at the Tanja River, 1968
oil on canvas 50 by 60 cm

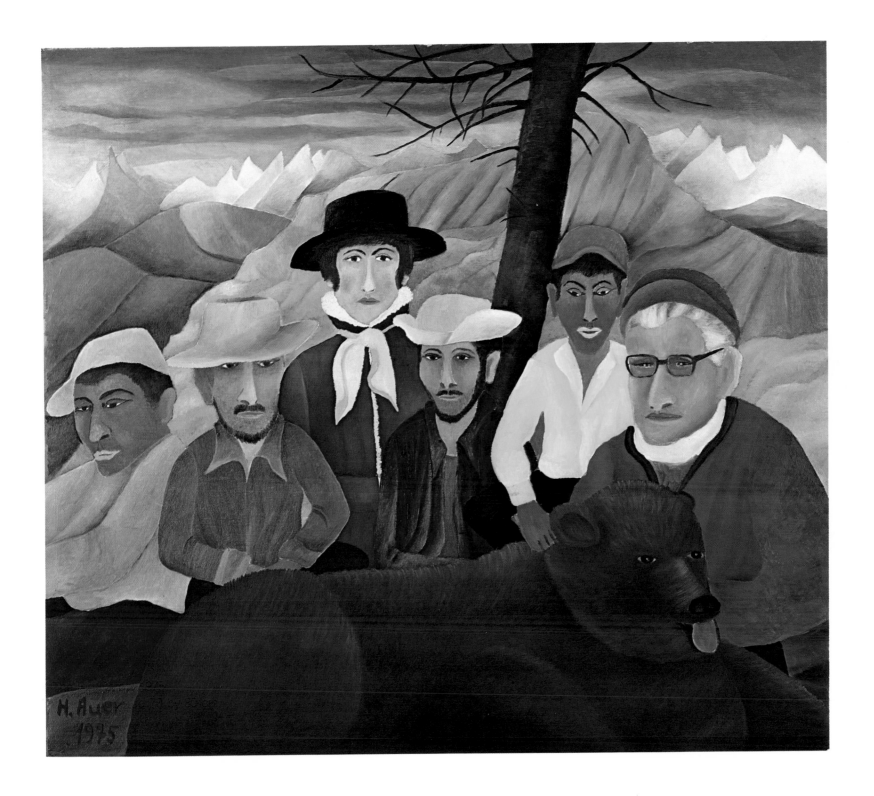

The Big Catch, 1975
oil on cardboard 70 by 80 cm

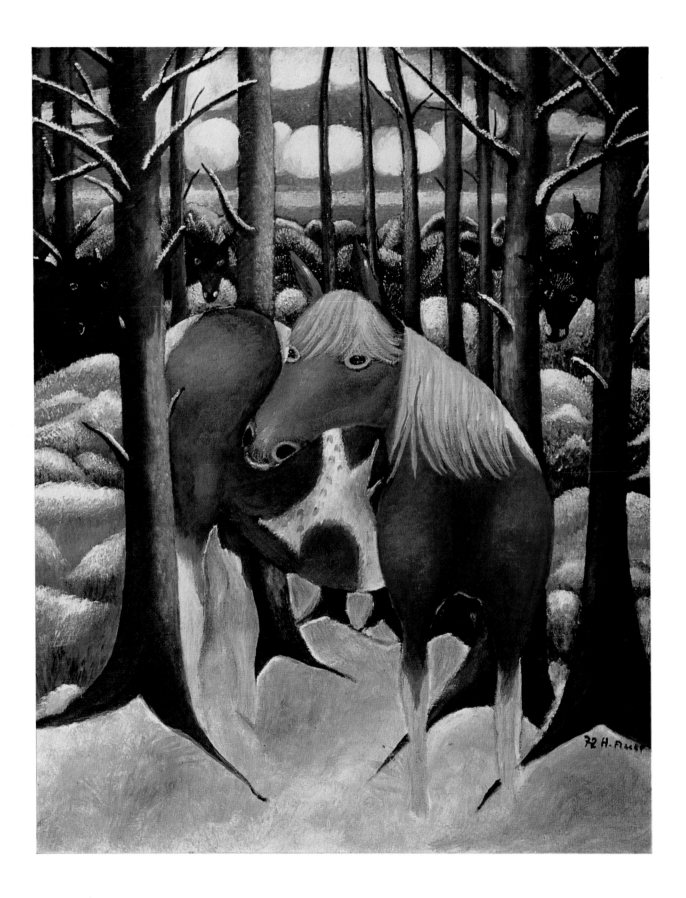

The Morning when the White Wolf Came, 1972
oil on cardboard 50 by 40 cm

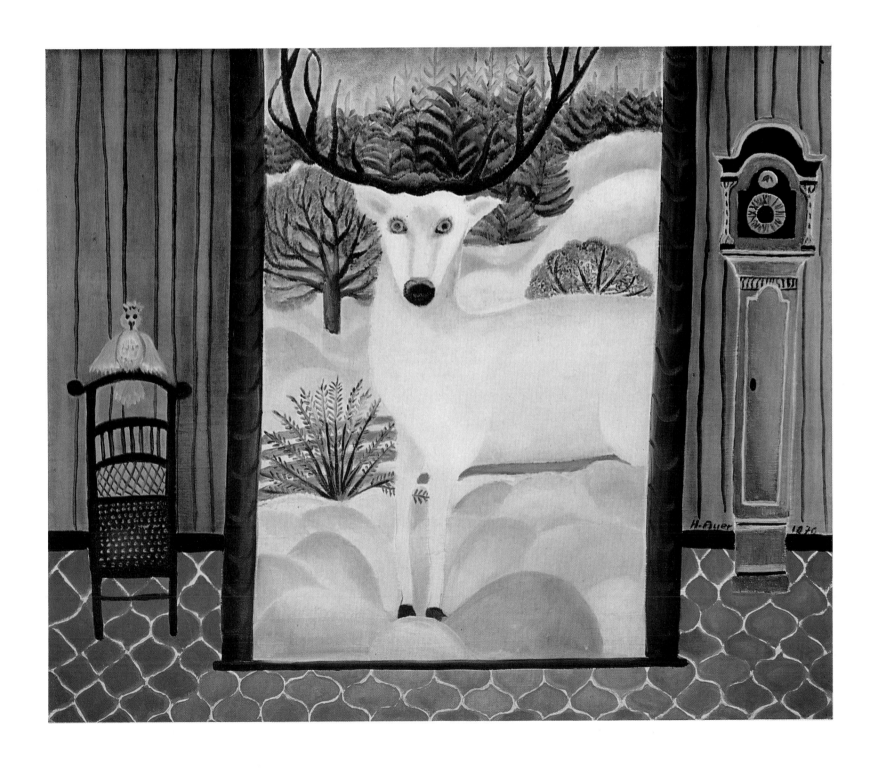

The White Stag, 1970
oil on canvas 50 by 60 cm

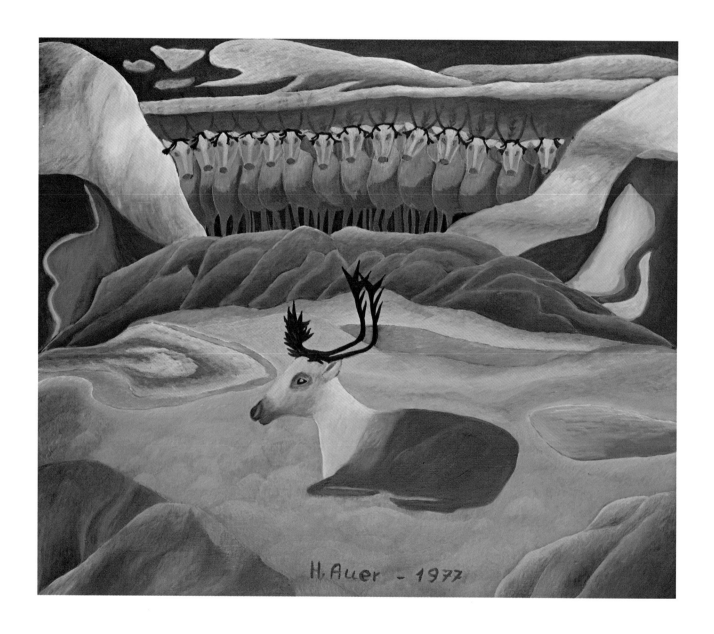

The Big Caribou, 1977
oil on canvas 75 by 90 cm

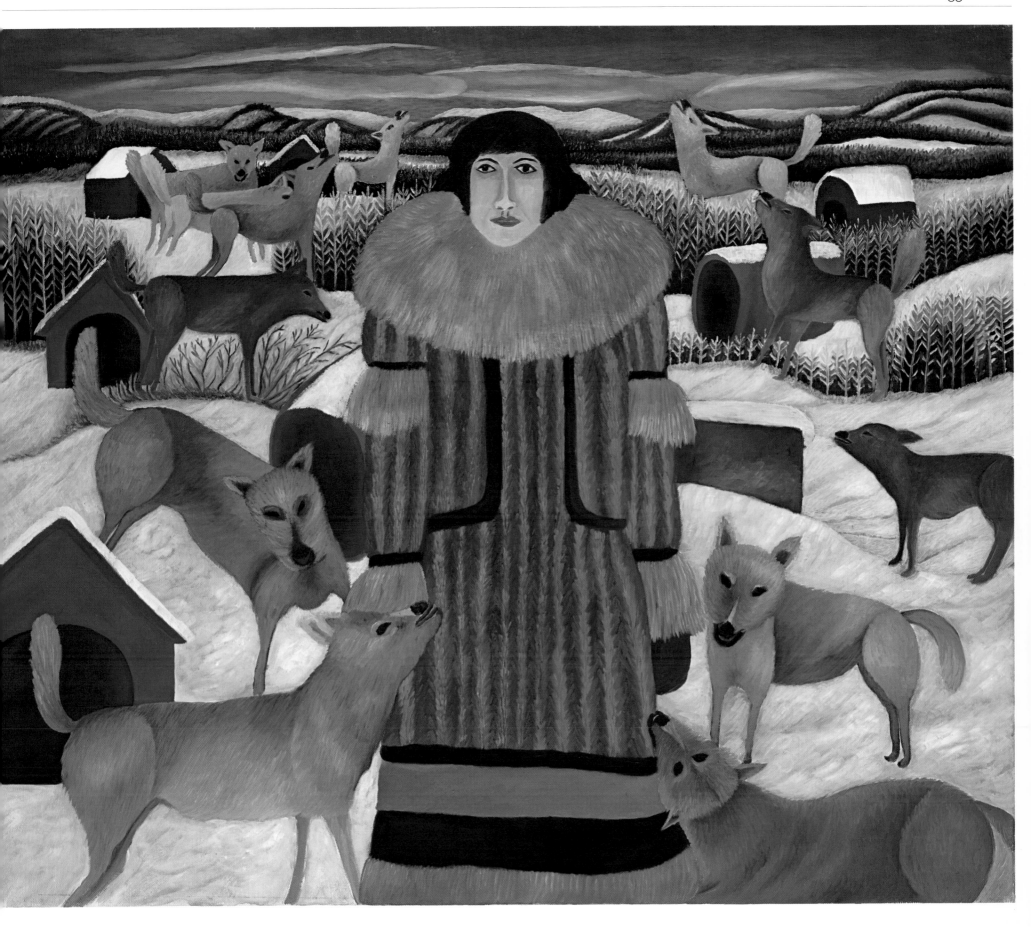

The Dogs of Bettles, 1976
oil on canvas 80 by 95 cm

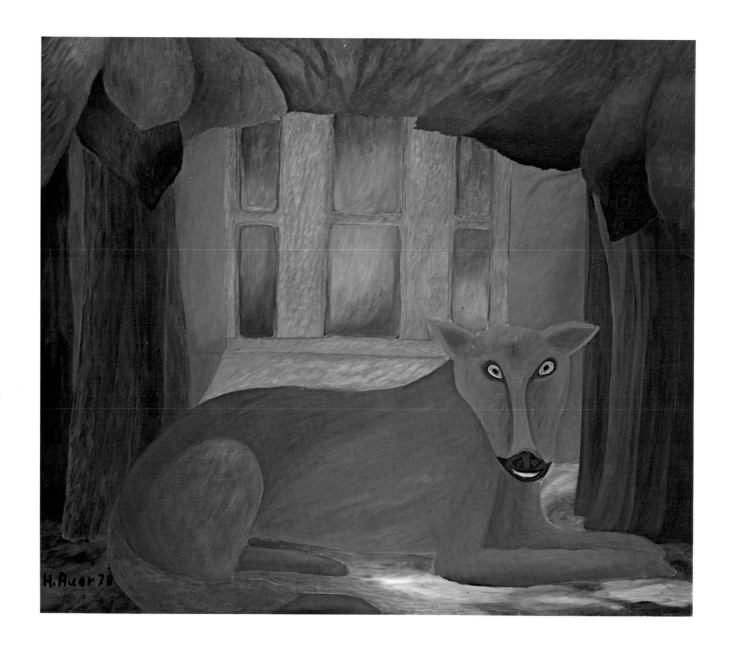

The Guardian, 1978
oil on canvas 60 by 70 cm

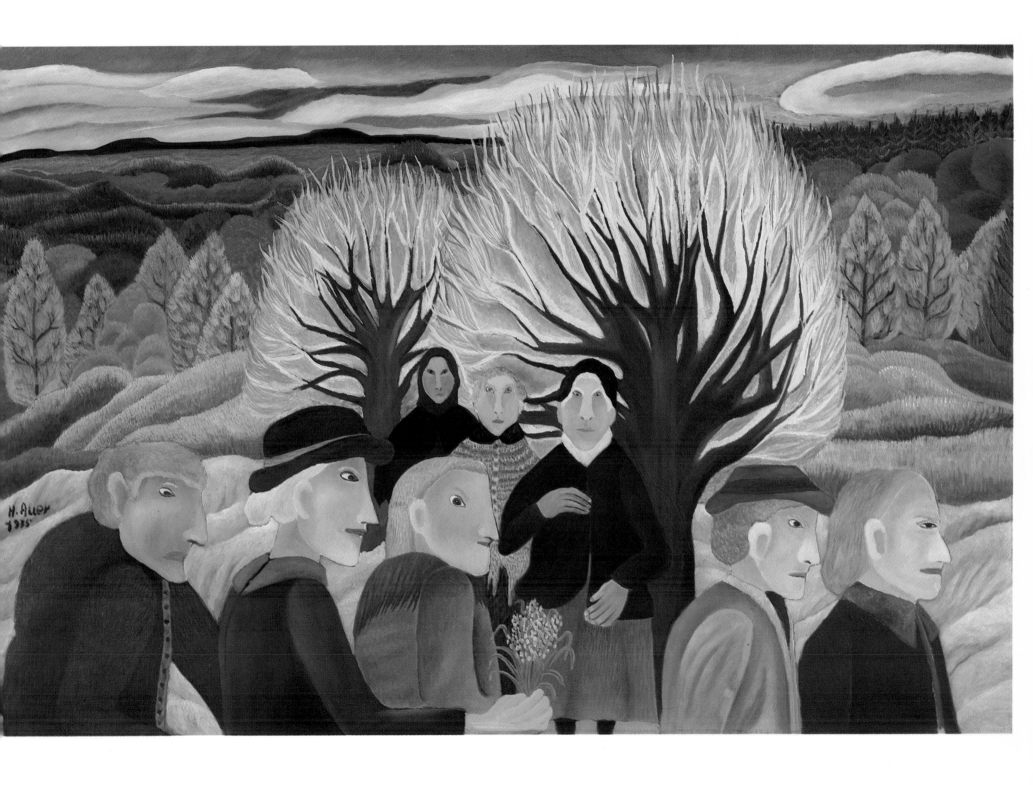

All Souls' Day, 1975
oil on canvas 79 by 105 cm

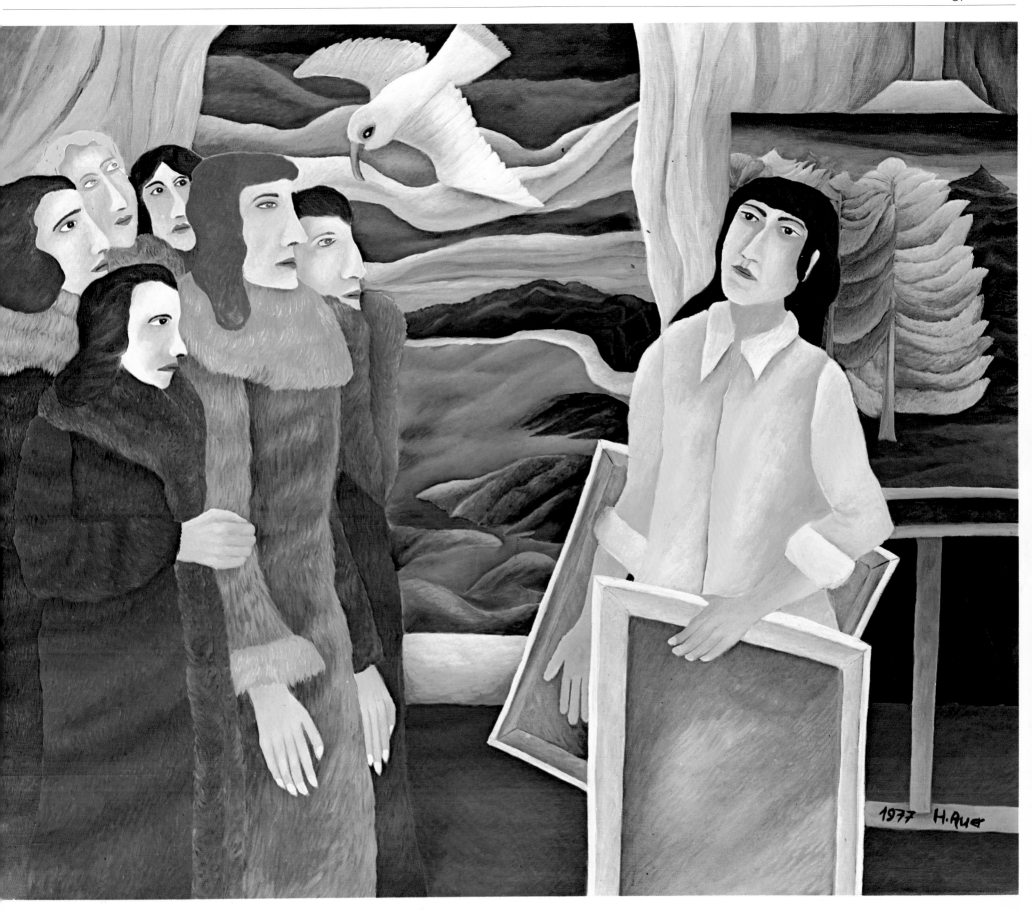

1977  H. Rue

Visit in the Atelier, 1977
oil on canvas 105 by 125 cm

88

Goldstream, 1977
oil on canvas 93 by 68 cm

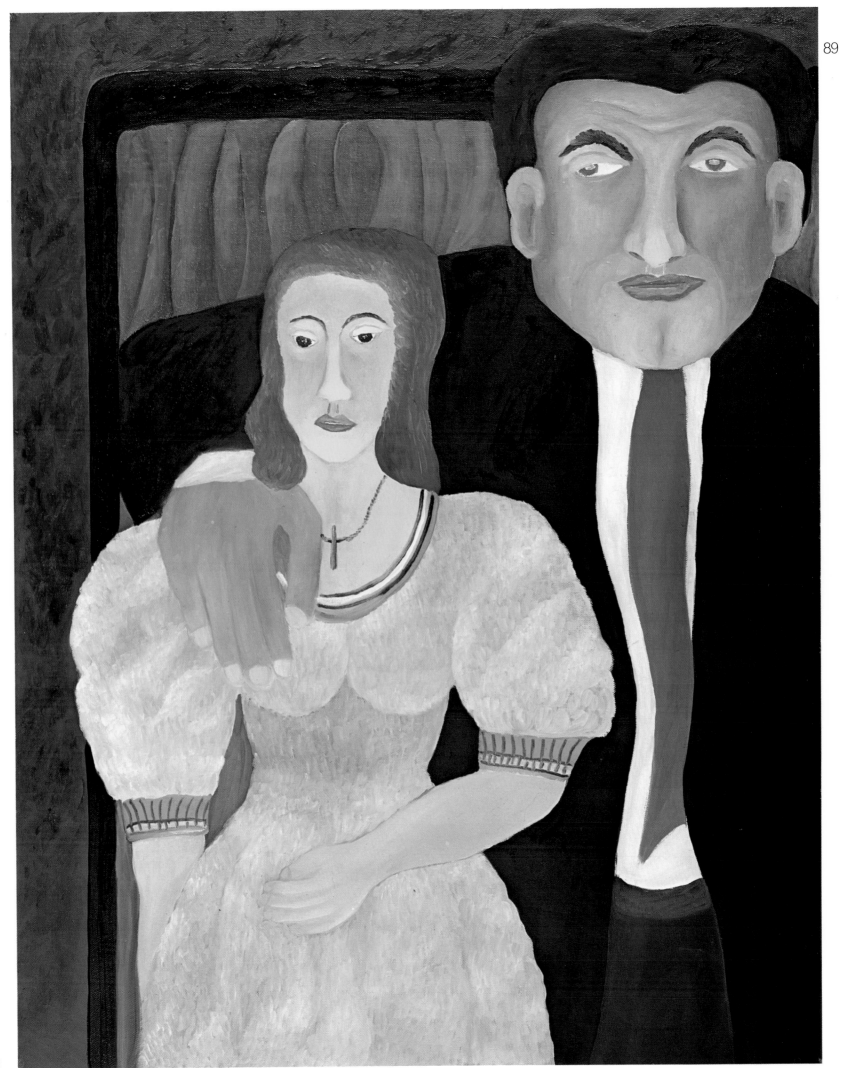

The Protector, 1976
il on canvas 70 by 55 cm

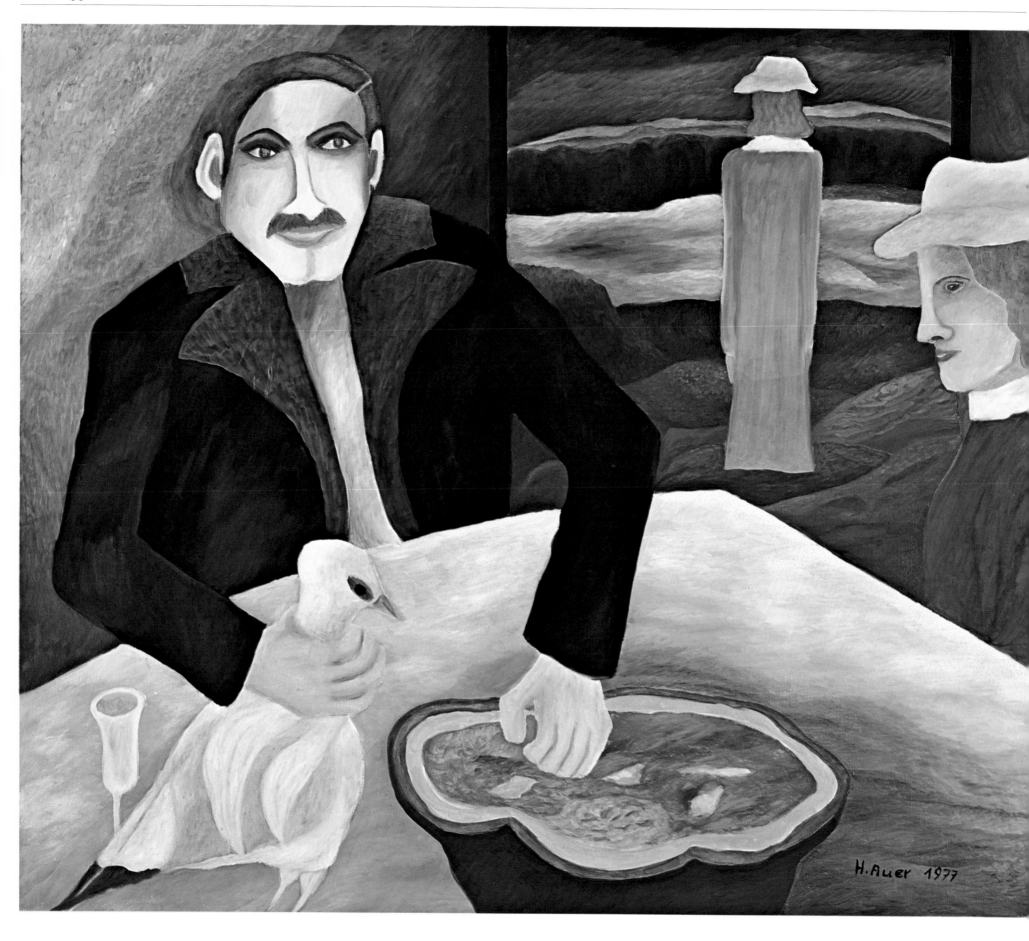

Mr. Kortoma with White Grouse, 1977
oil on canvas 80 by 95 cm

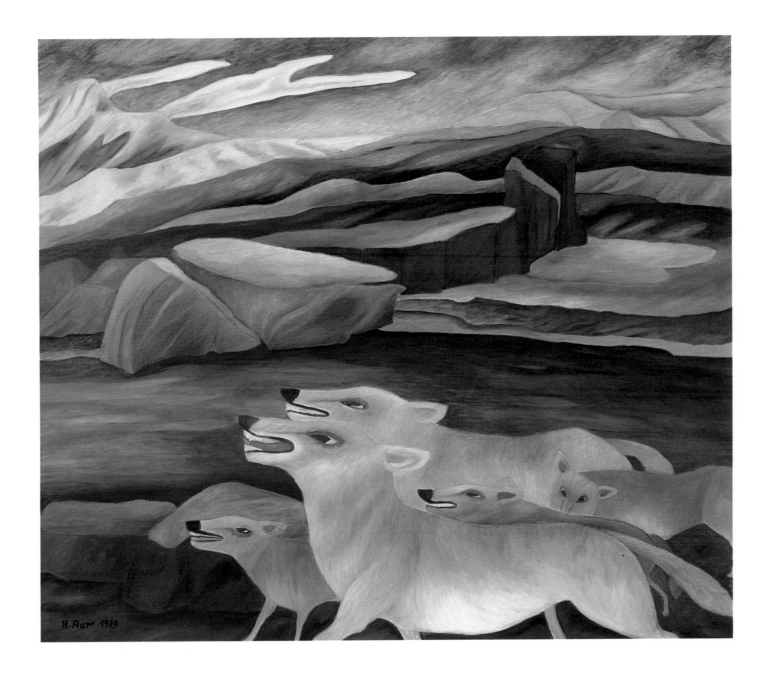

The Wolves, 1979
oil on canvas 80 by 95 cm

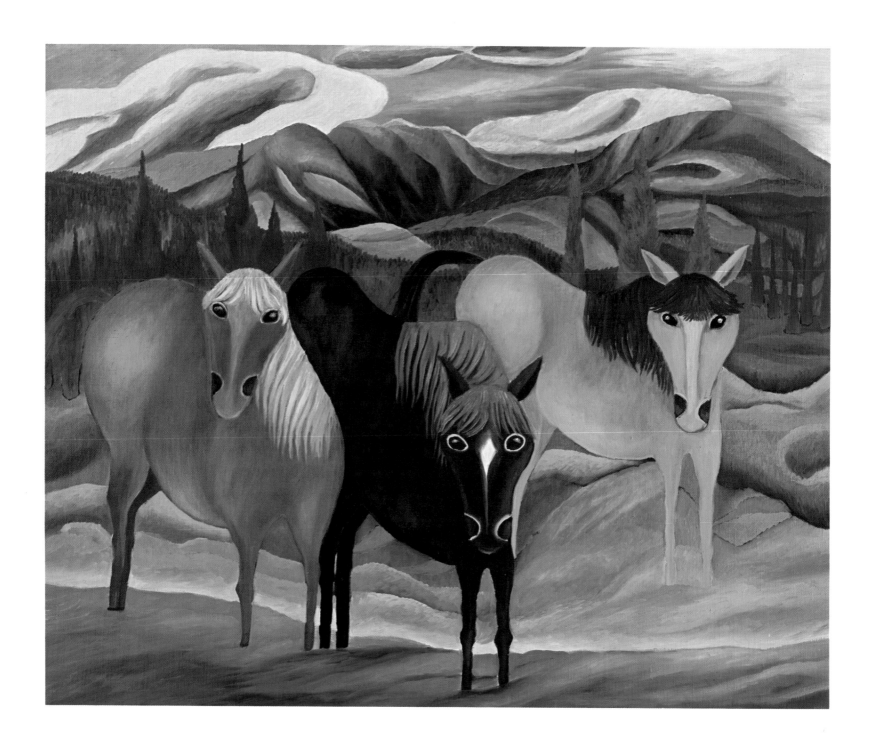

Horses near the River, 1977
oil on canvas 70 by 80 cm

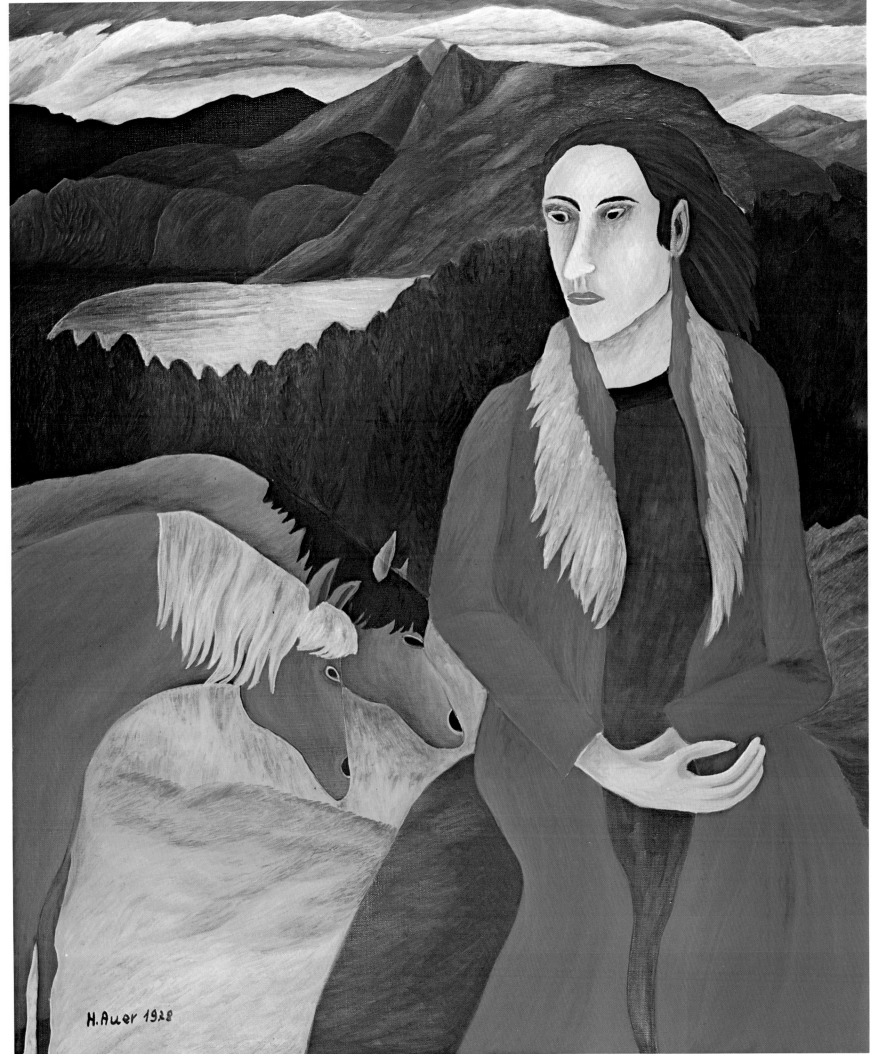

Encounter, 1978
oil on canvas
95 by 80 cm

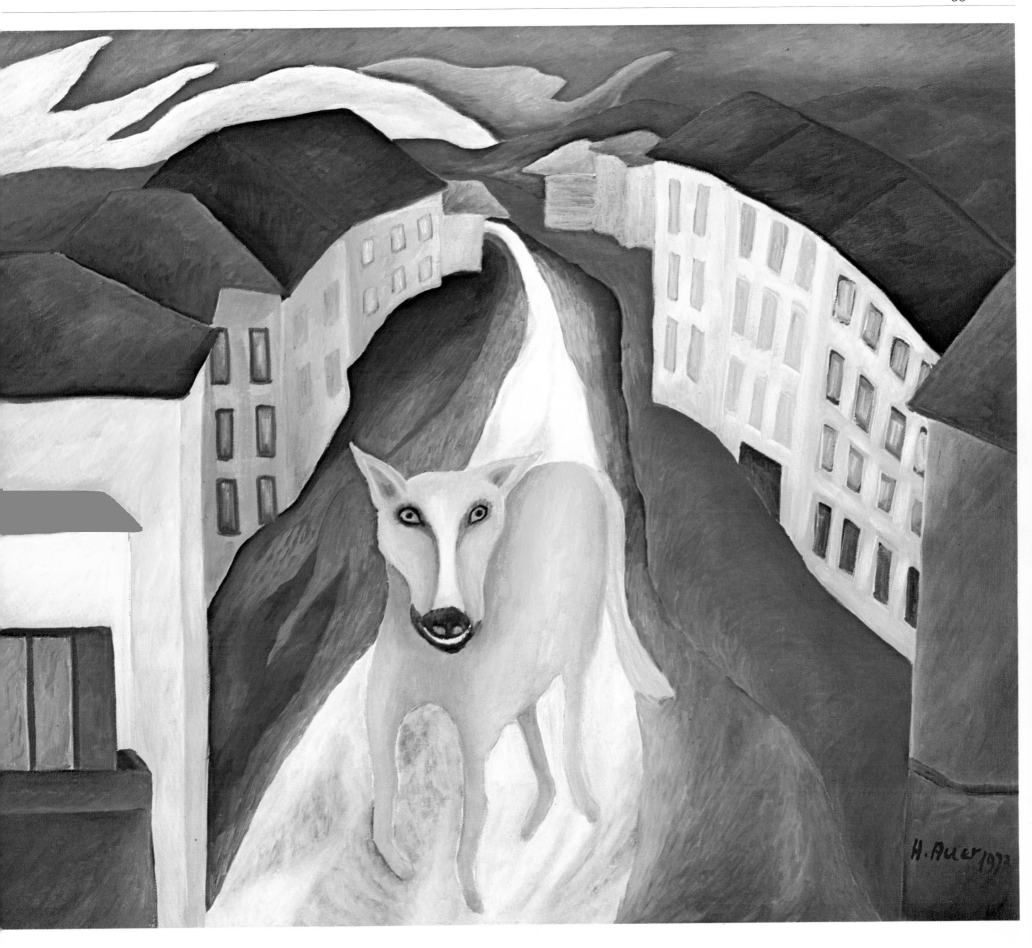

North Station Street, 1977
oil on canvas 60 by 70 cm

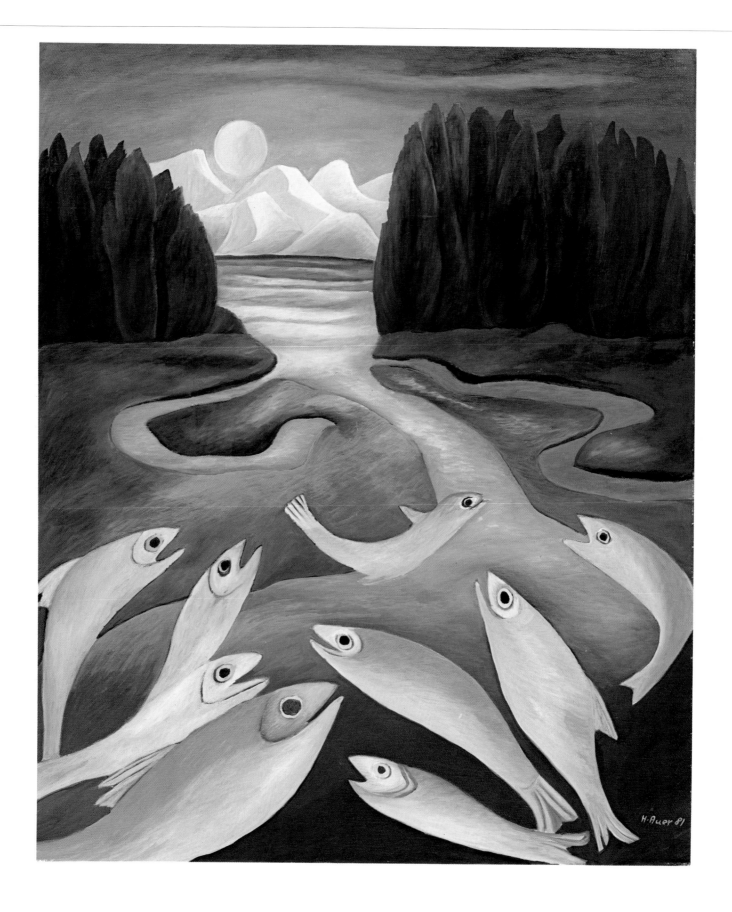

Wedding of the Salmon, 1981
oil on canvas 90 by 79 cm

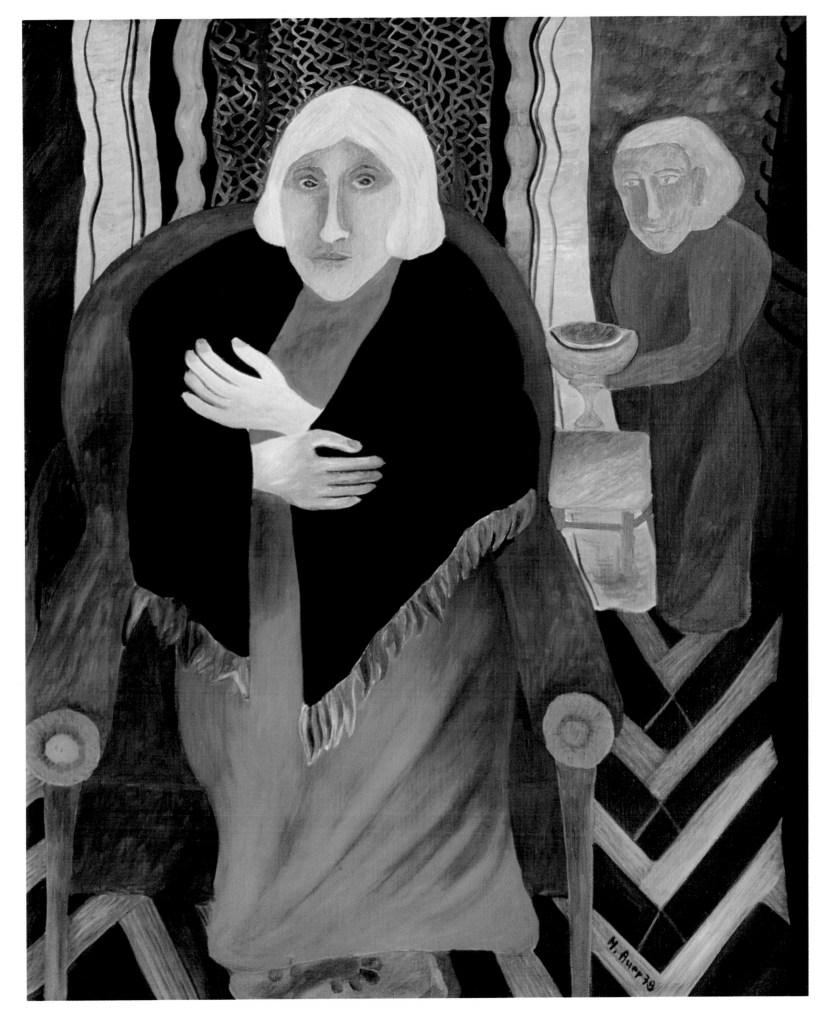

The Consul's Wife, 1978
oil on canvas 90 by 75 cm

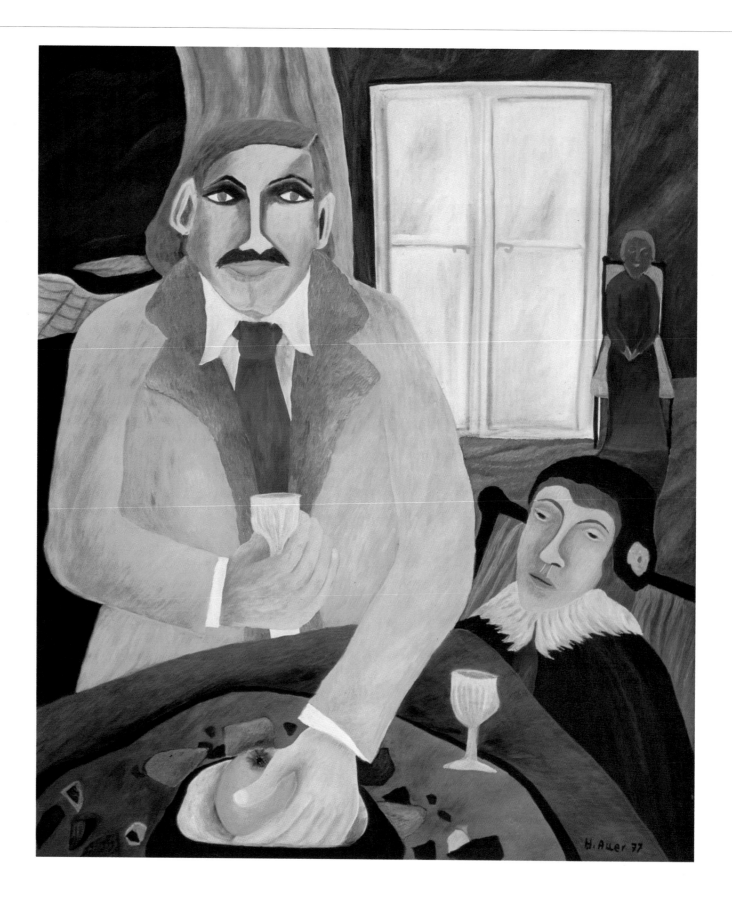

Mr. Kortoma has a Party, 1977
oil on canvas 90 by 75 cm

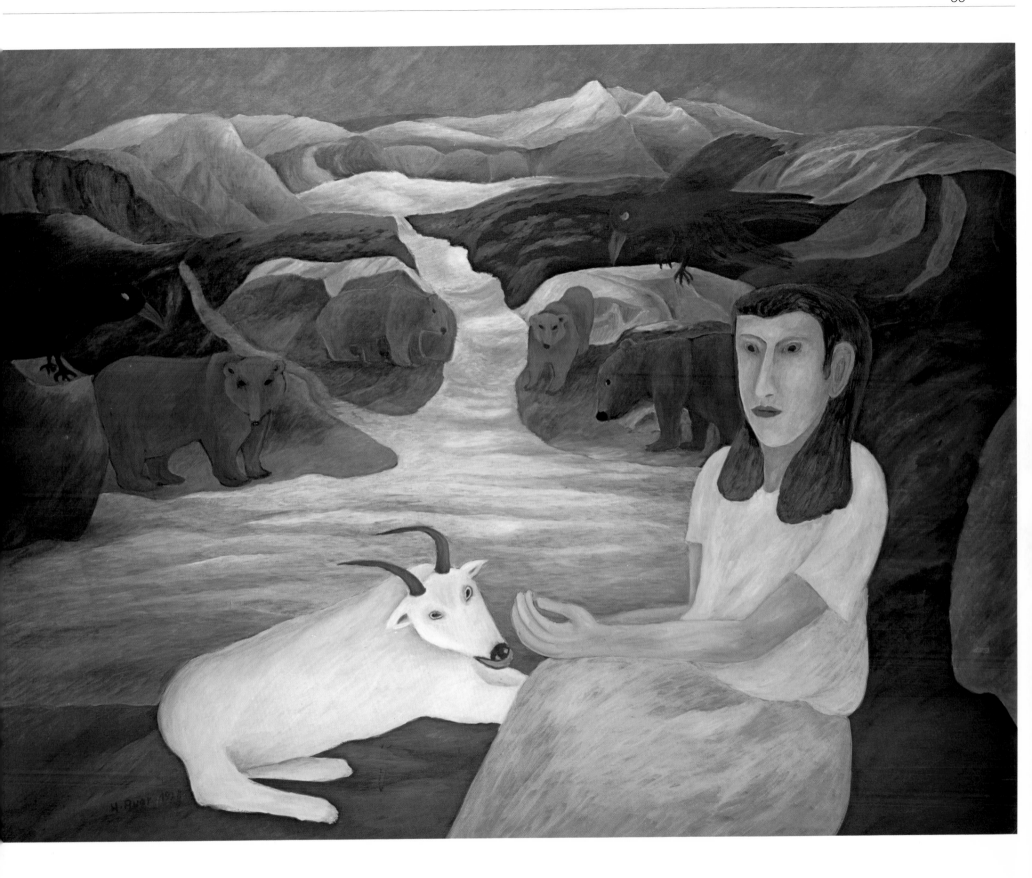

Death in Alaska, 1978
oil on canvas 90 by 120 cm

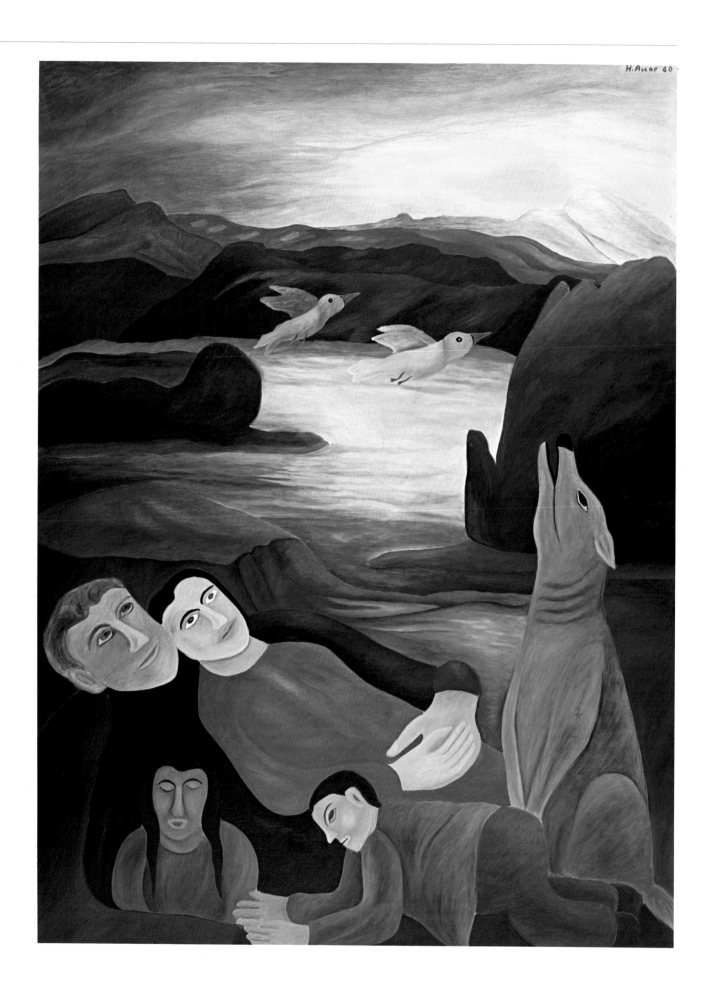

Morning (Triptych, left panel) 1980
oil on canvas 140 by 105 cm

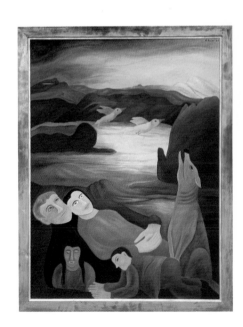
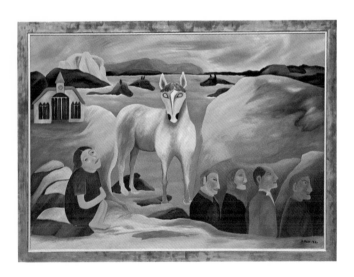
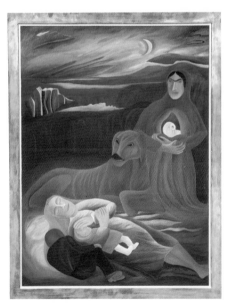

Morning, Noon, Evening
Triptych (entire view)

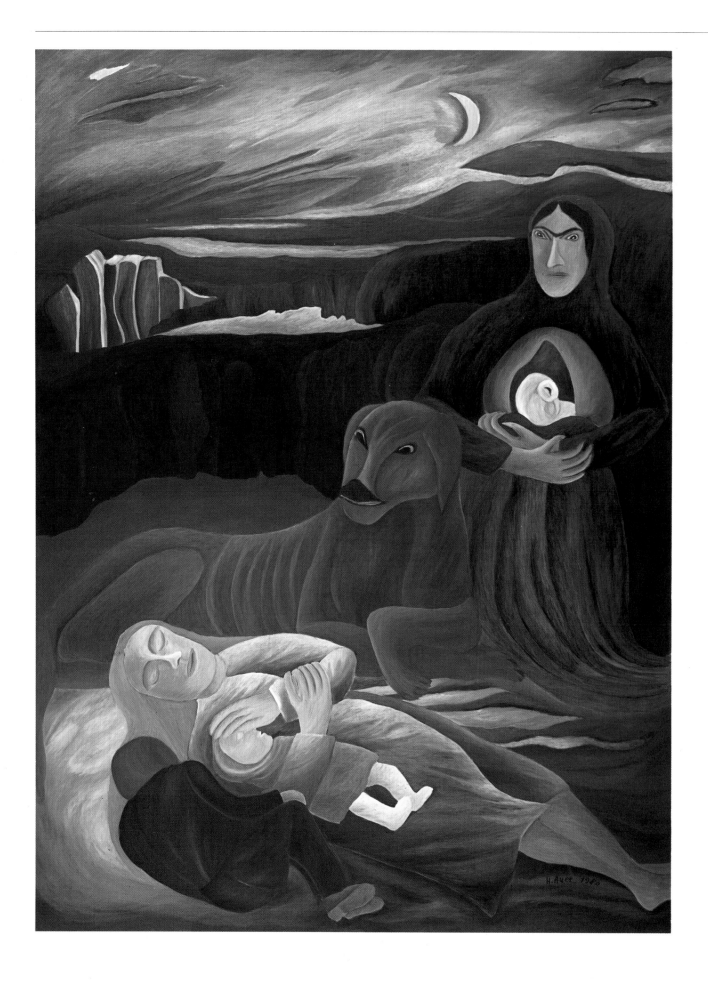

Evening (Triptych, right panel) 1980
oil on canvas 140 by 105 cm

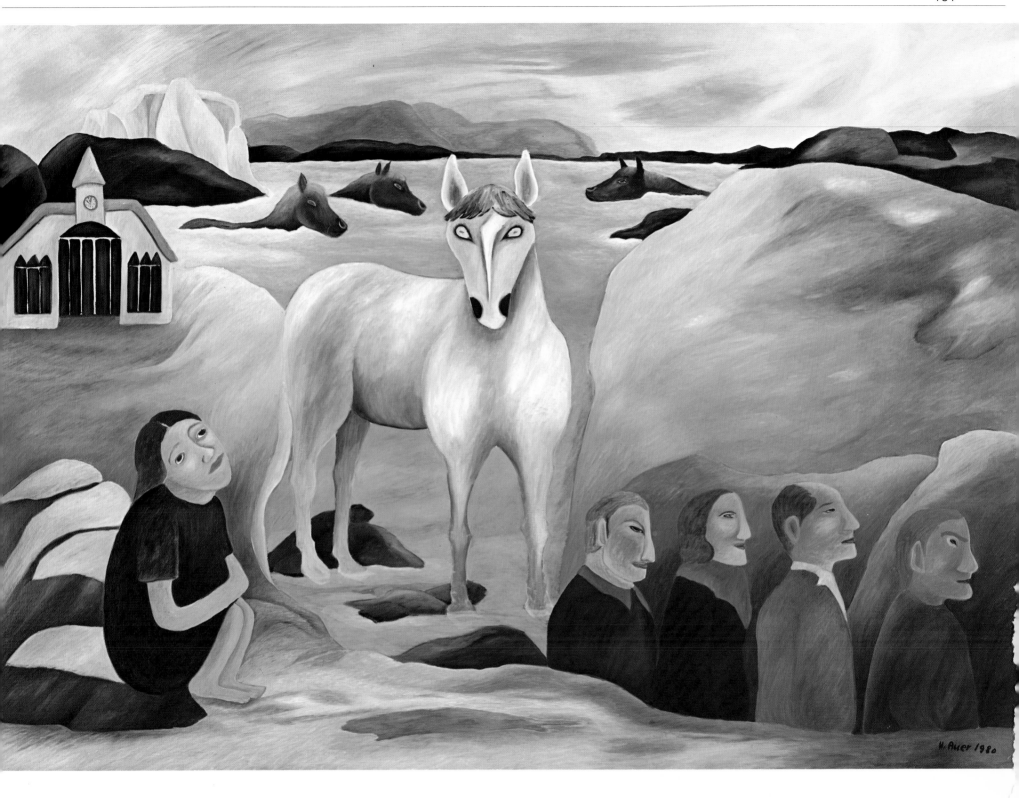

Noon (Triptych, center panel) 1980
oil on canvas 120 by 170 cm

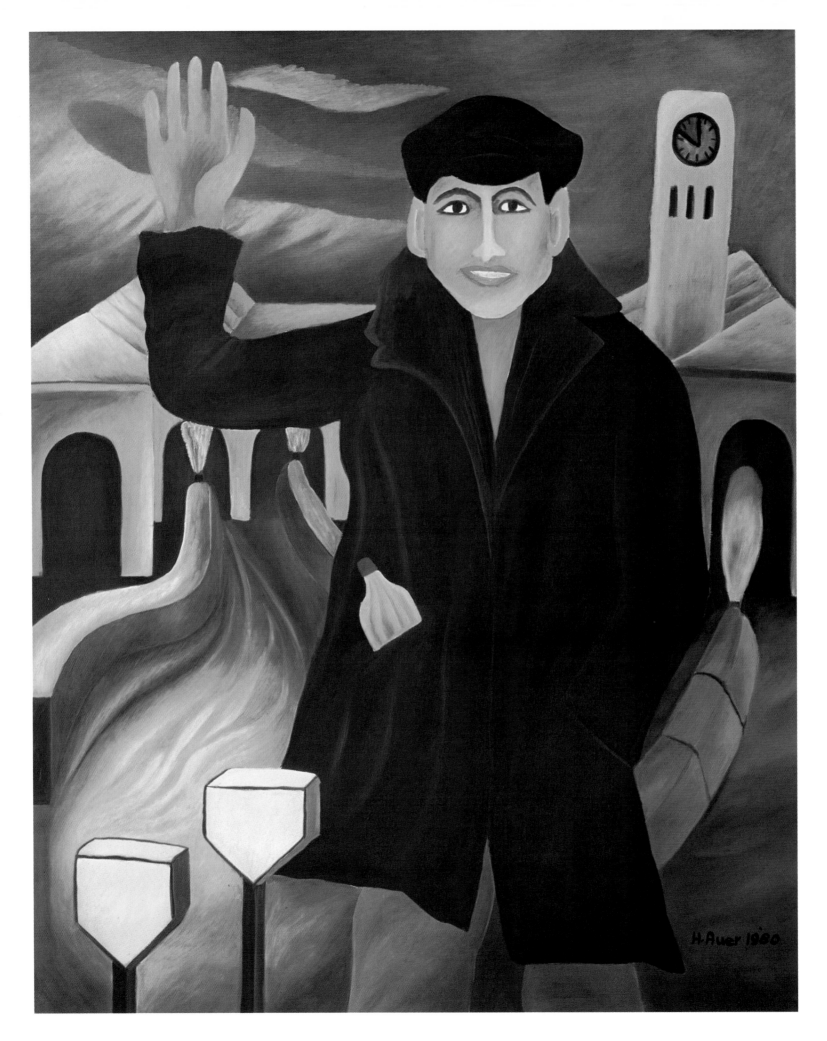

Main Train Station, 1980
oil on canvas 105 by 90 cm

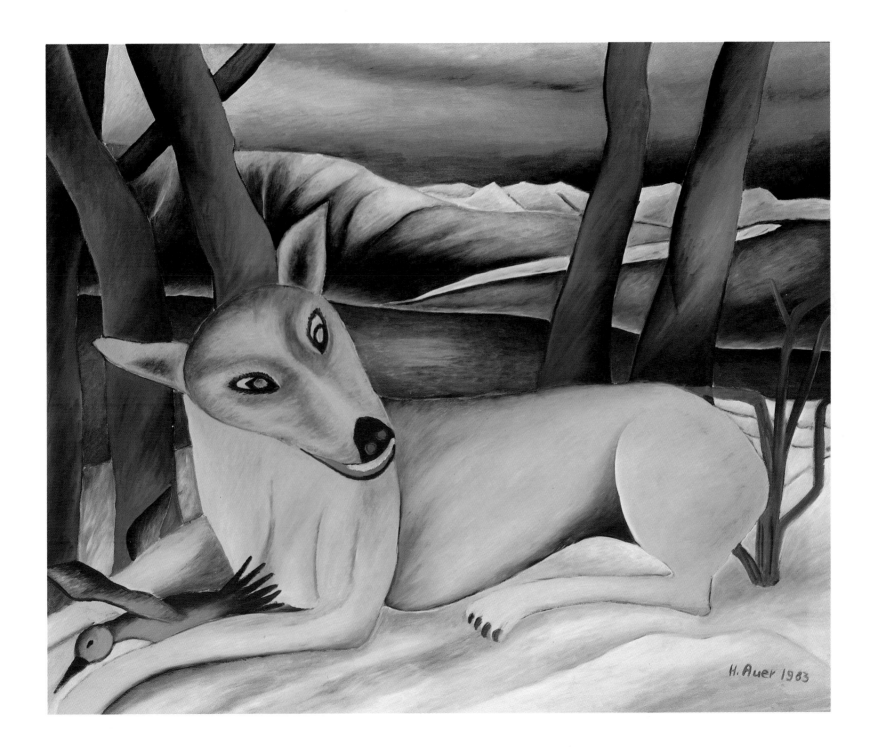

Wolf in Winter, 1983
oil on canvas 75 by 90 cm

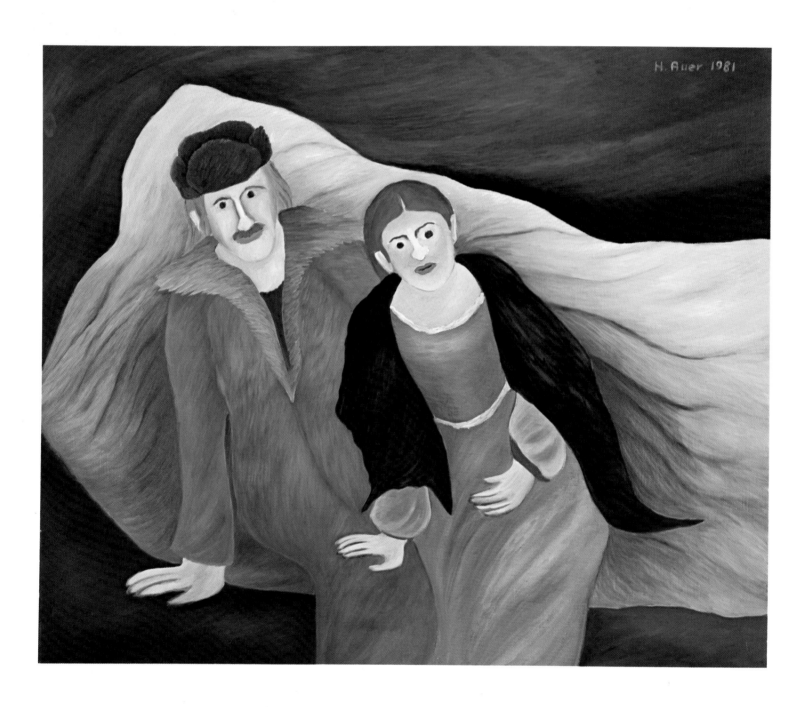

Leaning Couple, 1981
oil on canvas 80 by 95 cm

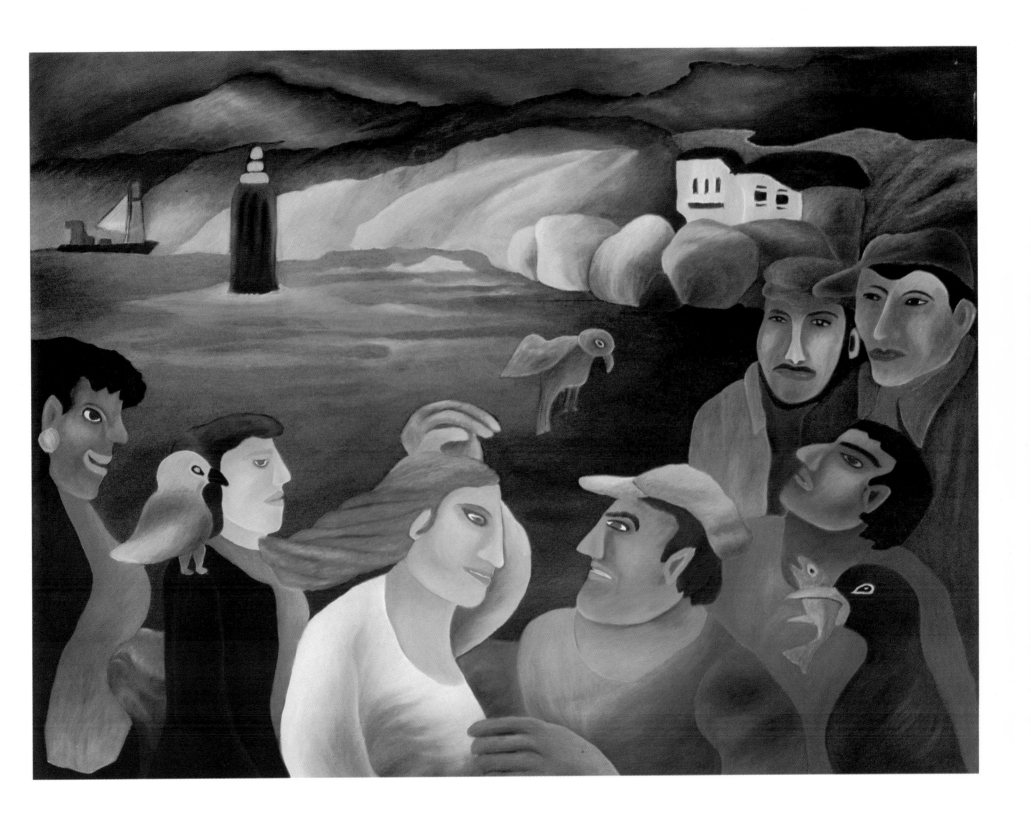

At the Sea, 1980
oil on canvas 90 by 120 cm

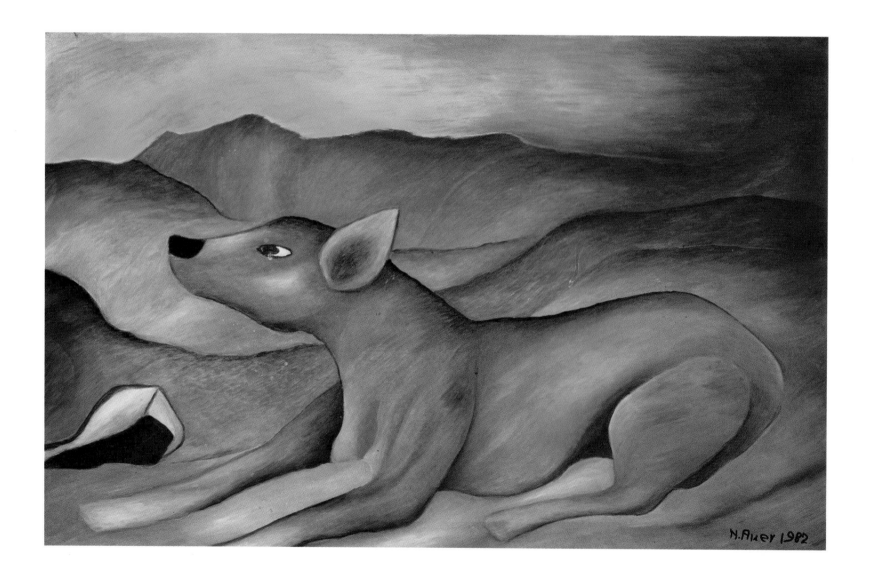

Gray Dog, 1982
oil on canvas 55 by 84 cm

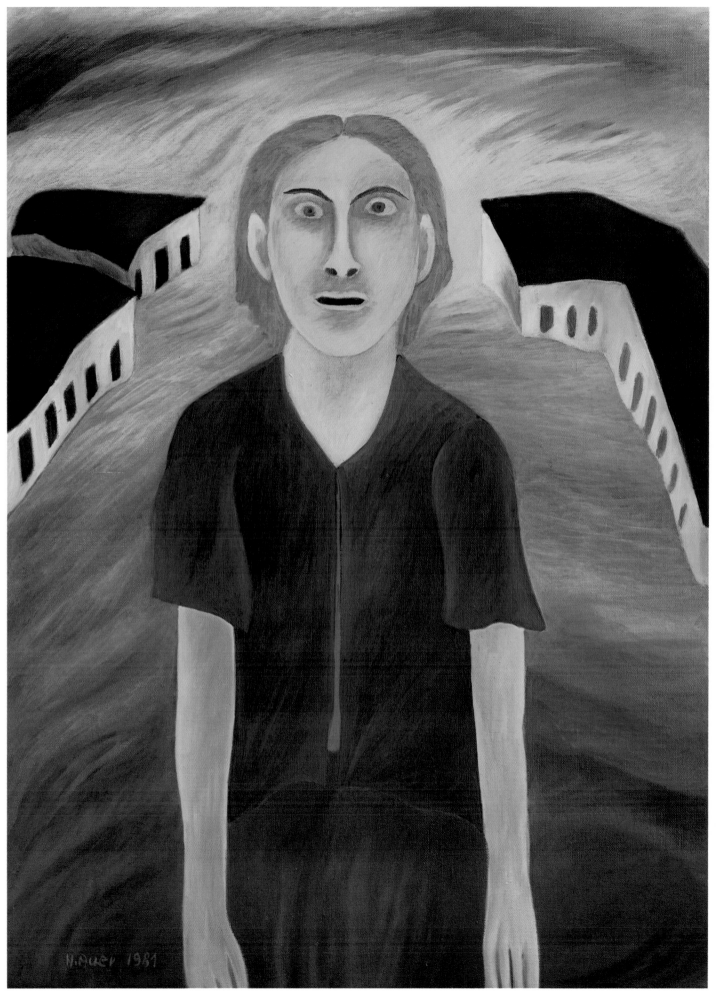

Deluge, 1981
oil on canvas 80 by 60 cm

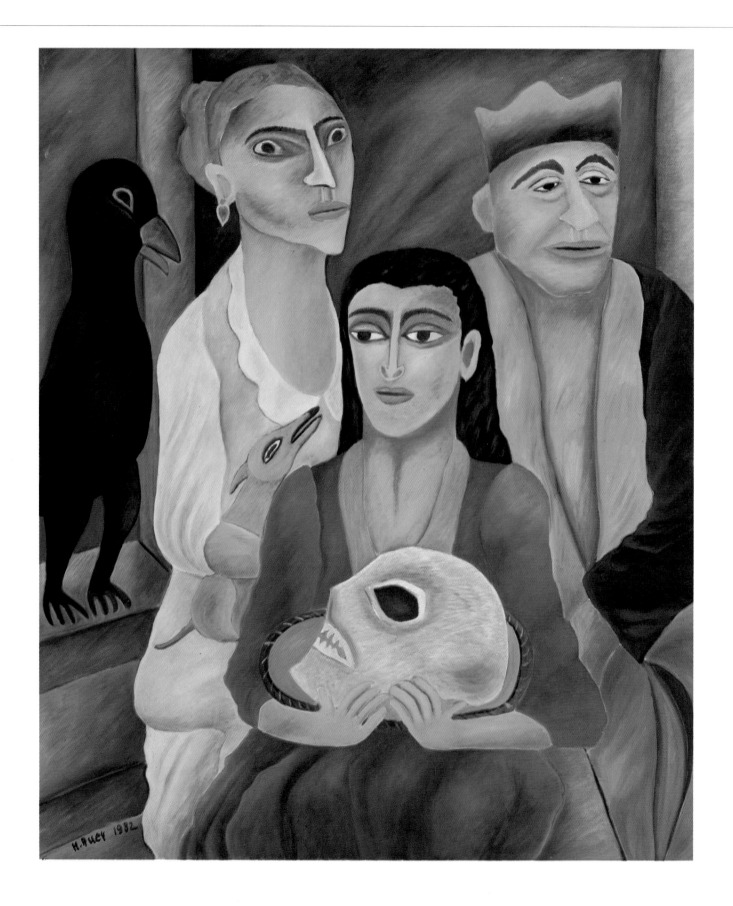

After the Dance (Salomé), 1982
oil on canvas 95 by 80 cm

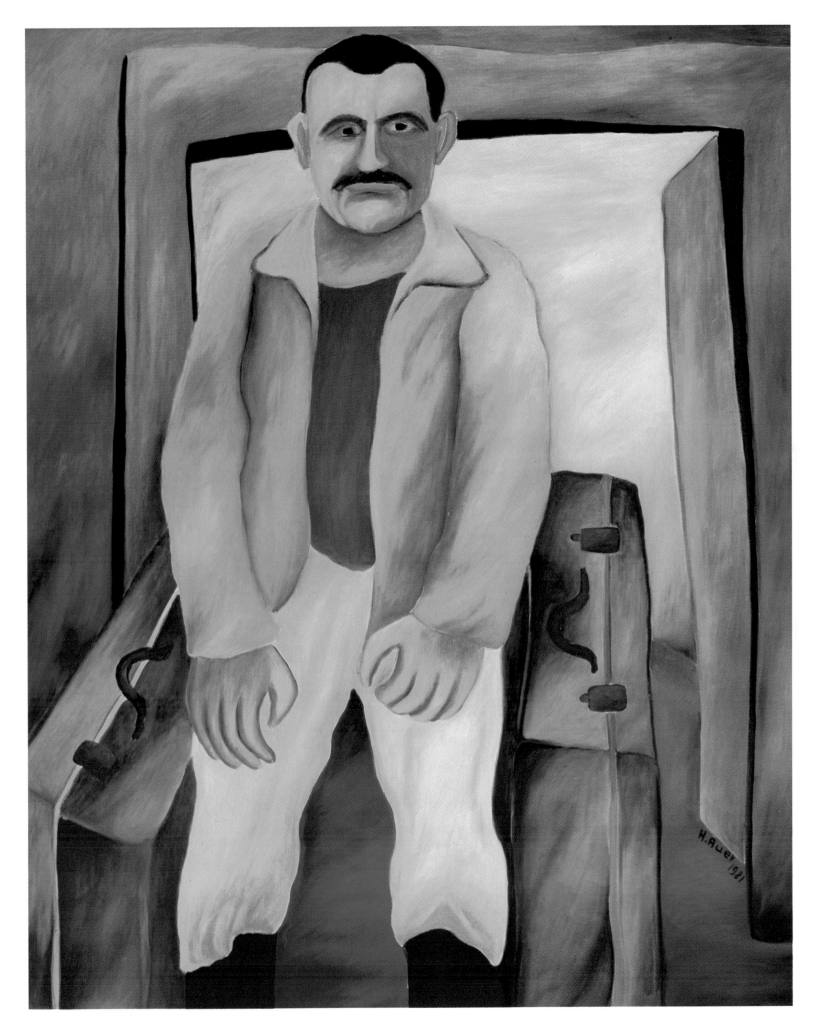

Man with Suitcases, 1981
oil on canvas 105 by 90 cm

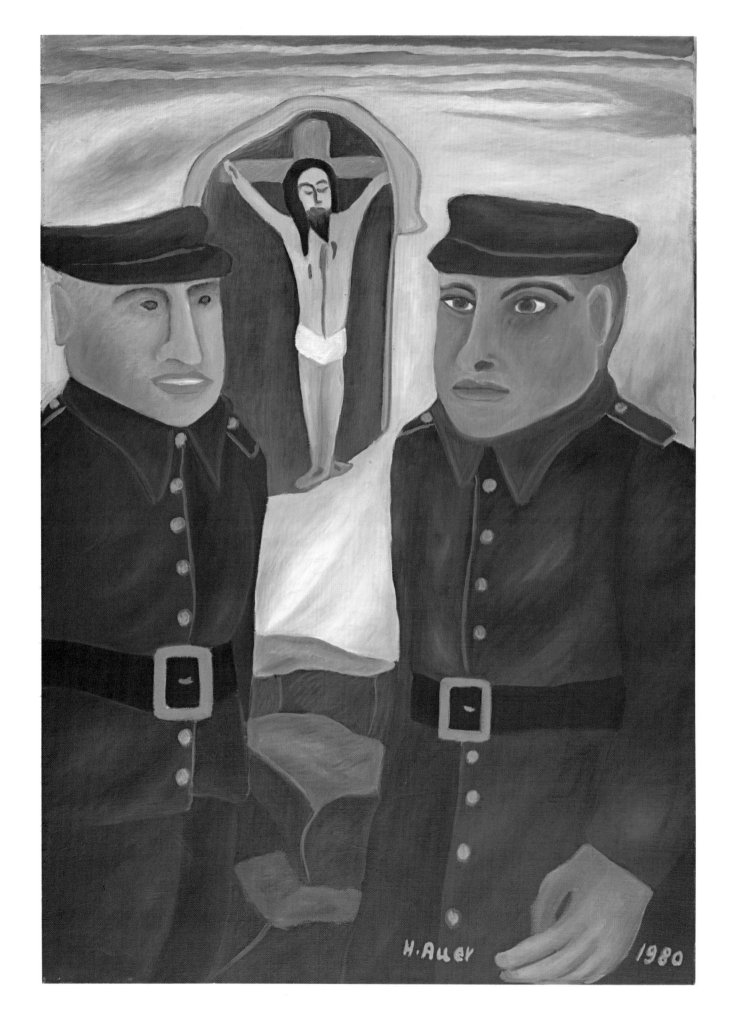

Border Station, 1980
oil on canvas 70 by 50 cm

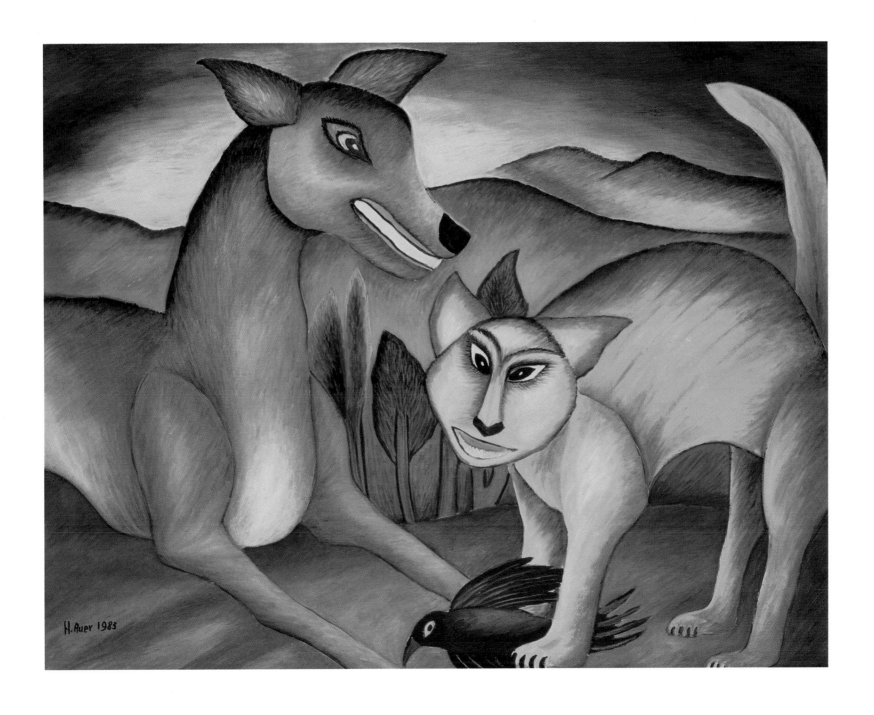

A Dog, a Cat and a Bird, 1983
oil on canvas 70 by 85 cm

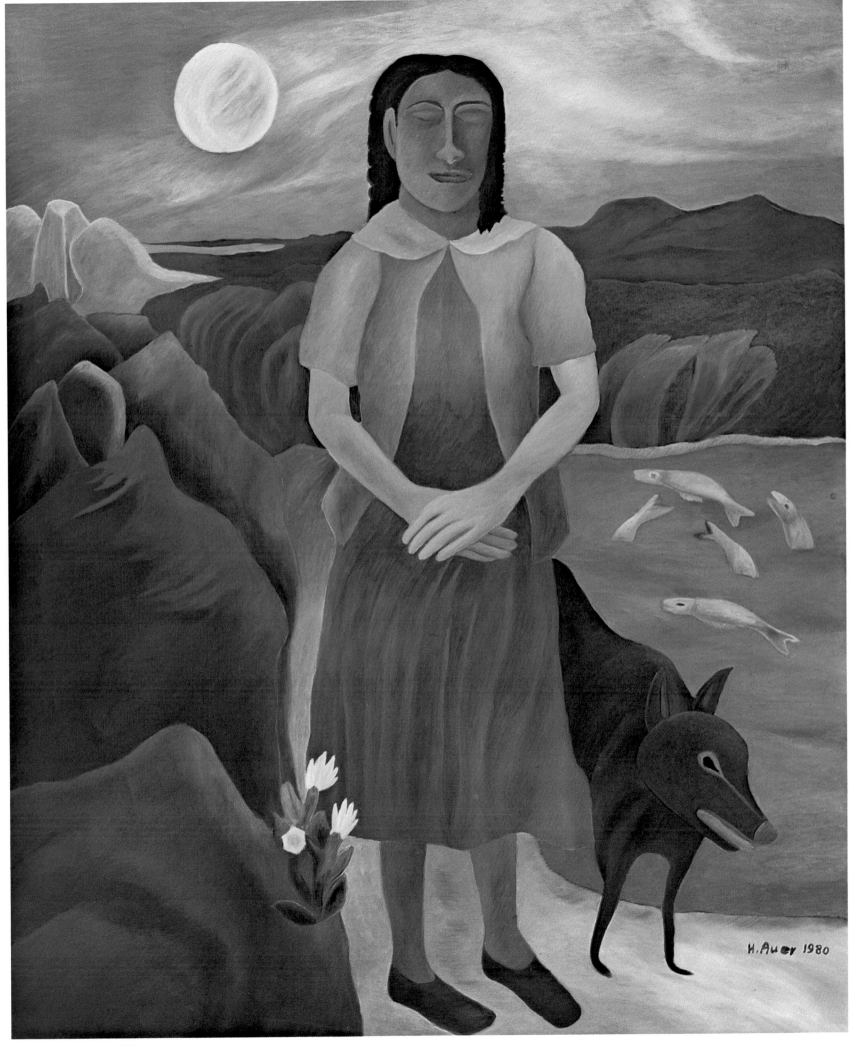

The Sleepwalker, 1980
oil on canvas 125 by 105 cm

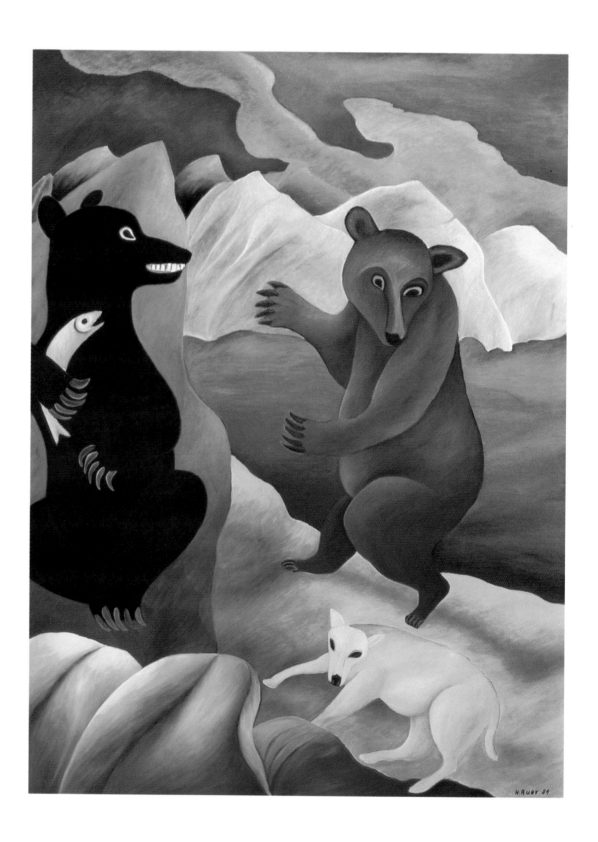

Alaska Festival (Triptych, left panel), 1982
oil on canvas 120 by 90 cm

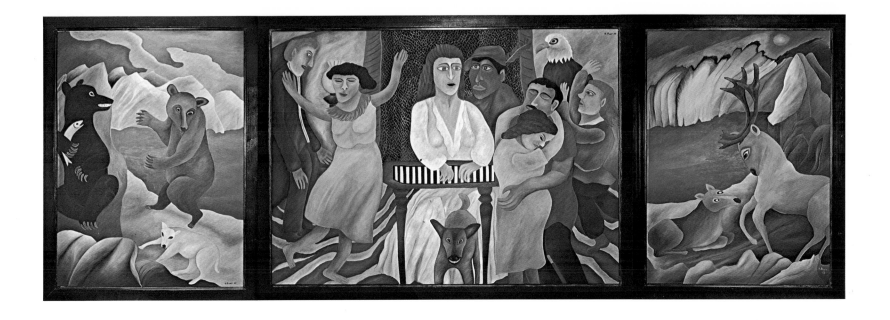

Alaska Festival
Triptych (entire view)

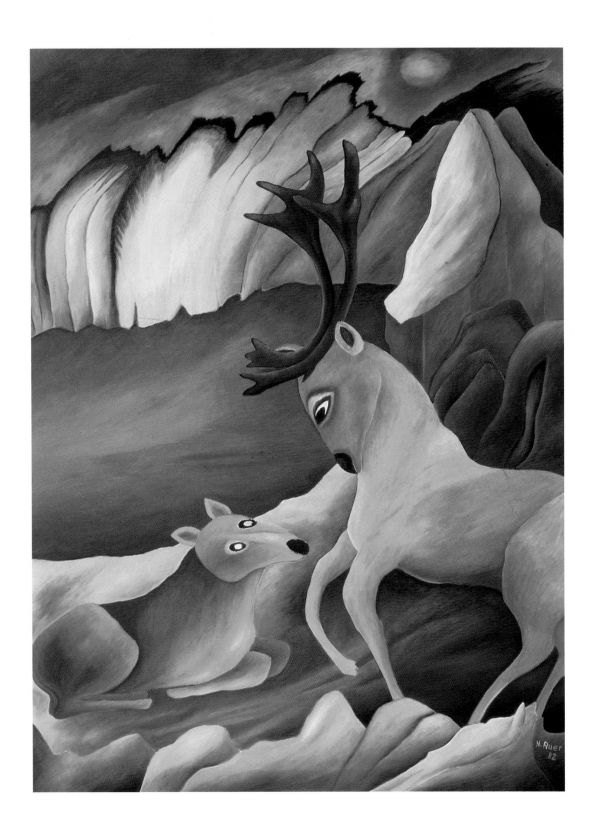

Alaska Festival (Triptych, right panel), 1982
oil on canvas 120 by 90 cm

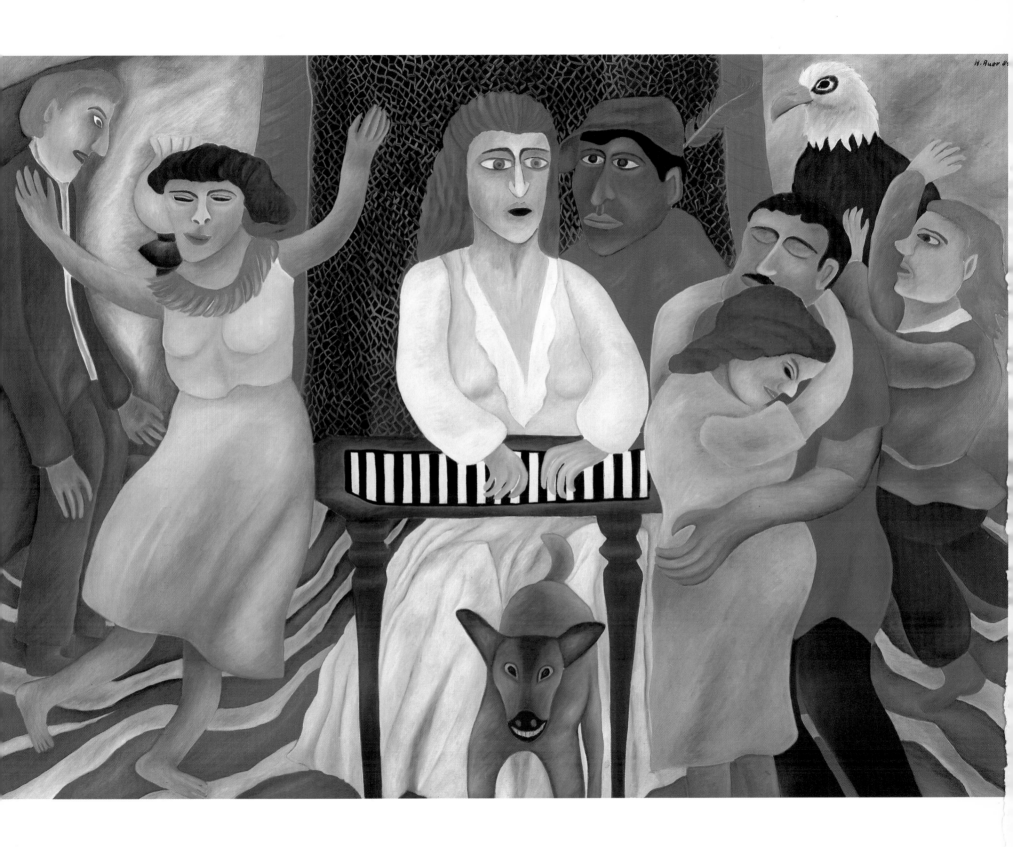

Alaska Festival (Triptych, center panel), 1982
oil on canvas 120 by 170 cm

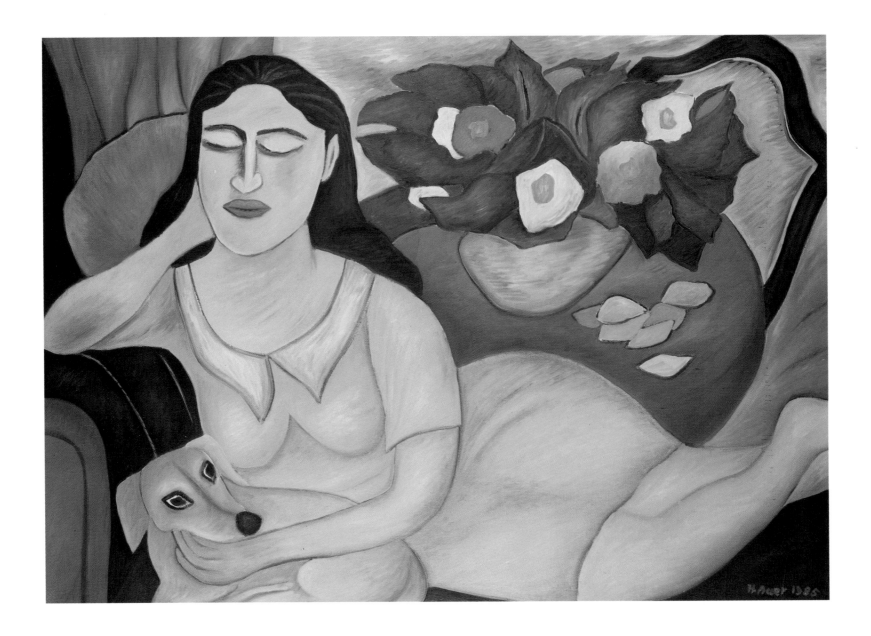

Lady with Dog on a Divan, 1985
oil on canvas 70 by 100 cm

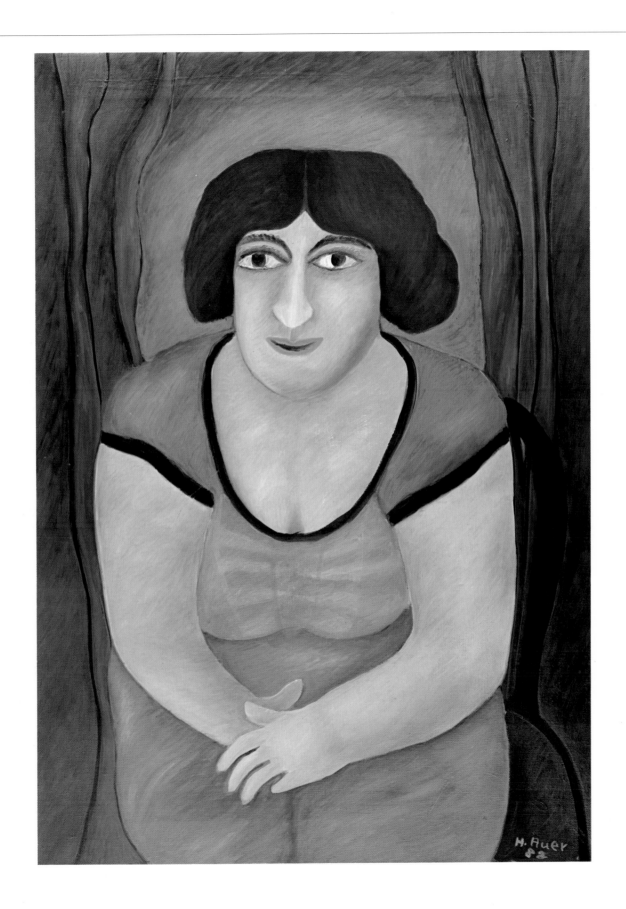

Mrs. Morrison Plots Revenge, 1982
oil on canvas 70 by 50 cm

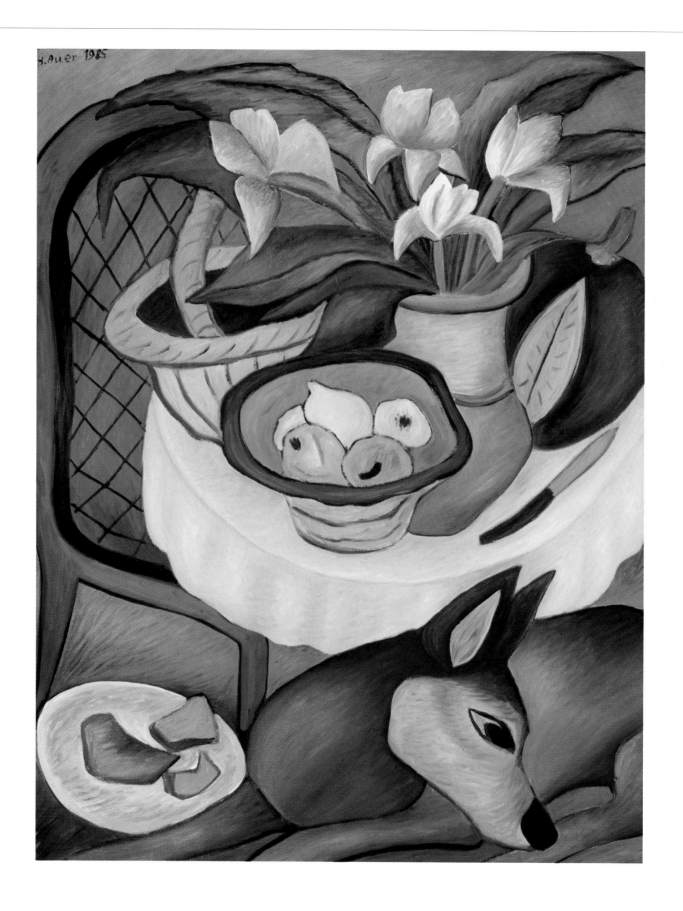

Garden Still Life with Dog, 1985
oil on canvas 90 by 70 cm

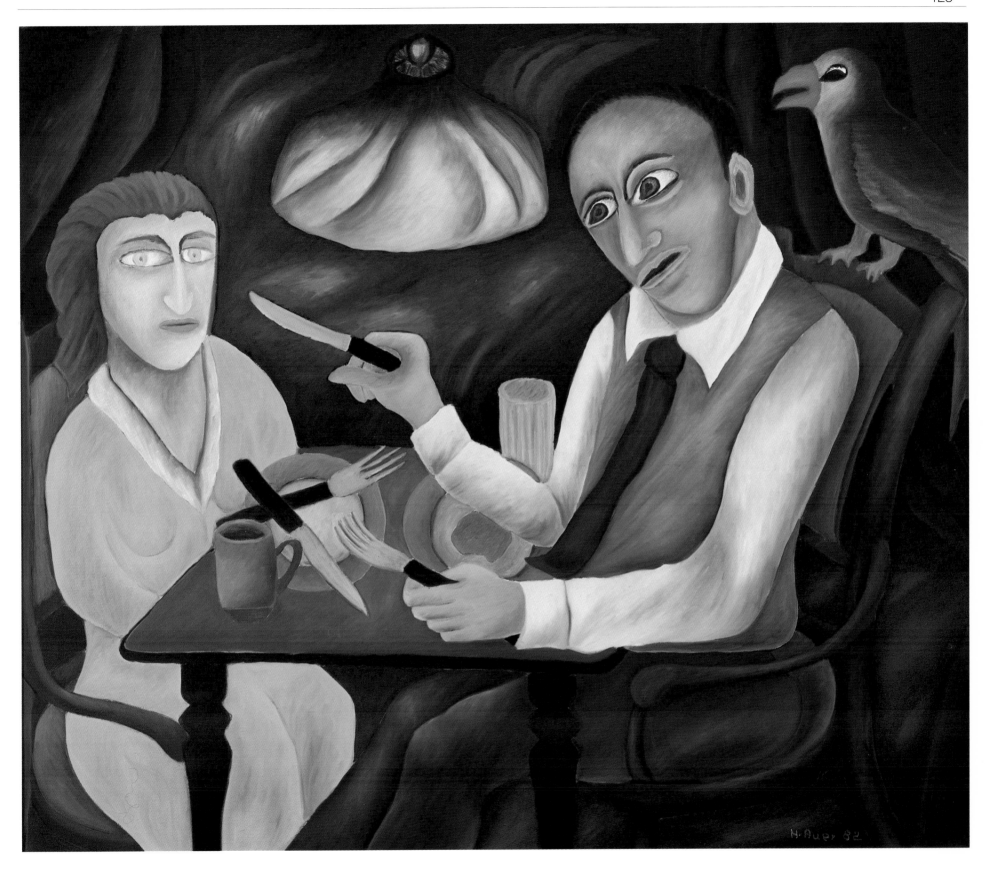

Tabletalk, 1982
oil on canvas 80 by 95 cm

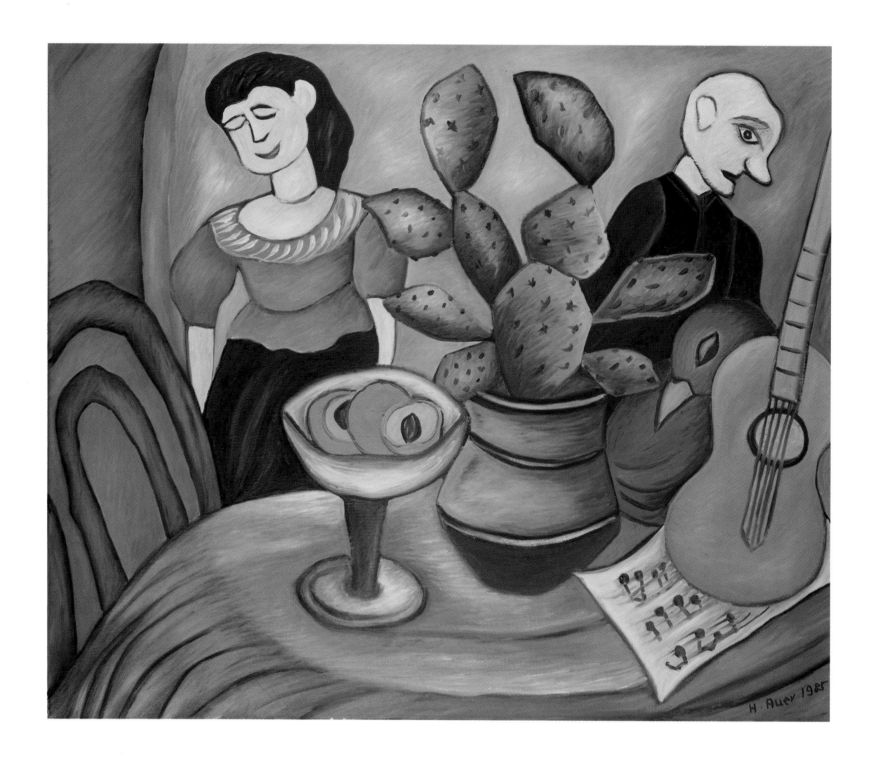

Still Life with Figures, 1985
oil on canvas 75 by 90 cm

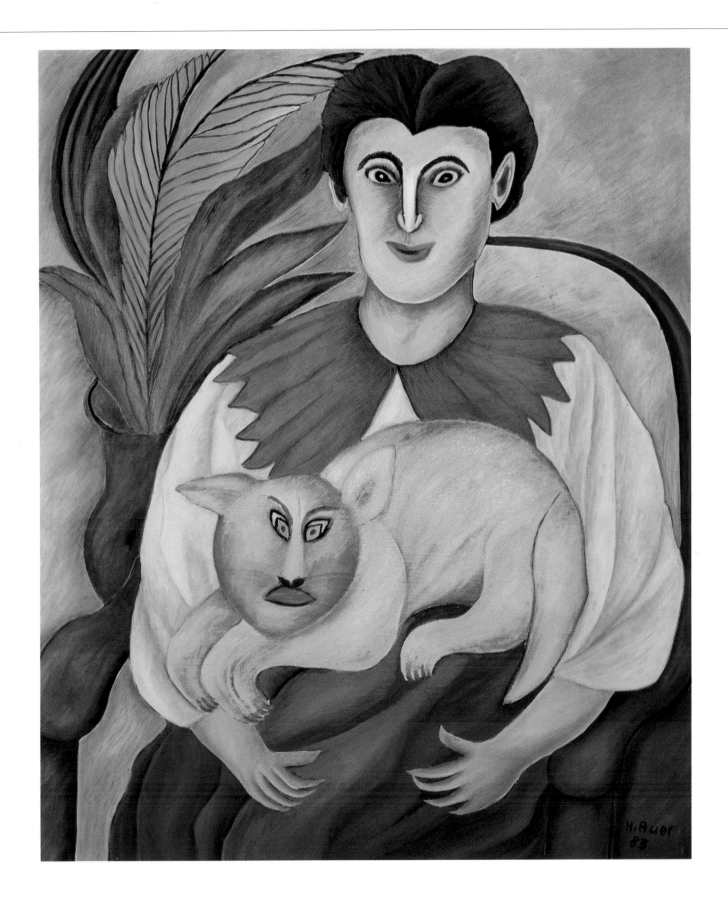

Woman with Yellow Cat, 1983
oil on canvas 90 by 75 cm

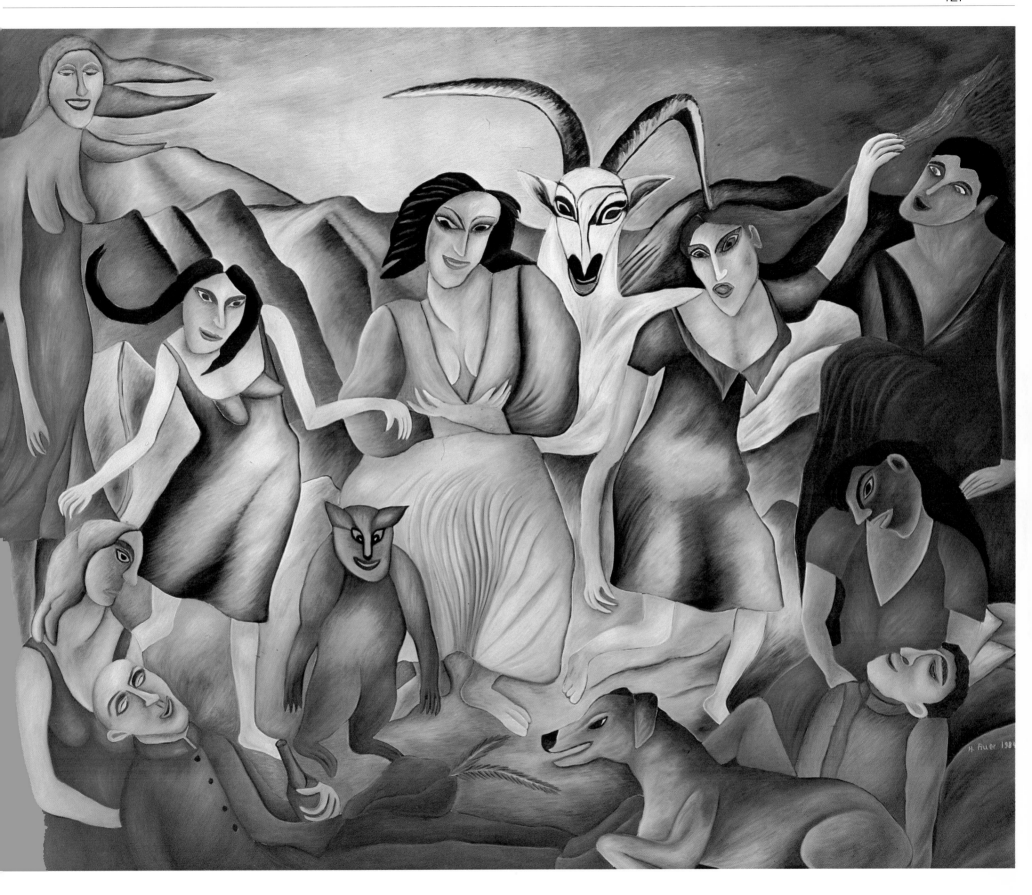

Witches' Sabbath (Walpurgis Night), 1984
oil on canvas 200 by 250 cm

Cathedrals of New York, 1984
oil on canvas 80 by 60 cm

After the Fall, 1985
oil on canvas 120 by 90 cm

Still Life with Cat and Ears of Corn, 1985
oil on canvas 60 by 80 cm

H.Auer 1984

The Guarded Object, 1984
oil on canvas 70 by 60 cm

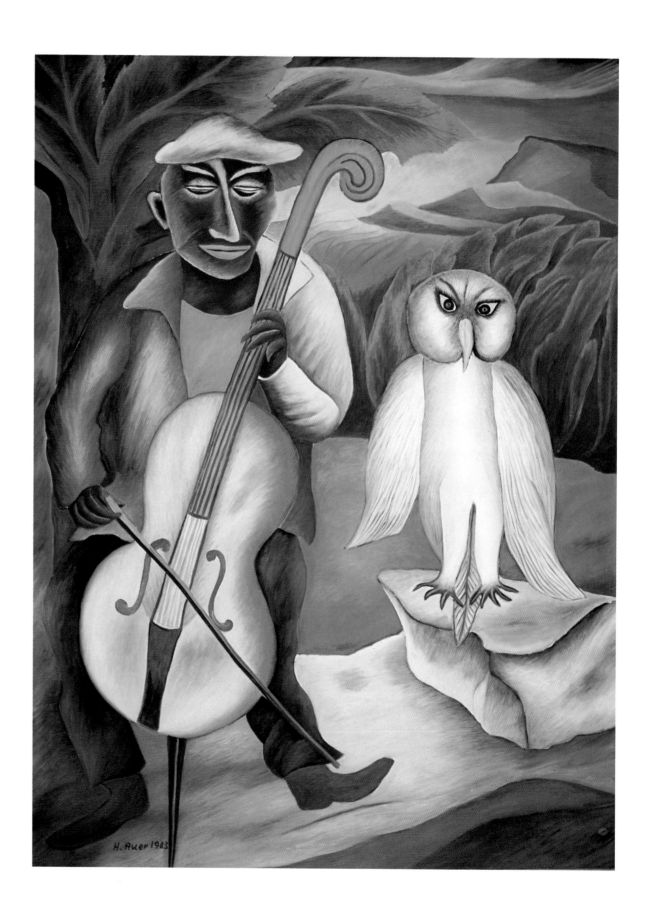

The Power of Music (Triptych, left panel), 1983
oil on canvas 140 by 105 cm

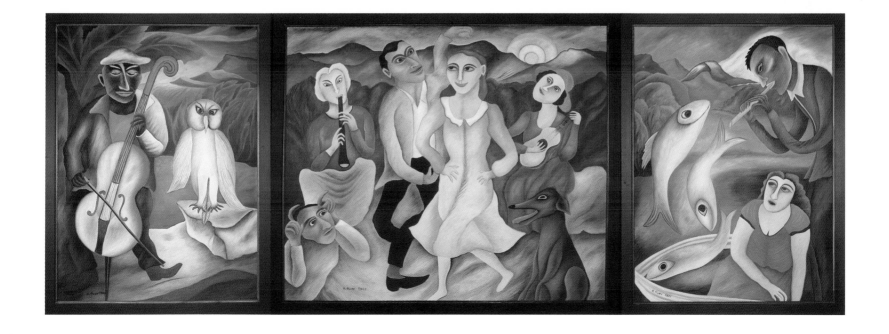

The Power of Music. Triptych (entire view)

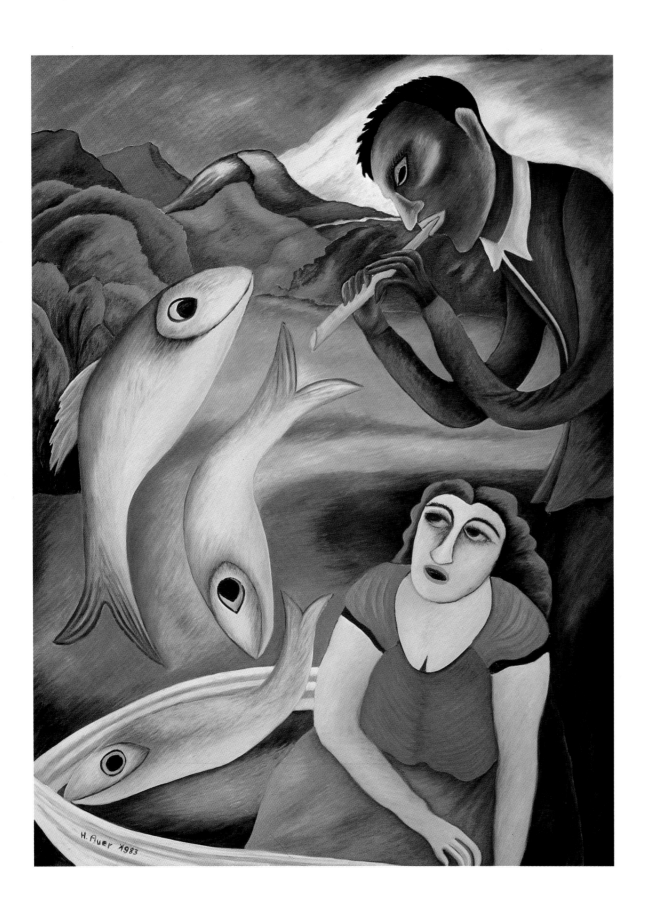

The Power of Music (Triptych, right panel), 1983
oil on canvas 140 by 105 cm

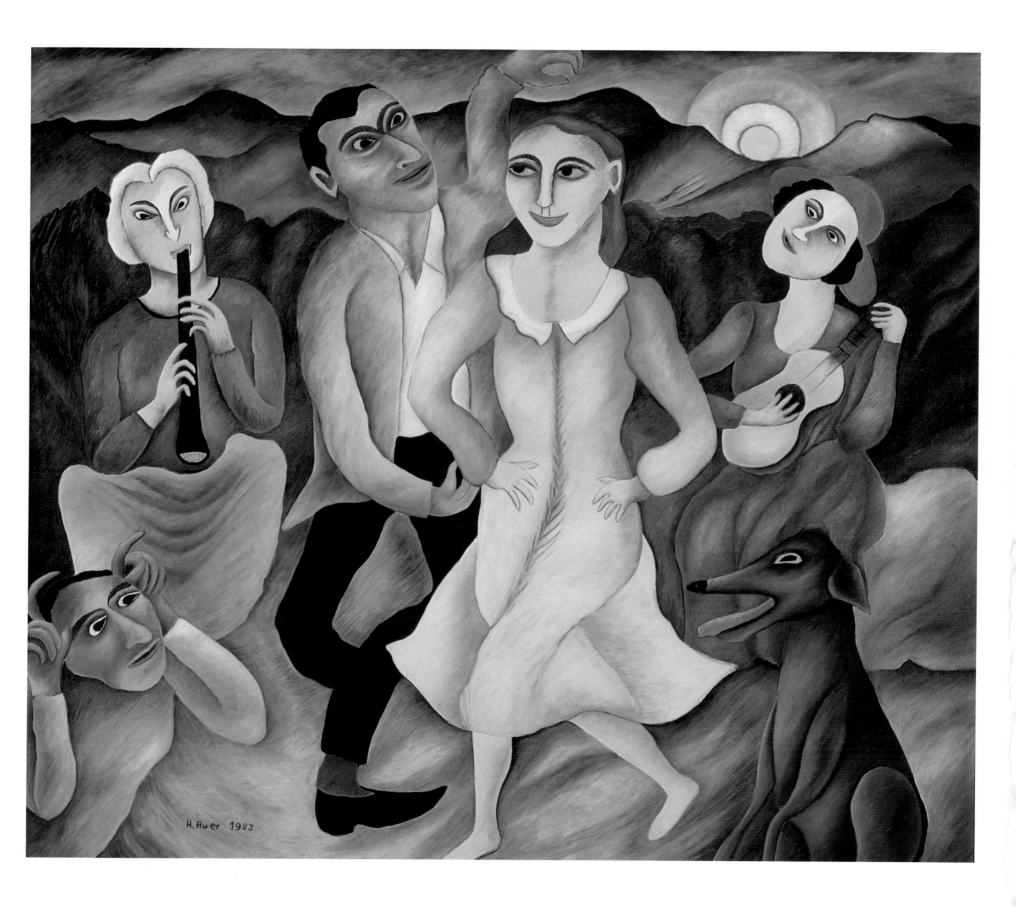

The Power of Music (Triptych, center panel), 1983
oil on canvas 140 by 170 cm

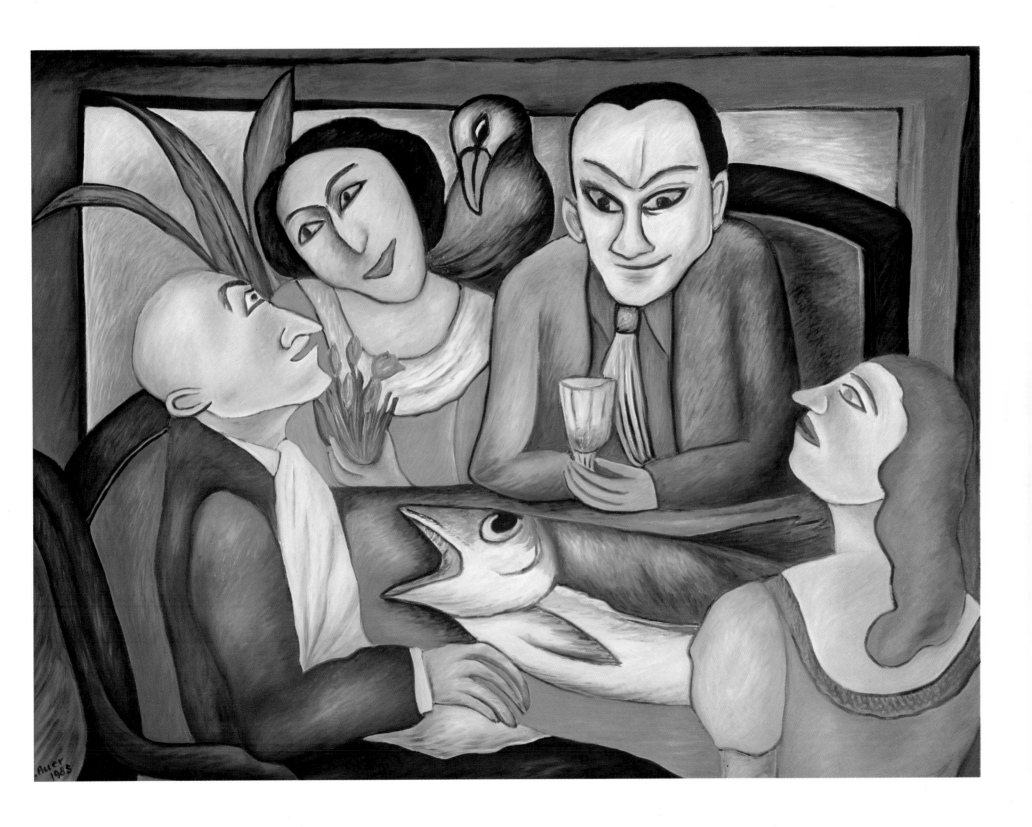

The Big Fish, 1985
oil on canvas 90 by 120 cm

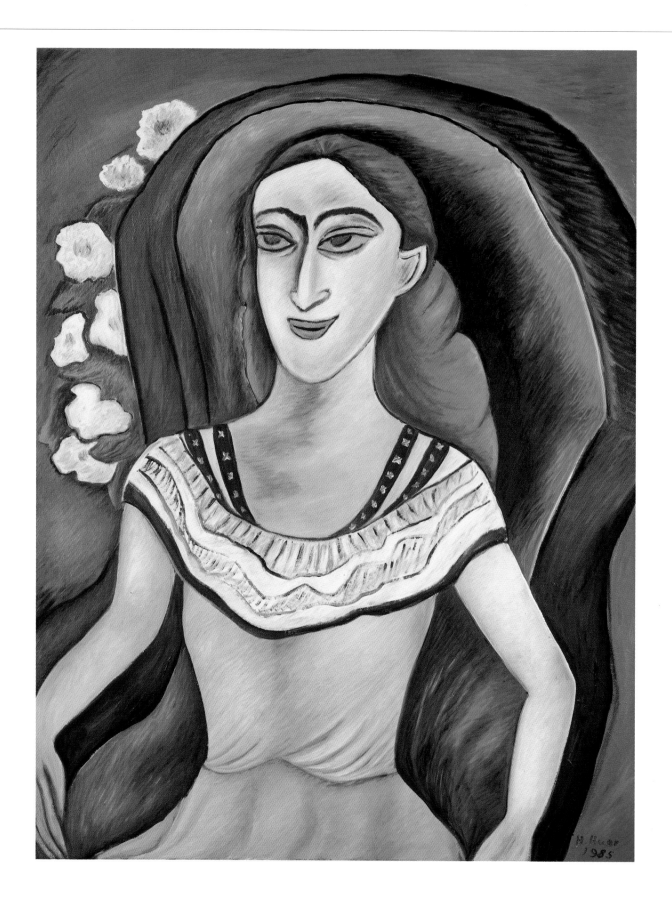

The Princess of Chicago, 1985
oil on canvas, 90 by 70 cm

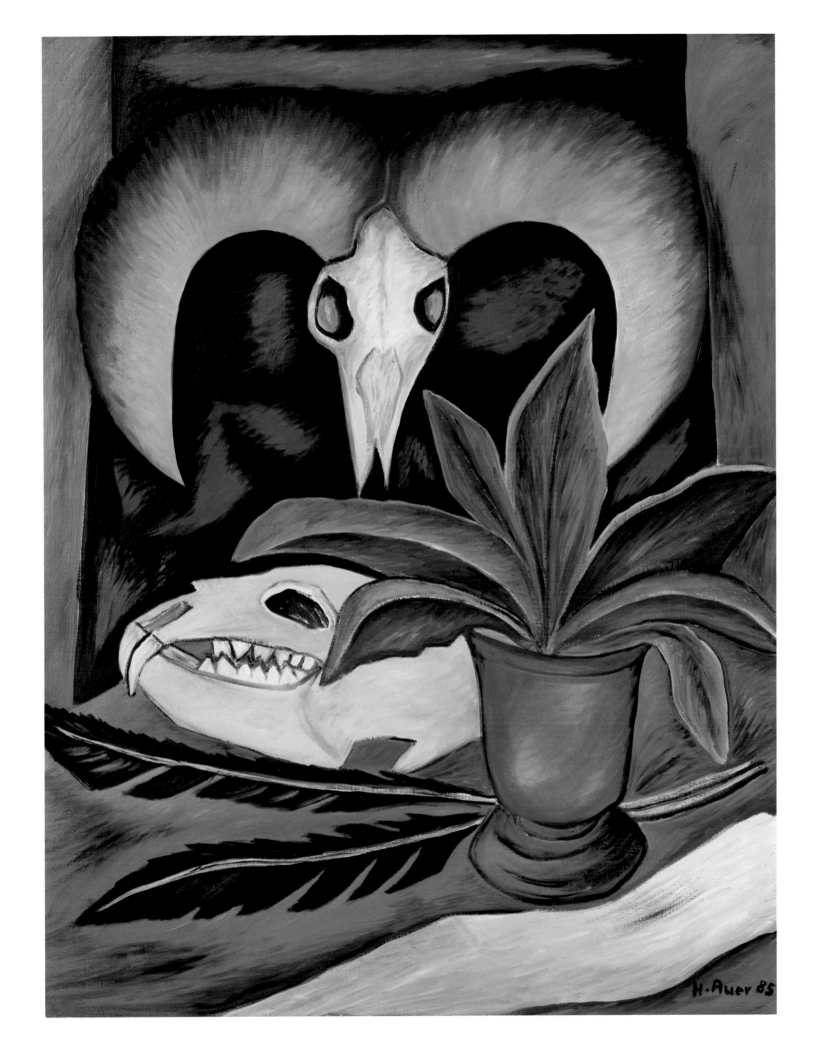

Still Life with Hunting Trophies, 1985
oil on canvas 90 by 70 cm

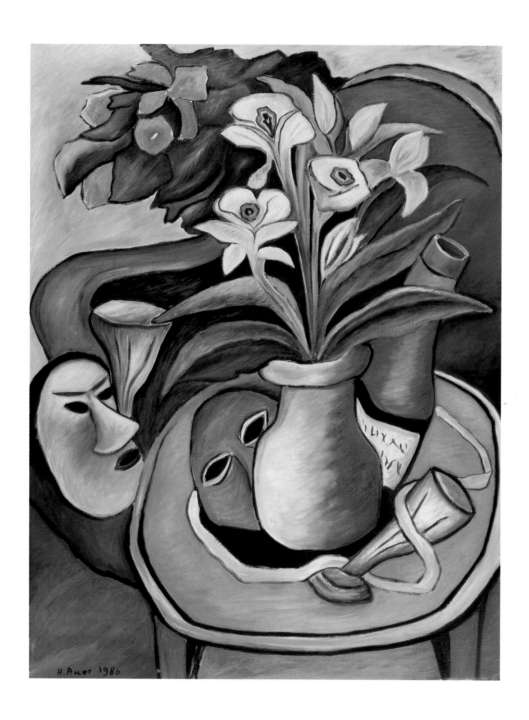

Still Life "Ash Wednesday", 1986
oil on canvas 90 by 70 cm

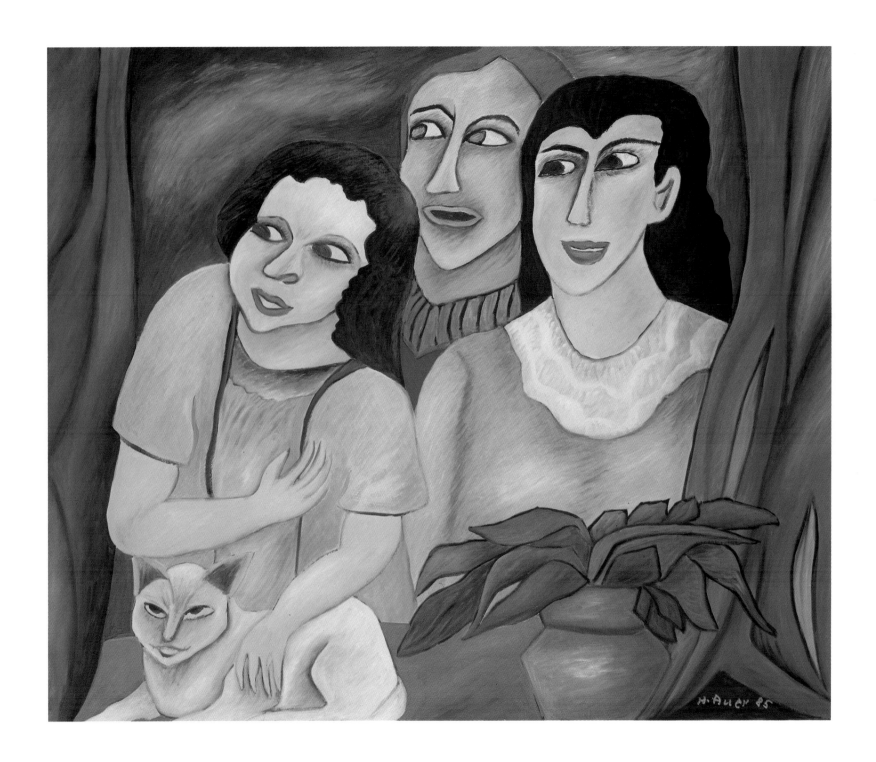

Three Women at the Window, 1985
oil on canvas 75 by 90 cm

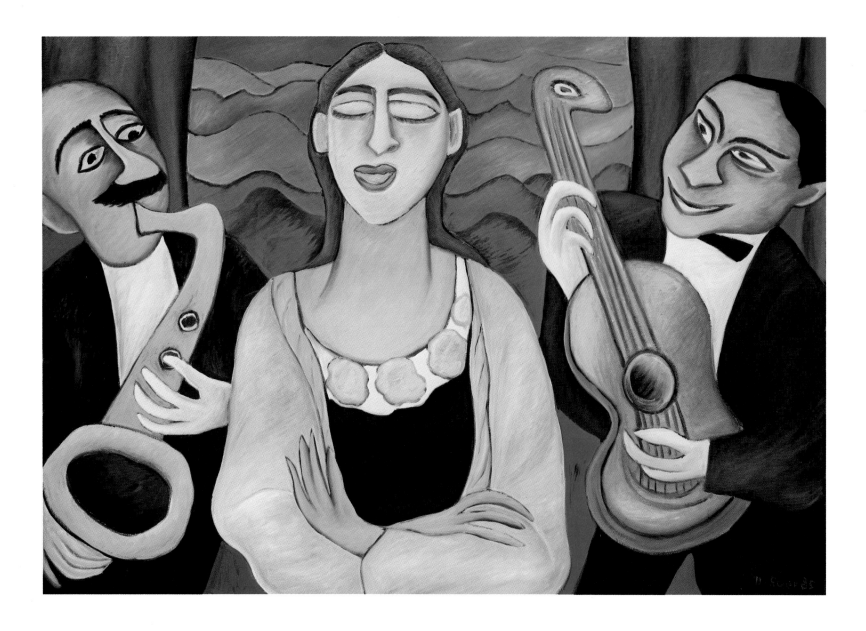

Love Song, Bittersweet, 1985
oil on canvas 70 by 100 cm

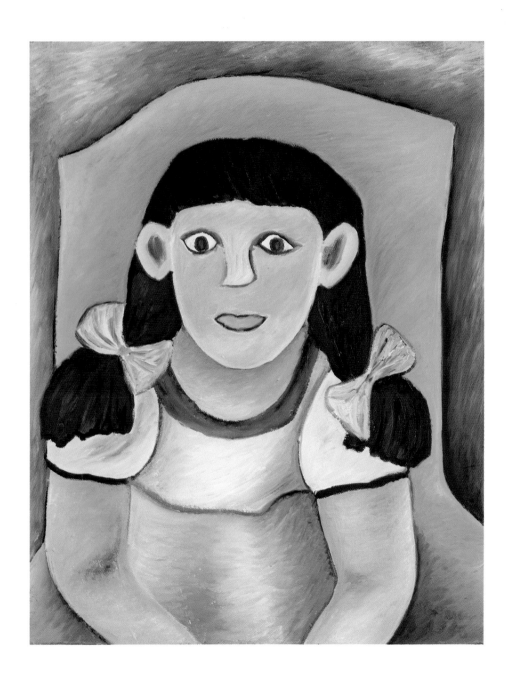

Child, 1986
oil on canvas 50 by 40 cm

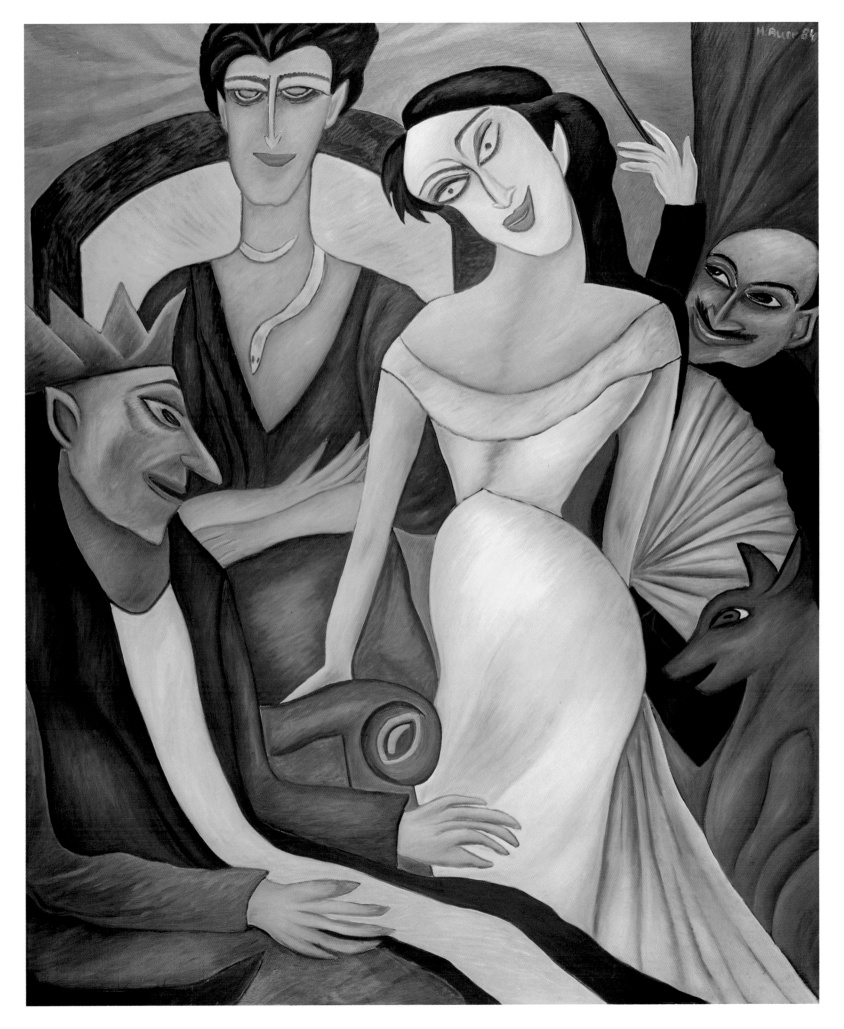

Salomé Dancing in front of the King, 1984
oil on canvas 125 by 105 cm

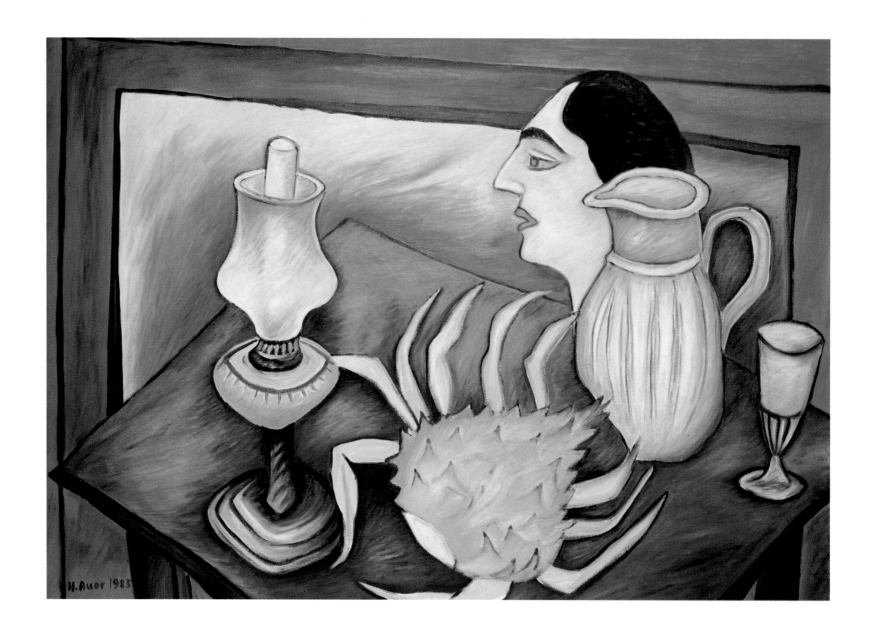

"Forward", Still Life with Ship's Figurehead and King Crab, 1985
oil on canvas 70 by 100 cm

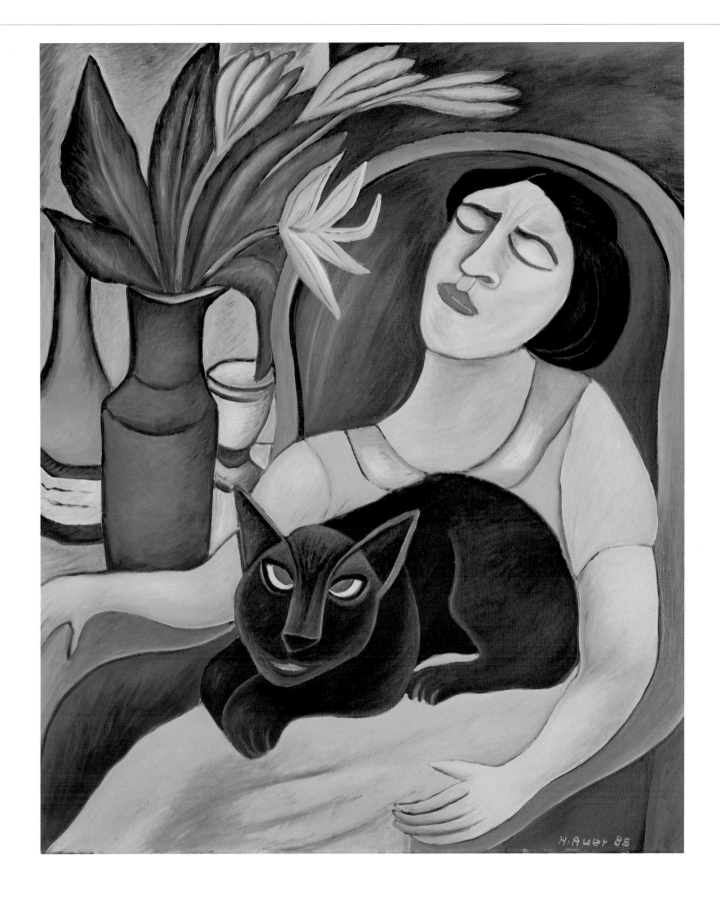

Nightmare, 1985
oil on canvas 90 by 75 cm

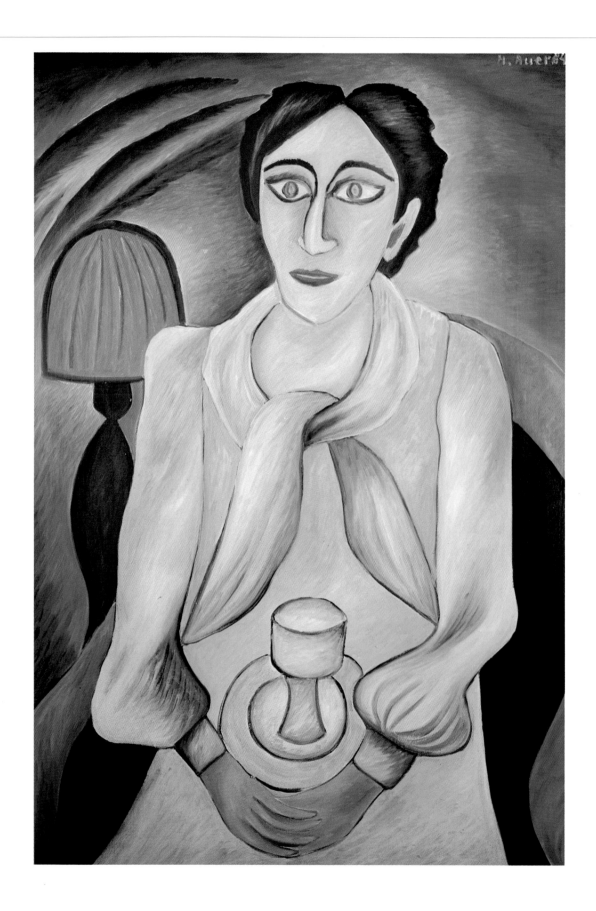

A Lady, Waiting, 1984
oil on canvas 100 by 70 cm

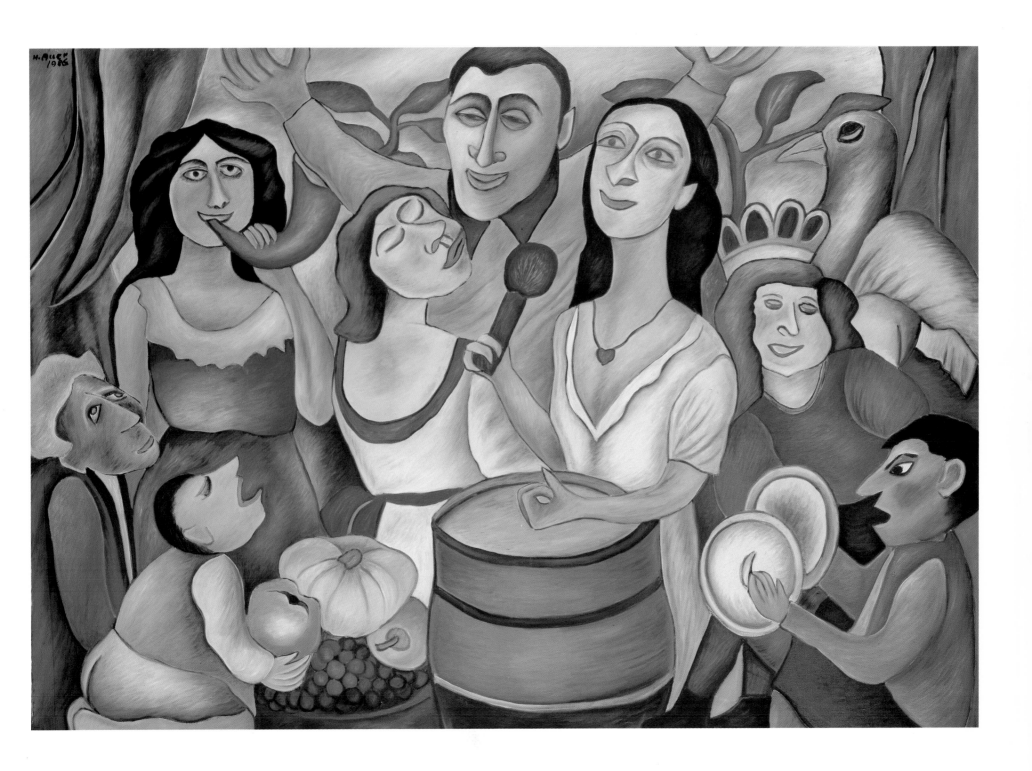

Rousing Welcome, 1986
oil on canvas 140 by 170 cm

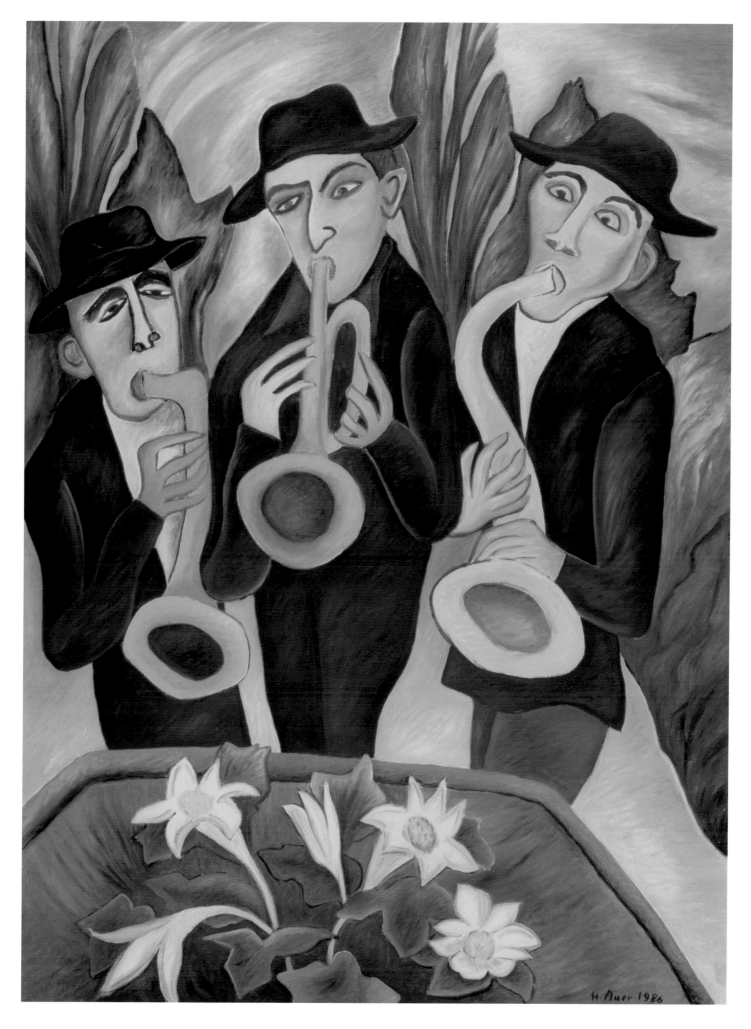

The Brass Players, 1986
oil on canvas 120 by 90 cm

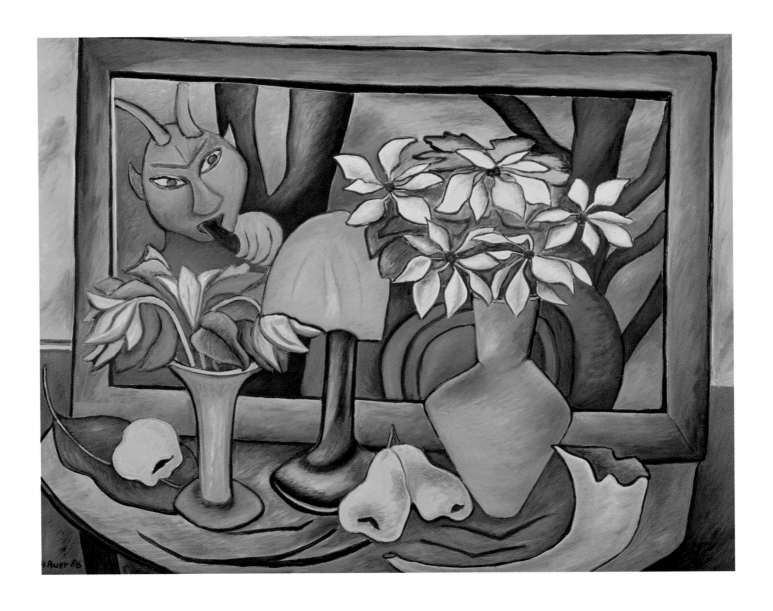

Still Life "Afternoon of a Faun", 1986
oil on canvas 90 by 120 cm

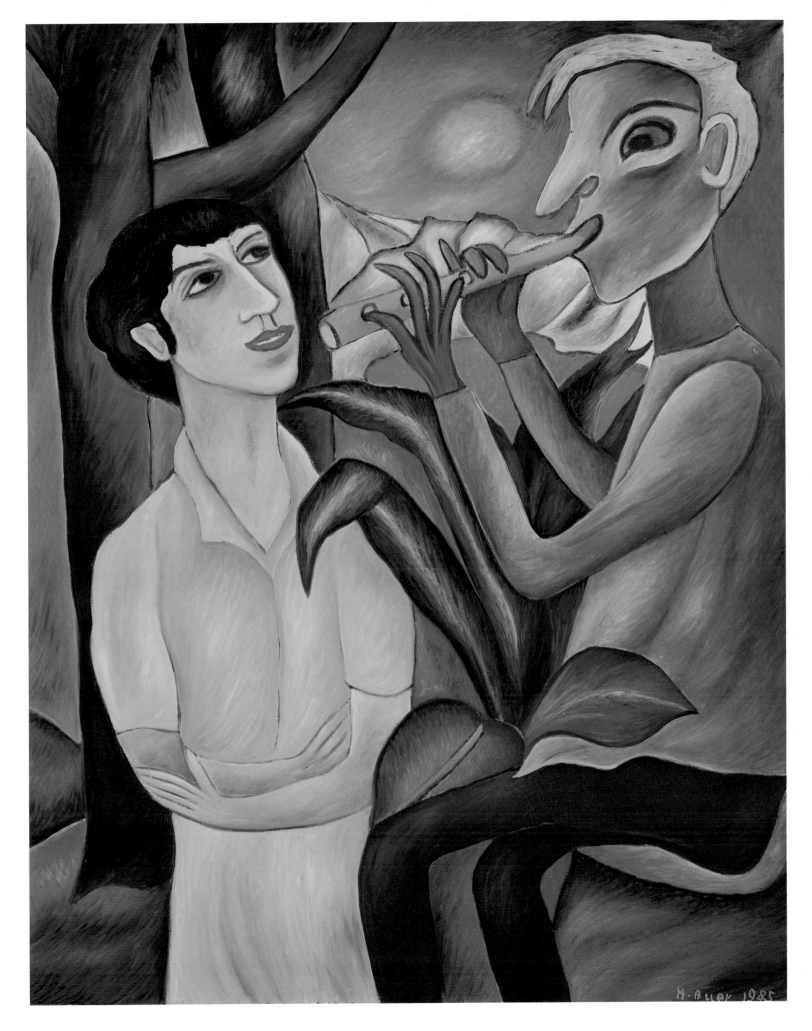

The Magic Flute, 1985
oil on canvas 105 by 85 cm

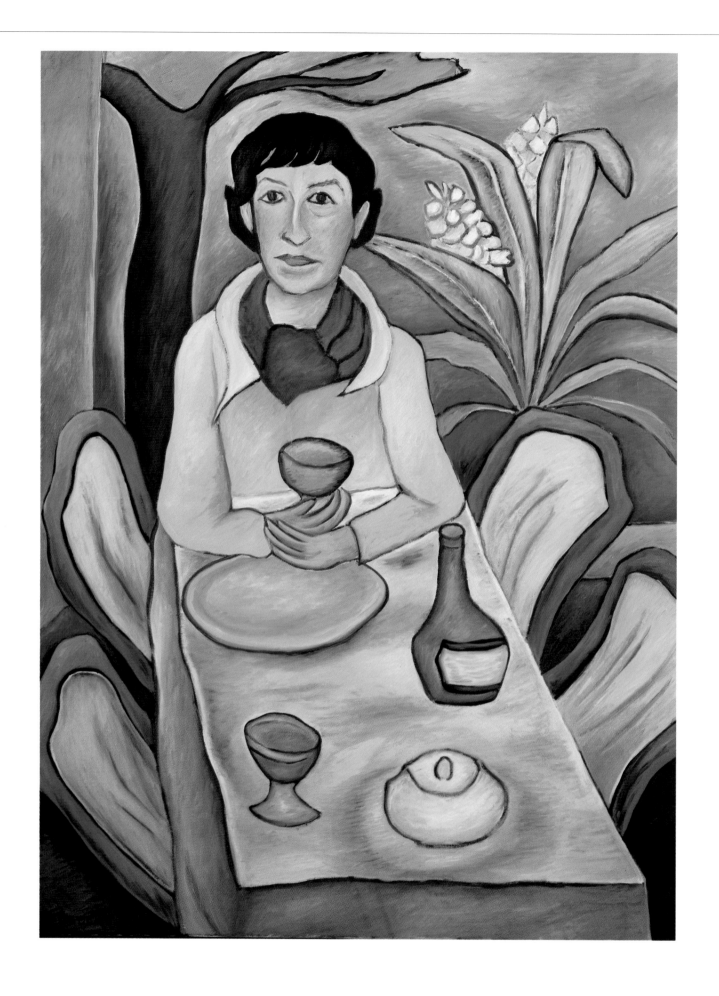

Dinner, 1986
oil on canvas 120 by 90 cm

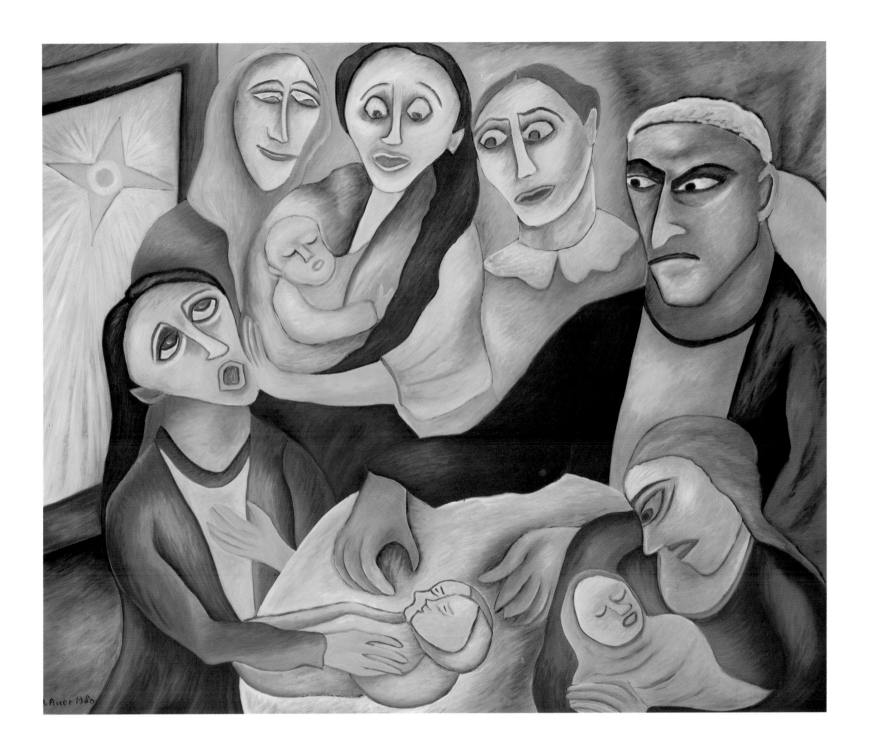

King Herod and the Mothers, 1986
oil on canvas 105 by 125 cm

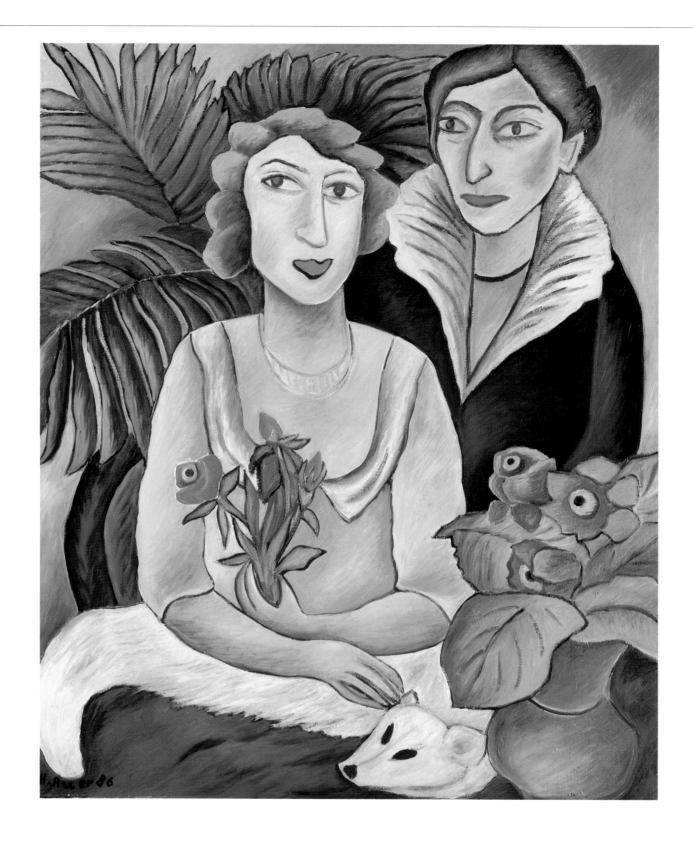

Two Women, 1986
oil on canvas 95 by 80 cm

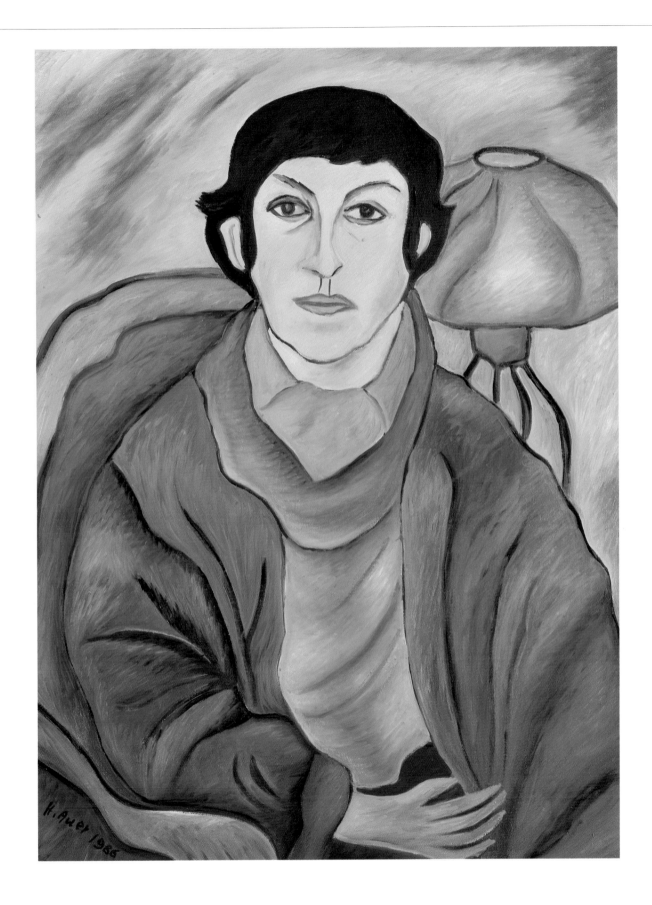

Self Portrait, 1986
oil on canvas 80 by 60 cm

# IV  Freedom Enchained

Beginning in 1971, Auer launched on a series of paintings that depict a man and a woman together in a close relationship based on his domination over her. *Summer in the North* (Oeuvre cat., No. 17) uses the intense vegetal growth of the Northern Canadian wilderness as a backdrop for the stiffly posed couple who gaze out at the viewer. The central and tallest figure is the dark haired man wearing a checked coat with white fur collar and ballooning striped pants. In his heavy, almost crudely painted left hand he holds a bird by its neck while to his right there is a dog with a chain around its neck. At his feet reclines a woman; blonde and buxom, clad in a multicolored horizontally–striped dress, which accentuates the curves of her body, she holds a branch filled with berries in her right hand. Birds huddle around her, as if seeking protection within her skirts, and yellow flowers cluster closely about her head, contrasting to the pink-violet thistle blossoms that extend from behind the man's broad shoulders out into the landscape. Standing spread-legged above the woman, the man in his geometrically patterned clothing emerges as a dark, alien presence in a landscape of verdant hills and valleys which seem to duplicate the contours of the reclining woman.

In 1977, two related paintings were created: *Mr. Kortoma with White Grouse* (p. 90) and *Mr. Kortoma Has a Party* (p. 98). The inspiration for these paintings is a short story, "The North", by the Russian writer and critic Yevgeny Zamyatin. First published in 1922, "The North" is set in a small village in northwestern Russia. Kortoma is the village's sole shopkeeper, whose account books keep a record of just what is owed him, as well as a record of just which vil-

lage wives have "visited his upstairs office." Reducing accounts in return for sexual favors, Kortoma subjugates and humiliates all who deal with him. The story concentrates on his relationship with a young red-haired Lapp girl, Pelka, who arrives in the village shortly before Midsummer Night. Rejecting Kortoma's approaches, Pelka becomes the bride of another villager. Gradually she gives up her Lapp customs, and at a party yields to Kortoma after he has presented her with a silken green dress. Pelka dies shortly thereafter in the arms of her dying husband, the two killed by a bear injured after being shot with a gun which Pelka had improperly loaded.

It was not the love triangle that Auer found memorable in Zamyatin's tale, however. Instead, she focuses on Kortoma's neglected and oppressed wife, Kortomikha. Kortomikha appears persistently in "The North," witnessing her husband's infidelities without protest, comforting him when Pelka slaps his hand with a ruler, only to be shaken off and shoved against the counter "like a flabby, empty glove." Zamyatin described her in his story as the visual equivalent of a composite of collapsed convexities:

"The innards have been taken out of her, and her cheeks are sunken forever, and the chest is hollow. But her hat is pink, with flowers, and the pink hat makes it still more painful to look at her. Between the wrinkles at the corners of her lips there is a smile, and the smile is even more painful than the hat. Kortomikha always comes to the store dressed up, in the pink hat, in gloves, in a smile. This is her husband's order: 'Let everybody see you're not just anybody.'

Pink and withdrawn, in the shadows with her hands demurely and obediently folded in her lap, Kortomikha is seated in the background of *Mr. Kortoma Has a Party,* smiling as she regards the person she considers "the best man in the world." Contrasting with her thinness and flatness is the figure of Kortoma in the foreground. Wearing a yellow-brown, fur-collared frock coat, he seems with his green eyes to be gazing beyond the confines of the painting. There is a smirk on his lips, as he grasps a glass with one hand and encircles an orange with the other. Expansive in color and form, he has not only pushed his wife to one side but also another woman—perhaps Pelka—who is disappearing between table and chair, incapable of sustaining herself against the oppressive male presence so near her.

A similar composition and situation appear in the other 1977 painting, *Mr. Kortoma with White Grouse.* Here the man is seated, green-eyed and smirking, at a table in the foreground. Like the man in *Summer in the North,* his hand is clamped around the neck of a bird, squeezing the life out of it slowly but persistently. The white grouse, like the birds in other Auer paintings, is a symbolic emblem for woman, serving here to represent Kortoma's cruel subjugation of his wife and others, but it is also, according to Auer, a symbol for nature, which Kortoma also abuses. At Kortoma's side, but almost pushed out of the painting, is Kortomikha in profile, dressed in pink-violet, and wearing a pink hat; she looks intently at her husband, separated from him by the expansive gesture with which he embraces the space in the painting. Between the two, the figure of Kortomikha again appears, here as a projection of her thoughts. In this, she

stands in a doorway, with her back to store, house, and husband, facing a snow-filled nocturnal landscape in which spots of vegetation glow blood red. Having finally determined to leave her tormenter, she stands totally listless, motionless, as if the act of leaving was sucking from her what little life she has and depriving her of all energy, depriving her even of her malleable personality. It is the beginning of a sequel to Zamyatin's story as Auer conceives it.

The analogy, between Kortomikha and Auer herself as both seek to leave the protective but also dominating—and possibly domineering—milieu which formed their lives, giving them shape, cannot be overlooked. Both women—Kortomikha as Auer would have her leave Kortoma, and Auer herself as she left the Eisenmann firm—are alone, a situation foreign to them as they face an unknown and perhaps threatening future. Despite this, the self-emancipation is necessary to each; psychologically, their escape was the unavoidable, sole means of preserving or re-creating their individual personalities. Auer had already visualized the image of a liberated but isolated Kortomikha in 1975, two years before the paintings of Kortoma the oppressor. *Mrs. Kortoma* (Oeuvre cat., No. 43) stands stiffly in the foreground of the painting, surrounded by a snowy moonlit landscape at the edge of a river. Her violet dress, hanging straight down on her featureless figure, sets Kortomikha off sharply against the blues and whites of the landscape, and her pink-white hat disrupts the cohesion of the cloud-filled sky. Her alienation and isolation are thus compositionally asserted as she stares outward with shaded eyes that yet catch the gleam of the moonlight. Auer decreases the degree of isolation, however, and offers

hope by granting Kortomikha the company of her emblematic birds: three white grouse accompany her, their colors and forms blending with the snow-covered ground even as she herself stands out against it. The birds symbolically seem to promise a more natural and freer future, no longer in the grasp of her husband. And on Kortomikha's shoulder, as if about to whisper instructions into her ear, is an owl, the traditional bird of wisdom, which is also at home in the nocturnal land which the woman must traverse. Because Auer herself was planning her retirement from the Eisenmann firm and faced both the freedom and anxieties of her departure from it, the painting of Kortomikha constituted a personal promise to herself, a reassurance about the future while affirming it as anxiety-generating.

Even when not depicting, with a certain obsessiveness, the two protagonists in Zamyatin's short story, Auer repeatedly turned during this period to the theme of repression and domination. In *The Tyrant* (1978, Oeuvre cat., No. 73), Auer's vision of the salesman who had employed her briefly after World War II ended and who had frightened her with his apocalyptic prophecies, the facial features of Kortoma again appear, a personification of modern psychological repression and its death-dealing powers. Even more related to the Kortoma compositions is *The Protector* (1976, p. 89), a work of claustrophobic compression in which, as has previously been pointed out, the figures of a man and a woman are pressed irreversibly together. Instead of grasping the neck of a bird as Kortoma does, however, "the protector" presses his heavy hand down on the shoulder and breast of the white-clad woman, placing her under a grip deadly in its possessiveness.

The enclosing walls of Kortoma's cabin and store have here been replaced by an abstract form that adds to the confining sense of the painting, enforcing the bend in the man's arm as he presses the oversized fleshiness of his hand down on the diminutive, decorative presence of the woman, the pattern of whose clothing seems reminiscent of those in Matisse's Moorish odalisques of the 1930s. The hint of an interior, abstract as it is, likewise reflects the style of the 1930s with its rounded corners, heavy curtains, and deep-hued wall coverings. The distancing that Auer created by finding a Russian story of woman's subjugation and for which she provided an Alaskan setting is here accomplished by projecting the scene into the past, beyond the reach of the present. The result is to disguise the reference to Auer's own self-perception as her position in the firm had become an intense barrier to her from which she was seeking release.

Kortoma and "the protector" are images drawn from deep within Auer's conflicting emotions as she proceeded in her conversion from industrial manager to woman artist. The same conglomerate of conflicts must underlie one of her most baffling compositions, *The Barrier* (1978, Oeuvre cat., No. 69). When asked about it, her only interpretive comment was that one must set barriers in order to prevent everyone from gaining access. But the statement fails to explicate the quasi-surrealistic composition even as it elucidates the painting's essential meaning. Unlike most of Auer's pictures, the painting defies the logic of narration, boldly mixing action and figure-scale to create an aura of absolute mystery. The setting is once again an Alaskan combination of rocky hills and shoreline with a body of

water: ocean, lake or river. In the foreground, dominating the painting, is a black-haired woman clad in intense red: consciously or unconsciously it is a self-portrait of Auer herself. In a ritualistic gesture the woman has placed a sheet of paper on a brown surface–a table top perhaps, or a mound of earth. On her shoulder lies a dog-wolf–the animal that in other works of this period was Auers personal totem–one paw resting on her breast. (In appearance and placement, the animal strongly recalls the fox in Paul Gauguin's *La Perte du Pucelage* [1891], but it is doubtful if this resemblance is in any way intentional.) Nearby, to the left, a small crowd of men and women have collected, innocuous witnesses to the mystical scene. Overlooking all, from behind the mountains, is a black Alaskan sea gull, its wings spread, its size overpowering as it is set off against a sky garishly flickering in tongues of white and purple-red. (If the dog-wolf recalls Gauguin, the bird recalls the work of the Belgian Surrealist René Magritte, an artist admired by Auer.)

The itemization of the painting's contents only increases its mystery, as does Auer's reluctance to discuss it in detail. It should be recognized, however, as bringing to conclusion Auer's series of images of transition and repression generated by anxieties over her career change and her father's death. While this psychological association is an intense and compelling one, in other respects *The Barrier* would seem to have little in common with *The Protector* or the Kortoma paintings. Other works of the 1976–78 period do however, share aspects of its imagery. The dog-wolf here identified with the self-portrait-like woman in red, for example, shares its identity in *North Station Street,* as well as in *The Guardian.* Sharing the same

concern about protective barriers, the latter painting particularly provides a suggestion for the further content of *The Barrier.* If *The Guardian* is seen as representing Auer guarding her newly constructed identity after her retirement from the firm, it is likely that *The Barrier* functions in a similar way. Auer herself guards her private world with its symbolic animals and landscape from external intrusion. The painting represents a confrontation between past and present, between contemporary industrial society and the untrammeled wilderness of Alaska, between the world of everyday life and the world of art, each proclaiming the limits of the other.

Confrontation between the world of the viewer and that of the painting is likewise represented in *The Old Shipyard in Petersburg* (1978, Oeuvre cat., No. 82), where access to buildings and mountains is blocked by a flock of gigantic dark sea gulls. Several of them stand with wings extended and touching the ground, their feathers on end in the posture of warning that precedes attack or self-defense. On the piers of Petersburg, the sight of such gulls flocking to sit in rows on railings and other perches as they wait to partake of the feast provided at one of Alaska's major fishing ports and fish processing plants is a common one, but Auer has transformed it into a mysterious image that bestows upon the birds a totemic, magical presence. She achieves this by increasing the size of the birds until they tower over everything surrounding them, become the principal inhabitants of port and town, and supplant the humans one would expect to be present. Their monumental presence and orderly arrangement–with their dark feathers they appear much like a funereal preacher with his congregation–in-

fuses the birds with an anthropomorphic significance as if, in the manner common to Eskimo legends, they were either recently human or are about to become so. The anthropomorphic Alaskan gulls confront the viewer and block access to the old pier and its sheds, an action whereby the present is prevented from disrupting the past, and access to nature, which abuts directly onto the shipyard buildings, is similarly prevented.

The confrontation between the painting's world and the world of the viewer echoes the direct confrontation, without transition, Auer constructs between the buildings of the town and the landscape adjacent to it. The theme of the edge or border that separates two realms of existence thus appears again in *The Old Shipyard of Petersburg,* as it did in other paintings of 1976–78 during Auer's time of transition between one reality and another. The theme of town and landscape and their transition continued into 1979 in the two paintings entitled *Houses at the Ocean Shore* (Oeuvre cat., No. 85; 91) and *In the North* (1984, Oeuvre cat., No. 141).

Auer's admiration for Gabriele Münter's views of Murnau (Comparative ill., No. 2) is once more apparent in the structures in these paintings, their exaggerated perspective, and the semi-organic sense the houses emit as their rectangular forms soften, begin to curve, and appear on the verge of movement and life. The sharp separation of town and nature appears as the sea rises immediately behind the houses, touching their very bases, but the confrontation is softened in the semi-organic structures Auer has painted. Landscape and town define each other's limits, but nature's forces also seem to be such as ultimately to undermine

the human intrusion, much as in Richard Peter's poem, "Untamed," which announces: "Alaska is not tamed. And never will it cease attacking men who try to hold its savagery at bay."[2]

The demarcation between human habitation and nature's persistent resistance to this frontier is expressed by the appearance of whales swimming in the bay on which a town stands in another 1978 painting, *Whales in the Bay* (Oeuvre cat., No. 71). In a nocturnal scene, house lights illuminate the frothing waters of the bay and its pier as the whales carouse and splash heavily with their tail fins, sending thunderous booms into the air. Huddled together in the foreground is a group of children and adults, as well as a dog, watching with combined mixture of anxiety and hypnotic enchantment as the movements of the giant mammals push the intruding waters of the ocean up against the red and yellow wooden houses and sheds of the town. There is, nonetheless, a distinction which Auer introduces in the way that the members of the human group regard the cavorting whales. The men and boys–a grouping that seems derived not from Auer's Alaskan observation but from her almost ten-year-old memories of Scandinavia with their Munchean overtones, which are also present in the background buildings glowing mysteriously in the blue nocturnal light– huddle together and fearfully, spasmodically clutch each other while stealing surreptitious glances at the churning waters of the bay. In contrast, the blonde woman, her baby, and the ever-present dog turn directly toward the whitened gray-blue waters; calmly, with amusement, they watch the behemoths of the sea. The markedly different attitudes of the two groups parallel the jux-

taposition of the sea with its whales and the land with its houses, a juxtaposition that speaks of nature and freedom as opposed to human artifact and order. As in other Auer works, the women and children continue to maintain an openness to nature; the men, however, view themselves as threatened by the loss of the strictures they have imposed on nature and themselves.

*Whales in the Bay* is an ode to nature's tenacity and man's ultimate powerlessness. It is also a celebration of the mystery of nature, a mystical sense engendered by Auer through the dominant blue tonality within which the other colors seem to glow, particularly the woman's golden hair. This cascading hair acts as the virtual source of light within the painting; it is the central focus around which the entire composition revolves. The incident of whales entering Petersburg's partially enclosed bay becomes a means of celebrating woman's role as mediatrix with the unique capacity to intercede in the existential order of nature and man. To woman, Auer has bestowed the instinctive power to harmonize the dissonance that man has introduced in his efforts to conquer and subdue his natural environment.

The world that Auer paints is seldomly so optimistically presented, however, and the juxtaposition of man and nature, or more commonly of man and woman, is filled with forebodings of violence, persisting antagonism, and man's proprietary attitude toward women.

The proprietary attitude of man toward women is a fundamental aspect of a patriarchal society. In the subordination of woman to man, moreover, conflict arises as woman's yearnings for freedom and self-fulfillment are thwarted. The ideology of femininity seeks to limit woman to the roles of house and family, where man is to be served; a professional identity might be reluctantly accepted, but frequently it is judged to be contrary to the essence of femininity. Zamyatin's short story provided Auer with the model for the application of such social attitudes within the lives of individuals; in *Tabletalk* (1982, p. 123), the suppressed violence of such individual relationships is further explored. In this paintings, the woman and man are seated at a table finishing their meal. Through a styleless glass lamp-shade a purplish light illuminates the table and the couple, leaving the remainder of the room mysteriously vague with shades of shifting blue that seem to throb poisonously. The dark-brown curtains are drawn back, as if to reveal a scene in a play; they create a barrier that presses in on the seated couple, enclosing them claustrophobically. The bourgeois interior, furnished with mass-produced imitations of pseudobaroque table und chairs, suggests that escape from its dank atmosphere is impossible.

The couple sit facing each other, their plates precariously balanced on the table in front of them, uneasily tilted as if threatening to fall at any moment, so that uncertainty and foreboding are suggested. On the man's plate is a large, disturbing, blood-red spot, the remnant of some unknown food. Clad in dull brown trousers, a sleaveless brownish sweater, and a brown-shaded shirt with a tie of the same dull brown as his trousers, the man with his bulk and active gestures takes up three fourths of the painting's area; the woman is compressed into the remaining fourth. Red-haired, she

sits looking out of the canvas with her large gray-green eyes, her hands folded demurely on the lap of her pale, shapeless, yellow-brown dress. Physically pressed almost to the edge of the canvas by the table, she sits in a position of absolute inferiority to the man she faces. His legs pushed out toward her, he sits confidently on his chair with darkness flowing around it, his skin a tonal variation of the dirty browns of his clothing. His head is lowered and tilted as he talks, his mouth opening into a black diagonal void. His almond-shaped eyes gaze viperlike at the woman. His elbows are propped on the table; in his left hand he holds a fork, its tines pointed toward the woman, and his right hand raises a black-handled knife toward her face, penetrating her space, linking the red of her hair with the amoebic red puddle on his plate. On the back of his chair, a large gray bird perches like a sinister omen that concludes the scenario of threats and repressions. No longer a genre scene of mealtime conversation, *Tabletalk* is a frightening presentation of the war between the sexes, of two individuals trapped in the confines of their complacent lives and possessions.

The painting suggests its own sequel, however. As the woman timidly sits in the small space created for her by chair and table, she is turned away from the man and toward the viewer, a slight movement that lends her entire body the tension of potential motion which could release her from her entrapment. Her plate, knife, fork and mug have already been constructed into a barrier parrying attack. Her expression mingles fear, doubt, and indecision, but just as her lighter-colored clothing, skin, and red hair lift her from the darkness surrounding her, she seems to be preparing to proclaim

her freedom. The painting thus captures a decision being made and a process of transition being courageously initiated.

The process of transition implicit in *Tabletalk* manifests itself repeatedly in diverse motifs found in Auer's recent works. A desire to attempt the representation of nude human bodies was the conscious motivation for her treatment of Adam and Eve in *After the Fall* (1985, p. 129), but the actual content of the painting is the movement from one realm to another. Here hints of the landscape are given simply by suggestions of a tree and an uneven ground with perspective lines moving sharply but briefly backward, meeting a darkened sky. Adam and Eve step toward the foreground, almost leaning into it; their bodies are schematically rendered and lack both detail and sensual presence. The drama of the painting is in their wooden staring faces. The features of Eve's face are out of axis with the disorienting result that all order seems suddenly disrupted. Adam's face is more calm, perhaps more determined, and more grimly ordered. As the two link arms, a silver-gray wolf with glowing red eyes, walks between them, Auer's substitute for the traditional diabolic snake.

Adam and Eve, whether in Paradise or being driven from it, are a common subject in naive art, where frequently the Biblical scenes are manifestations of deep religious faith. The naive artists most commonly provide our first parents with heavily vegetated settings in which the familiar components of the Biblical story, particularly the apple and the snake, play prominent roles amid the zoological plenty of a peaceable kingdom. Auer did not attempt to emulate these models, however. Instead, the Paradise of

her Adam and Eve is barren; the earth awaits the cultivation they must provide. The dark emptiness enveloping Adam and Eve's pale bodies (that most closely recall the nudes of the American naive painter Morris Hirshfield) creates the sombre pressure pushing them out of the scene, away from Eden. The sword-bearing angel also is absent in Auer's painting, instead a heavily three-dimensional cruciform shape looms behind them, blocking their return and prefiguring Jesus' death which would reverse the universal damnation that the sin of Adam and Eve caused. Auer's painting is, however, less a religious commentary than a psychological one. The emotions of remorse, guilt, and shame traditionally attributed to Adam and Eve as they are driven from Paradise do not appear. Instead, there are two categorically different reactions to their plight: disbelieving shock and defiant determination.

Two other times Auer has turned to Biblical motifs in her paintings, both exploring aspects of the story of Salome. The first, *After the Dance* (1982, p. 110), was painted shortly after the Eisenmann firm's collection of naive art added a religious work by Adalbert Trilhaase, an example of the classic German naive painting of the 1920s. Rather than follow the example of a particular motif, however, Auer emulated Trilhaase solely in the use of a Biblical, not a secular, motif. In the history of art, ever since the eighth century Salome has been depicted innumerable times, performing her dance before King Herod or displaying the head of John the Baptist, which she received as payment for her performance. In medieval and later Christian art, the artist's concern was to accentuate St. John the Baptist's exemplary behavior in rejecting sin and seeking martyrdom; Salome was cast as the instrument making possible his sainthood and as the personification of evil, particularly the sin of lust, the antithesis of the prophet's purity.

Since the mid-nineteenth century, artists have sought out the Salome motif less for moralizing purposes than as an occasion to represent feminine sensuality and to lend it a chillingly grisly connotation. As a *femme fatale,* whether shown naked or piquantly shifting veils during her dance, Salome became a projection of men's erotic fantasies, dreams, and fears. Particularly during the turn of the century and until the early 1920s, the story of Salome was depicted with amazing frequency by artists as diverse as Gustave Moreau, Franz von Stuck, Edvard Munch, Aubrey Beardsley, and Pablo Picasso. She was the subject of a play by Oscar Wilde and of several operas, the most notable being by Richard Strauss; dancers re-created her dance and emulated her use of veils; movies flashed her dangerously seductive image in darkened theaters; and Robert Stolz's extraordinarilly popular foxtrot "Salome" echoed the refrain:

"Salome, schönste Blume des Morgenlands, Salome, wirst zur Göttin der Lust im Tanz, Salome, reich den Mund mir wie Blut so rot, Salome, deine Küsse sind süsser Tod."

(Salome, beautiful flower of the East, Salome, goddess of pleasure in your dance, Salome, give me your mouth like blood so red, Salome, your kisses are sweetest death.)

Almost without exception, the composers, writers, and painters who devoted a work of art to Salome in an orgy of sensuality were men. For men, actresses and dancers took on the role of Salome and gloried in the publicity they received, but in their inde-

pendent work the popular tale of concupiscence, lust, and death was rejected by women as being too limited and negative of their sex. When Auer decided to paint, she therefore had virtually no precursor among women painters, nor did she seek out a model from among the countless works by men. Subconscious memories of Renaissance and Baroque depictions of Salome holding aloft the head of John the Baptist while in the company of Herod or Herodias—but never of both—may well have played a part in the compositional solution that Auer chose, but any actual influences were minimal, perhaps largely because they were unsuitable to the content she sought to express.

With colors a morose gray, *After the Dance* shows Salome centrally seated in the foreground, dressed in purplish red and pink, holding a stylized skull that rests large and heavy in her lap. Behind her to her right stands Herodias, red-haired, in a white dress, bearing a small, whining, hairless dog. Herod, with a crown on his head, wearing a blue robe, stands farther back to the women's left. The placement of the three figures is that used in a common photographed family portrait: a mother and father standing proudly and stiffly behind their daughter but with all communication lacking as each is absorbed in their own separate thoughts. The barren setting is another of Auer's entrapping claustrophobic environments in which the walls seem to press in on the motionless figures. A window is open at the left, but it is rendered useless as a giant black bird perches there and closes it off menacingly.

Two years later, Auer returned to the Salome story in *Salome Dancing before the*

*King* (1984, Oeuvre cat., No. 146). Manifesting the stylistic changes that her work had recently undergone, the painting is rendered in lighter, paler colors than its predecessor, and the figures, rather than being statically iconic, impart a sense of rhythmic movement as Auer uses the dance motif that she first introduced into *Alaska Festival* in 1982. With colors bouncing between the shiny white of Salome's dress, the deep blues of those of Herodias and Herod, and the lightly striated green-blue of the background, the painting generates a disjunctive, jerky sense of movement, which is accelerated by a linear organization of the composition that seems to swirl like a whirlpool around Salome.

The figures themselves have been turned into quasi-caricatures of their functions in the narrative. Salome distorts her white-clad body so that its forms find optimal display in front of her gray-faced stepfather without being actually revealed; she turns her large, white face toward him to show grimacing garishly red lips as her black hair luxuriantly frames her shoulders or stands wildly out about her head. Her face with its slanted eyes and black dilated pupils is twisted into a conscious effort at lewd sensuosity that mocks the old king even while it is intended to seduce. The tall figure of Herodias stands nearby, her head reaching nearly to the top of the picture. Her arms are crossed in front of her, closing herself off and denying all access to her. Through huge blue eyes encircled by heavy eye shadow, she stares unseeingly straight ahead, her mouth grimly horizontal. In the foreground, Herod looks like a resurrected corpse with leathery, gray skin tautly defining the shape of the skull over which it is stretched; his robe hangs loosely on his fleshless body; his

hands are claws, and his crown is a tarnished gray-green. At the right edge of the painting, a short, mustached man acts as conductor of the music to which Salome dances, and a dog sits bemused and removed.

Several aspects of the Salome story attracted Auer's attention, especially in the version she knew from Richard Strauss's opera. Its historical temporal setting, taking place as it did at the juncture of the Old and New Testaments, signified a time of transition such as Auer had repeatedly depicted. It is the negative qualities of the story on which she concentrated, however, so that the theme of temporal transition is lost in the paintings. It is one of the most horrible Biblical themes, she feels, one in which none of the participants display any truly humane or human emotions.

Herod exists only because of his lust for his wife's daughter; he has submerged everything but his desire for Salome. He makes no effort to consummate that desire, wanting only to have Salome consciously arouse it. Salome remains an attractive, seductive thing to him, never a human being. Herodias is similarly presented as having only one all-powerful desire: to see John the Baptist dead. Salome represents no more than a manipulated tool to her mother, an impersonal vehicle of sexuality. And John the Baptist is similarly depersonalized and one-dimensional, a frightening representation of physical self-denial, a negation of earthly life. All four are monstrous exaggerations of human existence transformed into no more than a series of interacting machinations and manipulations.

Auer's Salome is thus the antithesis of the witches she depicted in *Walpurgis Night.* There the women rejoice in their sensuality through which their unity with nature is proclaimed; Salome's courtesanship, in contrast, rejects this identification and posits a fragmentation of personality and body according to male sexual demands. Similarly, Salome's dance is not a response to the harmonies of nature but a manipulative configuration responding to a rhythm provided by the diabolic conductor behind her. And, of course, the compassion present in *Walpurgis Night* has been replaced by an effort culminating in death and destruction.

The witches in their actions behave like the matriarchs of prehistory, when according to Ernest Borneman, women had the capacity to make men subordinate but refused to do so, maintaining instead a system of equality. Salome and Herodias manipulated the subjecting systems of the patriarchy to achieve the death of John the Baptist, demonstrating a lust for power not unlike that of the men who were then their masters. Involved was a reduction of woman's existence because of male-oriented sexual desire, a perversion of woman's whole reality and therefore destructive rather than emancipatory. Salome's self-exploitation is antithetical to the liberation found in dancing that Auer envisioned in *Walpurgis Night* and such paintings as *Alaska Festival,* in which dominance and exploitation yield to harmony and communion and equality.

The Biblical, historical past is used in the Salome paintings much as Auer used the Alaskan wilderness, as a commentary on the imperfections of the present and, more universally, on the imperfections in human nature. Salome's self-prostitution is emblem-

atic of analogous manipulative behavior in other contexts in contemporary professional and personal life. As alternatives to this courtesanship and subjugation, Auer recognizes two possibilities: either emancipation through which both women and men achieve freedom and the polarization in society is overcome; or the woman incapable of either emancipation or continuing subjugation suffers psychological collapse.

Such paintings as *Walpurgis Night* and *Alaska Festival* suggest the first of these alternatives; the second emerges in *On the Edge* (1977, Oeuvre cat., No. 61) and *Deluge* (1981, p. 109). Auer's proximate source for these was the psychotic crisis that occured in a woman deserted by her husband, unable to counter her childrens' increasing withdrawal from reality into a world of drugs and self-deception, and also incapable of growing herself beyond the attitudes of submission and helplessness fostered in her during her own childhood to make her properly "feminine."

Auer's presentation of this motif uses the device of a single figure isolated in a landscape. The compositional arrangement in other paintings signified the unity of woman with nature; here, however, alienation and distress are the thesis. The setting for *On the Edge* is not Alaska—as it is in *Goldstream,* for example—but the Swabian landscape of the Stuttgart area, with its low, rolling hills rather than the high peaks of mountains. The season is autumn, causing the trees to turn brilliantly gold and red, but the picturesqueness of the autumnal scene is countered by harsh contours that generate sharp and often pointed shapes in the meadow and darkened waters of the stream. The trees likewise appear to writhe

and twist uncomfortably, and in their midst the exterior of a red house simultaneously faces in two opposite directions, threatens to split the scene apart. A single dark cloud, massive and tubular, extends over most of the sky and with its tip cuts into the house. Overshadowed and largely enveloped by the sinister cloud is the head of a figure emerging from the autumnal landscape scene.

Wearing a fedora hat, a heavy fur-lined coat, gray slacks, and a red blouse, the woman presents a figure more androgynous than female. Elsewhere, most notably in her fathers portrait in *Main Train Station,* Auer made use of androgynous features to meld male and female into a positive composite. Here the effect is the opposite. The woman has been largely robbed of her femaleness, leaving a subtracted state as unstable in its existence as the seasonally changing landscape she inhabits but which, with its jarring edges and omnious cloud, does not welcome her. Although the landscape makes visible the woman's state of distress, the two are also antagonistic to each another. Woman and nature find no unity.

In *Deluge* another essentially sexless figure, whose identity as a woman is only divulged by the clothing she wears, appears frontally in the absolute center of the foreground. Two rows of houses, their windows dark, are transformed into pincers that entrap within them. Gray tones characterize the color scheme as they mix with the tones of her flesh, darken into surging blue-green waters, or lighten into a poisonously acid-yellow sky, which looks more like a stretched membrane about to break than like an appropriate atmosphere. The mem-

branous, acidic sky gathered around the woman's head, concentrating the painting's tensions there, draws attention to her mask-like face: the fearful gaping mouth, flared nostrils, and wide eyes that stare, but stare simultaneously in disorientation in different directions. Gloomy, raging floodwaters nearly engulf the two rows of barren houses and encircle the stress-filled woman. Even more than in *On the Edge* the landscape here is threatening, testifying to alienation, annihilation; it is an environment in which the woman can only succumb.

*Deluge* encapsulates psychological death in a woman to whom the world has become only a threat from which to withdraw into inactivity in a futile last hope of survival. From similar attacks of anxiety, Auer herself was not immune, notably at the time of her separation from the Eisenmann firm when the promise of unprecedented freedom brought dreams of death. Death itself has, moreover, been a constant motif in her work, beginning with her Macke-emulating *Funeral Procession* in 1964. The paintings of her father, before they take on any other meanings, are likewise images of death symbolically situated in winter landscapes or in the terminal train station to which all tracks lead.

In animal paintings, the theme of death is similarly explored. One of her most prototypically naive paintings, *The Dying Elk* (1968, Oeuvre cat., No. 11), depicts the quiet death of an animal which Auer had watched after it had been shot during her first participation in a hunting expedition in Canada. The elk's acceptance and calm awaiting of its fate, as if recognizing death as an aspect of a continuing life cycle in nature, had deeply impressed Auer; and

she had gazed directly into the elk's great eyes, watching the progress of death in them. The painting, accordingly, reveals neither pain nor morbidity, but focuses on the animal as it slowly seems to sink down into the soft earth on which it already lies, its head tilted quizzically, its eyes grandly open and aware. In a related work, *The Great Caribou* (p. 82), what will become another hunter's trophy reclines in the foreground of an autumnal setting. Nearby other members of the caribou herd stand and watch, encircling and protecting the death to which they bear witness in mute testimony.

Death, as Auer depicts it, lacks pain and lacks suffering. It is instead a quiet process even if inaugurated by the shot of a hunter. *The Great Trophy* (1975, p. 79) portrays a dead bear showing no visible scars or wounds, no signs of struggle, only a somewhat questioning expression with half-closed eyes and lolling tongue. More than the animal, it is the landscape that denotes death, for it is almost totally bare of vegetation, its mountains ending in spiky chains of snow-covered peaks, and a single leafless tree overshadowing all. Even the hunters, in what might otherwise be almost a souvenir photograph celebrating a kill, seem subdued and thoughtful, demonstrating none of the exuberance common to hunting parties, as if they recognized both the nobility of the dead animal and the mystery of death itself.

Auer herself is in the center of the group, clothed in black like the barren tree next to her, serious and solemn as if enthralled by a vision she alone sees. The vision is revealed in *Death in Alaska* (1978, p. 99), where a woman again appears in one of the deep extensions of Alaskan mountain-

side and river valley. The woman is dressed in yellow, the color that Auer often associates with herself, although in other respects this is not a self-portrait. At her feet lies the body of a white mountain goat, its head tilted, its mouth open, its eyes glazed in death. Moving within the landscape, a huge bear and gigantic raven appear as over-life-sized personifications of themselves. Remaining in the land which gave it life, the goat would soon be stripped to the bone by bear and raven, its flesh providing nourishment for continuing life, thus remaining part of the life-generating processes of nature. To this perpetual life cycle, the woman reacts with an open-handed gesture, both in acknowledgment and acceptance of the processes of nature with which she is so closely allied.

A work outside the patterns of Auer's other paintings–much like *The Protector* in its emphatic concern with massive foreground figures that tend to block off the background space–is *Border Station* (1980, p. 112), which Auer deciphers as a commentary, in part, on death. Two Russian border guards are depicted as Auer encountered them during a trip to Mongolia, assertively pushing their dark presence in front of an obscure, stage-like setting of tiered rocks and an old votive border sign portraying the crucified Christ. With their overpowering presence, the Soviet guards proclaim their physical dominance, but the indefinable light of the background within which the small symbolic figure of Christ appears fails to be subordinated. It may be possible to interpret the image as a commentary on the repression of religion, but this would trivialize Auer's concerns. Religion and Christianity and their status in th Soviet Union were less a part of her content than was an effort to depict a severe patriarchal de-

sire to overcome and control everything. The transition from life to death, symbolized by the border station, defies all such control and force, and the ancient border marker of a previous culture and regime continues to mark the life-death juncture in the society proclaiming itself to be that of the future. The transition remains, as unknowable and mysterious in one time as in another.

Auer's preoccupation with death is neither a sign of her longing for death nor an unhealthy fear of it. Frequently the death motifs can be linked to specific experiences, the death of her father being the most apparent. The paintings sublimate and control her grief while visualizing her ruminations and curiosity concerning death. She places death into a context of life so that, when permitted to achieve its free expression as in the wilderness of Alaska, it is perceived as a process of nature and of life. In *The Mask* (1978, Oeuvre cat., No. 75), death prompts the exchange of faces as an actor on a stage listens to whispered instructions while removing one facial mask and thus revealing another. Death is a process of transition in which there is no true destruction. "There can be no final end," Auer maintains, "and life continues even if in the form of fertilizing the future."

Death in *The Mask* appears as the second major transformatory process of life, accordingly, being parallel in effect to the first, that of becoming an adult. That there is movement from one phase of life to another is apparent, but in neither case is the result a known quantity. Metamorphosis takes place, and perhaps it involves a transmigration of the soul into an animal body, into a more natural and often freer existence than that found within human society. None of

these ruminations fit into the rigid framework of religious dogma, especially not the extremes of Heaven and Hell promulgated by the fundamentalist Christianity that, in Auer's eyes, destroyed the unity of her own childhood home. The deliberate imprecision about death, the use of it to celebrate transition finally form another component in Auer's constant struggle to remain independent, to asure her freedom from the family confines she strives to overcome. In the riddles of life and death, as in other aspects of her personality, she demands to find her own independent answers.

Two paintings may serve to summarize these attitudes in which death proclaims the limits of life's freedom. The first of these, *All Souls Day* (1975, p. 85), shows an early November landscape in which frost covers the grass and trees but fall's celebration of color has also remained visible. Through the organically contoured landscape, a group of elderly people pass like a frieze in the foreground as they move in procession toward a cemetery to honor those who died before them. Standing between two trees, sparkling with the hoarfrost that covers their branches, are three other figures who seem to gaze beyond the procession, out of the landscape segment that enshrines itself, as if to announce a world different from the surrounding one. The dead look in upon the living; they continue as a part of life even when not consciously perceived by those who mourn them. The form which that continuation takes is the question, and to this no answer is provided.

The second painting, *The Brass Players* (1986, p. 151), presents a totally different mood than the majestic solemnity and powerful mystery emanating from *All Souls Day*. The colors play in variations on browns, violets, greens, blues, and golds, scarcely the colors of mourning that predominate in the earlier work. Here three musicians stand, or rather sway, playing on Baroque brass instruments. A rainbow seems to emerge from behind the cypress trees in the background, and in the foreground white lilies grow out of a coffin. The painting contains several of Auer's themes. The power of music is present with its ability to transform and to fuse our life with nature's, to overcome humanity's limitations; and there is death which seems to bring with it the growth of flowers and the appearance of the miraculous rainbow in a process of transformation abetted by music. But beyond all these is the element of humor, ever close to the surface in Auer and manifesting itself here in the caricatural rendering of the musicians with their earnestly distorted faces. With its jerkily undulating contours and writhing rhythms expressed in nearly garish colors, *The Brass Players* is a lightly comical pavanne to a young woman. Even in death, the supreme enchainment of the freedom of life, Auer recognizes humor, the ultimate and undefeatable means of attaining liberation, of cutting the chains of patriarchy and even those of death itself.

# V The Artist

A small woman with dark hair cut short, Hildegard Auer is most frequently dressed in brown corduroy trousers, a sweater, and brown boots. She wears dresses upon occasion, when going out or attending some function, but she prefers the freedom of movement and comfort that her trousers, sweater, and boots provide her otherwise. Lively and very active, she is almost constantly in motion, working at tasks she assigns herself in the two white stucco bungalows that serve as her home and studio in Sindelfingen-Mainingen, just outside of Stuttgart. Both houses are sparsely furnished in a mixture of dark, South German peasant furniture and complementing modernist chairs or tables. The wooden floors are covered by numerous rugs patterned geometrically in bright colors. A large collection of feathers, books on art and other topics, antique dolls, and various curios fill shelves and tables in slightly disheveled arrangement. Over chairs and sofas, the dark skins of bear and deer are draped, adding to the textural diversity and completing a sensual contrast between polished and painted wooden surfaces, cloth and tapestry and feathers.

Paintings by the German Expressionists, especially Gabriele Münter's intimate Expressionist work, by naive and folk artists, densely cover the white stucco walls, interspersed from time to time by photographs taken during vacations in Scandinavia, Mongolia, and more than anywhere else, Alaska. Auer has reserved most of her own work for her studio, where it hangs in the rooms flowing around a cooking space with a collection of antique copper pans, bowls, and molds, their surfaces dulled by a century's use. Large windows overlook a large, well-tended garden in which rose-

bushes and other flowers and plants intermingle with a few pieces of sculpture, surrounded by the tall, dark fir trees which are typical of the Swabian countryside as it approaches the Black Forest. Effectively, the closeness to cities and factories has been blocked out and denied by an alternate world, calm and ordered.

When she is working, Auer sets up her easel so that the light from the banks of large windows opposite strikes it, while she herself faces a bare white wall, on which to focus the images of her personal cosmos of memories and fantastic invention. The hustle of the modern industrial world, which once so totally contained her, is absent. In the quiet of her environment, the sole intrusion is a large, heavy-pawed, and playful terrier who brings into Auer's realm the unpredictable enthusiasm and vitality of the animal world.

Auer largely avoids contact with other artists. She seeks out their exhibitions in galler-

ies and museums, and reads criticism about them extensively, but otherwise insists on her own independent personal stance which permits no membership in the groups and coteries of her present profession. "I will not hem myself in" is the sole aphorism of her present calling. Although her artistic development originated in the company of amateur painters, and although she herself during the 1960s and 1970s was one of the major organizers of the annual Eisenmann exhibitions of the work of naive and Sunday painters, she no longer identifies her work with theirs. In part this is because of the very success that amateur and primitive painters have had in Germany where an audience hungry for unindoctrinated art and with a romantic's faith in art's ennobling capacities found itself unable to identify with the art and artists of post-modernism, just as earlier it had not entered into the enthusiasm for abstraction.

Encouraged by diverse supporters ranging from labor unions to Theodor Heuss, the Federal Republic's first president and himself an amateur painter, numerous Germans took up art as a hobby with varying degrees of seriousness, but with a nearly unanimous conviction that men such as Joseph Beuys or A. R. Penck were clowns or, worse, charlatans ridiculing the true values of art. In 1972, a competition of nonprofessional artists in Hamburg brought entries from more than twelve thousand contestants, each depicting a variation of the theme "Ships and Harbors." In such an expansive amateur enterprise, the terms Sunday painter, hobby painter, dilletante, amateur, and naive artist were willfully intermingled and subsumed under the one stricture that the painter be primarily engaged in some profession other than art. Even in

efforts to isolate the naive artist and to establish norms of quality, as in Thomas Grochowiak's book *German Naive Art* (1976), well over a hundred currently active West German naive artists (with Auer at that time numbered among them) received equal recognition and praise; a postscript identified further "Latest Discoveries." The work of nonprofessional artists, with naive painters probably improperly listed among them, has become a vast secondary art world; largely invisible to or ridiculed by the representatives of "professional art," it has also necessarily become institutionalized, having museum collections devoted to it, and in this institutionalization has sacrificed a large degree of its original freedom and independence, as well as its inventiveness.

Such institutionalization, which seeks to determine the appearance of her paintings and to catagorize them according to rigid preconceptions, is rejected by Auer. Her work defies easy compartmentalization of this sort, as does the art of other independent artists. Initially, when she first attempted to paint, she was totally helpless and ignorant concerning the basic matters of painting technique. Certainly at that time, while she tried to depict the picturesque landscape of the Bavarian Alps, it was impossible to view her as anything but a struggling dilettante who was seeking relief from the demands of her professional career. What changed that estimation was the challenge provided by the Eisenmann firm's exhibitions of its employees' artistic attempts. In competition, Auer characteristically sought to excel, and she diligently set out to learn the technique she lacked in order to be able to create paintings she judged competitive, not with her fellow employees but rather with those primitive and untutored

artists she most admired. As soon as she entered into this process, she broke with the patterns characteristic of dilettantes, amateurs, and also naive painters.

The person who on some whim, or because of a lifelong urge to do so, attempts to learn to paint during their spare time and then practices painting as a hobby, usually begins by sitting in front of an object or scene, or perhaps photographs, of whatever they wish to paint. Almost without exception, the effort is made to be as "realistic" as possible, but invariably the effort fails. This generally results either in frustration, whereupon the failed effort remains the sole attempted painting, or in the amateur seeking help from someone more experienced. Teachers of evening or week-end art classes organized for the adult amateur, or manuels that offer hints from either "the masters of the past" or from an arrangement of the simple geometric shapes underlying all reality seek to fulfill the function of the experienced guide. The result of this process is what might be identified as a contemporary international amateur style which consists of tight brushstrokes mixed with quasi-Impressionist touches, colors that base themselves on the colors of nature but that, whether because it is intrinsic to them or because of a mixing process, tend toward an artificial fluorescence, and forms that, perhaps because of the intense effort at imitation, become slightly distorted and artificially stiff. Unintended errors of perspective, of foreshortening, and inconsistent points of view are likewise common. Alternatively, the amateur painter may decide to copy the style or specific painting of a past artist, usually a nineteenth-century naturalist, perhaps an Impressionist. With such absolute dependence on past authority, on emu-

lative patterns, and not infrequently on photographs, the amateur painter seldomly achieves any originality or works of interest to anyone beyond a small circle of relatives or friends who see the person more than the art.

Except in her very first paintings, which she rejected as failures, Hildegard Auer fails to fit into this pattern, either in the process of acquiring a painting technique or in the style she acquired. A true autodidact, she never sought out a teacher—either person or book—and similarly she never slavishly copied the style or painting of any past master. The process for her was more synthetic. Indeed, through a process of intellectual analysis and examination, she came to understand the techniques and stylistic devices of such artists as Macke, Münter, and Munch; and when she applied what she had learned in this mental process of absorption, it was in her own personal mixture totally free of any emulation, applying her own personal style to subject matter seemingly unrelated to them. This demand for originality, even if rooted in the past, is alien to the amateur and dilletante artist; it was present in Auer's work as soon as she began to paint for the annual Eisenmann shows and increased as she became more and more certain of her own technical abilities.

Neither amateur nor dilletante, Auer also does not truly match the qualities of the naive artist, even if she lent her work, especially during the later 1960s, the appearance of the classically naive primitive painter. There is stylistic diversity among naive artists, but certain visible characteristics, (outlined earlier in Chapter 2) are almost universally to be found among them so that

a certain coherence in appearance is attained. Like the dilletante and amateur, the naive artist usually lacks formal artistic training; unlike them, however, the naive artist does not seek to overcome that lack by seeking out substitute forms of training in an emulation of established models. Instead, the naive artist paints, usually on a small scale, scenes from memory and only seldomly a current experience; untutored and working without visual models against which to test their vision, the naive painters' art most frequently takes on the appearance of that of children about ten or twelve years of age. The emphasis on pattern, on the frontal or profile depiction of objects to arrive at a characteristic gestalt, the outlining of shapes, the frequent use of hieratic size differentiations, the willful disregard of conventional proportions, the limited color spectrum and minimal indication of three-dimensional modeling, the flattening of space or alternatively the exaggeration of perspectival effects, and the airless and dreamlike effect of the image—all these are as much the characteristics of naive painters' works as they are of those of children. They are qualities shared as well with certain prehistoric art and past folk art, as well as some of the art of the mentally ill. It is not surprising, therefore, that all these non-academic, nonprofessional forms of art should have been discovered at the end of the nineteenth and the beginning of the early twentieth centuries. What attracted was not only their immediacy, but their common practice of rendering a recollected image, of departing from illusionistic reality to arrive at an archetypal representation which Kandinsky identified as the Great Realism.

It is not unusual for an amateur painter to create naive images when first attempting to paint, but characteristically this quality is generally perceived by the would-be artist as something to be overcome and rejected. The truly naive artist, in contrast, perfects and maintains it, so that there is no stylistic development, but only a purification of factors already present at the start; painterly skill evolves and matures, but not representational style, which retains its attachment to the untutored vision characteristic of children and primitives, and in this attachment achieves its appealing charm. The childlike manner of a naive painters' art does not, however, testify to a childlike or even childish perception of the world, as is frequently assumed, but may be a manifestation of an astute intelligence. The ability to maintain a "primitive" style should rather be recognized as a particular talent, a capacity to achieve the primordial effects of a vision not harnessed to the surface illusionism characteristic of Western post-Renaissance civilization, and consciously to maintain and preserve that primeval manner of perception. It is, in the final analysis, this consciousness and awareness of what they are doing and how they do it that distinguishes the naive painter from those others—the prehistoric man, the folk artist, the mentally ill, and so forth—whose art shares similar stylistic and formal properties. For them, it is either a phase in a process of artistic evolution, maintained by tradition and not by personal choice, or it is a largely involuntary effect, with one or several of these factors contributing to it.

Hildegard Auer, after her initial short-lived amateur phase, shares many of the concerns and attitudes of naive art, but in her perception of her own work she never truly

became a naive artist, although she created paintings during the 1960s that bear all the visual characteristics of naive painting. Like other naive artists, she sought a primordial reality and wished to translate this into a visual vocabulary commonly comprehensible. To achieve this goal, naive painters provided a model readily to hand, but the stasis of their styles was alien. Instead, continuous exploration and experimentation within the realms of naive painting and Expressionism—the eclectic conjunction of the two is significant—were the instrument through which she sought her vocabulary.

It was a conscious effort to move away from the direct dependence on naive art, after first mastering its techniques, creating illusions of them, and extracting from them those elements that remained viable to Auer's mature work, beginning in the later 1970s. Such a conscious manipulation of naive elements can be found as well in the works of Gabriele Münter and Paula Modersohn-Becker, of Marie Laurencin, and of such painters as Georg Schrimpf, all of whom used styles perhaps best identified as neo-naive. However, just as they cannot be considered naive artists, so Hildegard Auer cannot. Without the static attitude toward style of the naive artist, a quasi-naive manner does not constitute naive art.

Auer's self perception of herself as an artist thus at all times distinguished her from the naive and Sunday painters with whom she exhibited in the Eisenmann exhibitions of the 1960s and 1970s. Like other painters who have consciously adopted an artistic identification that distinguishes them from their contemporaries, Auer has repeatedly turned to the self-portrait as a means of both affirming for herself and presenting to the public the persona that she has constructed. By fixing on an appearance, and frequently also on a defined role, in an image, the self-portrait both assures and announces a private comfort and a public proclamation. With an artist who frequently focuses on the human figure, as Auer does, moreover, self-portraits frequently are unconsciously created so that the self-likeness which gradually becomes apparent emerges in the process of an intense involvement with the process of making the image and clarifying its content.

Auer's first attempt at a self-portrait was in 1975 (p. 77), but her visage or a conceptual self-projection can be seen in numerous of her images of women. Probably the earliest of these is *The Party Dress* (1965, Oeuvre cat., No. 2), where she merged elements of the naive and of Alexei Jawlensky's Expressionist portraits. The deliberate amalgam of stylistic sources is proclaimed here more overtly and with greater self-assurance than in Auer's previous paintings. Directly and confrontationally, the self-portrait faces the viewer and the world outside the painting, a world oriented around the painting and thus distinct from the professional business world. Festively, even garishly clothed, the woman in the portrait appears quite unlike the Auer who served as an executive in a thriving engineering firm, a position that fostered neutral dress, not self-assertive, quasi-bohemian colorfulness.

The excited color patterns of this unconscious self-portrait are, however, more appropriate to Auer's newly formed existence as an exhibiting artist. It is a challenge cast out to the world of naive artists in which she perceives herself newly entered. With its extraordinary intensity of color, its drastically

fluid delineation of highly simplified, patterned forms, its somewhat outrageous self-presentation with heavy necklace, dangling earrings, and flowers in the hair, the self-portrait was designed to draw attention to itself. The reserve and hesitation apparent in Auer's work heretofore have been proudly replaced in this display. The elements characteristic of a naive painting have been manipulated to achieve a personal statement which manifests the lessons that Auer learned from the exhilarating colorism of Expressionism. *The Party Dress* makes visible an artistic progression, even before Auer herself was fully conscious of it and before she possessed the vision of a style through which she might continuously achieve expression.

Her second major self-portrait—like the first—was not consciously intended as a likeness. Completed six years later, *At the White Wall* (1971, Oeuvre cat., No. 18), was painted shortly after Auer moved into the pair of bungalows at Sindelfingen-Maichingen. Appropriately, the moonlight setting is her garden with its carefully nurtured plants, among which there is incongruously set a huge upholstered armchair striped in red and gold. Auer is seated on it, in the midst of nature but also strangely separated from it by the heavy chair. Behind her, glowing in the moonlight, is a snowy white apparition, seemingly a segment of Alaska or Lapland transported into the Swabian garden, but the shimmering white structure reveals itself to be an encircling wall.

The painting consists of a series of enclosures in whose center is the artist, seated in the chair as if entrapped and captive. The terrier, Benno, large in white and brown, intrudes into the scene, breaking through the containment to bring friendly confrontation to Auer and also potential release from her imprisonment. It is possible to argue that at the time that she became managing director of the firm, this self-portrait depicts her discomfort with her newly won position in an establishment that held her in comfortable but uneasy captivity. The structure of the chair separates Auer from her garden and from nature, but the confinement is also broken by her tentative reaching toward the dog, toward an animal, toward life and nature.

Despite its representation of the conflicts in Auer's personal life, the painting exudes an eerie sense of silence and majesty. The moon, its pale light reflecting on the white scalloped wall, and its duplication in the brooch that holds Auer's shawl together at her throat are to a great extent responsible for this, as is the harsh frontality of the figure which seems to deny motion except for the reach of her arms and thus assures quiet. Likewise contributing to the atmosphere of silence is the painting's almost total dependence on the naive imagery of Henri Rousseau, from whom the artist has borrowed such aspects as the figure placed into a landscape on a piece of living-room furniture, the rendering of plants as large dominating vegetal presences whose every detail, including the individual ridges of the leaves, is given, the dark nocturnal sky in which a full moon shines in silver-white, and the creation of a shallow space that focuses on the figure by encircling it with the horizon-blocking screen of wall and luxuriant garden flowers. Even the interplay of colors and the style employed in the facial features has its parallels in Rousseau's work. As an example of Auer's consciously naive paintings, it is one of the most directly derivative.

As such, it largely reflects her taking on a persona not her own, both as artist and in life, and the nondeliberate appearance of her own face, as well as the forced uneasy injection of her dog into the composition, testifies to a determined struggle to maintain a personally constructed reality in the midst of an alien milieu.

Auer's conscious borrowing of Rousseau's naive style in order to create a naive painting of her own involves a process of artistic emulation which, as we have repeatedly seen, is antagonistic to truly naive painting, which is derived from the direct confrontation of an untrained artist with recollected memories—even if in a photograph—joined by an intuitive sense of form. Auer's deliberation denies the process of naive art, even as she borrows from it. In adapting rather than borrowing what such artists as Rousseau could teach her, Auer by the mid-1970s had achieved a more independent, consistent visual vocabulary. To this she joined her concerns with issues of freedom and independence, the role and nature of women, the nature of nature itself, and the dualities of life and death that had marked much of her work since its beginning.

The *Self-Portrait* of 1975 (p. 77)—a consciously rather than unconsciously created likeness—serves to document this regained sense of self identity and assurance. The manner of rendering forms retains hints of naive practices, but is fused into a personal vocabulary. Large areas of color, relatively flatly applied, dominate in green and yellow against which blue-black and terra-cotta, as well as a slash of intense red, are made to play in a color harmony closely linked to that attained by Gabriele Münter. A synthe-

sis of diverse sources translates into Auer's own style.

The painting shows the figure of Auer seated at a table and clothed in the bright yellow she most frequently identifies with herself in her work, although it is not a dominant color in her actual wardrobe, so that here it functions to announce a distinction between her professional life and her identity as an artist. The self-protrait predicates this distinction, so that it becomes the total content, in direct contrast to the entrapment and false identity presented in *At the White Wall*. Auer sits contemplatively smoking a cigarette in a milieu that defies external association. There is no background scene but rather the vertical patterning of a curtain's heavy folds, an abstracted rhythm having no extrapictorial correspondence. In the foreground, on the textured surface of the table, there is a still life composed from Auer's collection of bird feathers, objects owned by her and having personal associations. The most striking aspect of the painting consists, however, of two dark Alaskan sea gulls that spread their wings protectively behind Auer, embracing her in a mass of gigantic feathers as they proclaim their totemic presence as extensions of the artist's own persona and symbolize her kinship with the free life of nature as she perceived it in the Alaskan wilderness. With Auer in an enclosed private milieu totally of her own making, a world in which she is protected and embraced by the self which is her creation and which proclaims her nature as woman and artist, this self-portrait is a proclamation of her independent reality in a world of art, a personal world without intrusions except those willed by her.

own psychological health, lost its strength and virtually ceased to exist.

Insufficient vitality in a search for emancipation is Auer's judgment on Münter's fate, and despite all her admiration for Münter's art, she has refused to model her own too closely on it, rejecting, for example, the idea of landscape painting in which Münter excelled. Similarly it was perhaps Münter's cautioning example that, consciously or not, caused Auer to reject permanent romantic attachments throughout her life. The threat to her independence and freedom, and perhaps also to her strength as a woman, becomes too great once a relationship of dependence is imposed upon the patterns of her life. Freedom can only be maintained, freedom can only be recognized, she argues, when limits are imposed upon it; its existence gains definition and consciousness only in the ability to contrast it to a process of enchainment and containment. Emancipation exists only in the recognition of chains that have been broken, or alternatively, in the recognition of limits yet to be reached, yet to reveal a further process of expansion, liberation, and containment.

These limitations on freedom are defined by Auer as the essential content of her art. As she responded to her yearning for a meaningful figurative art by attempting to create it herself, so now she strives towards emancipation in her new career as artist. The effort remains in process, not yet completed.

the divorce between patriarchally imposed institutions and the creative, free woman who is an artist must be maintained, at least until social conventions are changed into an order more faithful to the dictates of nature itself. The world with which Auer surrounds herself in her work thus necessarily denies the existence of the business world which she left behind when she turned to art, when she found in art and in the wilds of Alaska the salvation she had sought since her youth from the confines of paternal authority.

In her grandmother, the purely female projection of the androgyny she projected onto her father, Auer saw a metaphor for woman's nearness to nature and her natural creative powers; in *The Old Wife of the Consul* (1978, Œuvre cat., No. 84), she demonstrates the living death of a woman denying herself any reality other than that granted to her by men. The model for this picture was the woman from whom Auer rented her first apartment early in the 1950s. The widow of an honorary consul, she never referred to her husband by anything but his title, deferentially identifying herself with it as well as Madame the Consul. It represented a total submission to institutions and to a male authority which even the destruction of the society that had spawned it failed to break, as the death of her husband similarly failed to break her total identity within the framework of his existence. The results of war had forced her to rent rooms in her home, but she continued to sit gray-pallored in her dark room, its timid conventional wallpaper pattern and the chevron patterns of its uptilted floor serving as testimony to the uneasy continuance of her life, a life with roots only in socially imposed abstractions, a life barren of life and tended

by a deformed alter ego, a deathly *Doppelgänger.*

The danger of too great an identification with a man and the accomplishments of a man, Auer also recognizes in the work and career of the artist who, more than any other, she has permitted to inspire her, if not always overtly influence her art. This is Gabriele Münter, whose career in Auer's view exists as a series of failures at self-assertion. Seeking a career as artist late in the nineteenth century under the German Empire, Münter participated in a movement aimed toward woman's emancipation, and her unorthodox cohabitation with Vassily Kandinsky likewise represented this yearning for independence from enchaining patriarchal culture and society, Kandinsky, however, asserted a definite masculine authority over her, first as her teacher and then as her lover, which frequently proved more repressive than the institutions she expected to escape, even as an apparent process of liberation and emancipation was taking place. Münter did not sufficiently assert herself. Her art grew, seemingly in the shadow of her artist lover, but taking on an independent existence from it which did not receive the encouragement it needed to be properly maintained and continued. To the vast sweep and ambition of Kandinsky, Münter brought the contrast of intimate scale and personal reference as she depicted the streets and moors of Murnau and the members of the Blue Rider milieu. Her sphere was the domesticity of life and the infinity of nature while Kandinsky sought out the drama of apocalyptic vision and the imposing power of his own spiritual vision of the universe. With the collapse of their relationship, when Kandinsky married Nina Andreevskaja in 1917, Münter's art, like her

time, *The Dogs of Bettles* was a statement of her rediscovery of her own natural self, a woman no longer capable of accepting patriarchal or masculine subordination, who recognized the continuing links between her own rhythms of life and those of the cosmos, and who perceived the possibilities of an alternate existence through the corrective fictions of her art.

*The Dogs of Bettles* with its howling, half-wild dogs, many of them part wolf, reveals the sources of Auer's self-image as dog-wolf in such paintings as *The Guardian* and *North Station Street* during the next few years. The power of the dog's barks coalesced in Auer's thoughts about herself and her views of contemporary life. What had been intuitively sensed or vaguely perceived subconsciously, and which found its way into her art largely unconsciously or as implication, now became a conscious and dominant awareness from which a veritable flood of images suddenly burst forth giving visibility to her vision of an alternate reality and of the perversions existing in the patriarchal system of modern civilization. Irritably she painted the image of resistance to her vision several years later. *Voices* (1978, Oeuvre cat., No. 70), she notes, represents how everyone whispers instructions on how one should live, on what one should do, on how one's paintings should look and what they should represent. It is a metaphor for attempted domination and sought submission. To this, she countered *The Barrier,* its self-portrait presenting an extreme of self-protection that permitted only limited access, a self-limiting through which to assure retention of her newly gained freedom and newly discovered reality, the realities of nature, womanhood, and art previously denied her.

Auer's self-identification as both woman and artist links her work with the still underestimated role of women in the art of the past. Her allegorical self-portraits in which she propounds both her status as woman and her function as artist, the two of them interrelated, ties her perhaps most closely to the precedents of Paula Modersohn-Becker and Käthe Kollwitz, both of whom were profoundly aware, although in different ways and to different effect, of the social limitations placed on women and the detrimental repercussions those limitations have on the quality and value of a woman's life, of the fetters placed on their capacities as artists.

Kollwitz largely responded by exploring the plight of proletarian womanhood, which suffered most extremely and overtly from social injustices imposed on both class and sex. For Modersohn-Becker, the tragedy of woman's repression and the necessarily conflicting search, in existing patriarchal society, for fulfillment both personally, in her career as painter, and biologically, in her role as wife and mother were direct experiences. For her, the two remained divorced and, within the attitudes of even her semi-bohemian milieu at Worpswede and in Paris, could only result in her desparate outcry, "When can I really be something?" which she wrote in her diary in 1898. Her self-portraits seek to resolve the conflict and the schizophrenic split inherent in Modersohn-Becker's dual desires, in order to achieve her single desire for unity and fulfillment. That is their allegorical function.

Auer's self-portraits function similarly, but instead of positing an existing resolution, as Modersohn-Becker did by accentuating the analogy between the maternal generation of life and artistic creation, Auer insists that

Traditionally, in art, poetry, and folklore, birds represent heavenly messengers. "Kommt ein Vogel geflogen," a German folksong proclaims, "setzt sich nieder auf mein Fuss, hat ein Brieflein im Schnabel und vom Schätzle ein Gruss," [A bird it comes aflying and on my foot does sit; in its bill a letter it carries, that for me my love gave to it], as birds, likewise provide the means of lovers' communication. Similarly birds act as heralds of the dawn of the arrival of spring, of the approach of winter, announcing nature's transformations to mankind. In Christian art, the Holy Spirit takes the form of a dove similarly to announce the message and presence of God. Auer's birds also are heralds, proclaiming the messages of nature, of woman and the artist herself.

In the self-portrait *Visit in the Atelier* (1977, p. 87), a white sea gull from the Alaskan seacoast flies through the window toward the group of fur-coated women who confront Auer. The bird swooping down from the beclouded sky past the curtains of the studio functions to unite the two worlds— that of feminine nature and of the woman-artist's studio. It also seems about to make a diving attack on the six women, who stand so crowded together that they seem more a single being with multiple heads than separate individuals. A stiffstanding cluster of anonymity clothed in death, the women are the opposite of the yellow-bloused artist, the tense space of the background with its threatening feathered messengers separating them into antagonistic camps.

Pushing into the studio in an almost cubic mass, the women carry with them the artificiality and psychological death of contemporary society, the world Auer as artist wishes to supplant with her own reality founded on the liberating wisdom of nature and the Alaskan tundra. Auer stands facing the intruders into her world of art; in contrast to their rectangular stiffnes, her form suggests movement and variation, and she wields two canvases as if they were shields with which to protect herself from the alien force of the subjugated women. Within her art, within her own vision of nature, Auer stands free and independent. The painting was among the first she immediately completed after her retirement from her directorial position. It provided an image and reality for her new identity as independent woman and artist.

There is one additional self-portrait painted a year earlier, *The Dogs of Bettles* (1976, p. 83). The concept of the painting originated during a visit to the Alaskan town of Bettles, more an outpost with its sixty, mostly Indian inhabitants than a true town, and Auer's waking to the sound of the innumerable dogs, who far outnumbered humans in the settlement, all barking simultaneously as the sky began to show signs of the approaching day. The dogs in their various shelters and the searing sound of their howling and barking became the motif of what Auer likes to identify as her first painting devoted to the theme of music. It is a natural "music" that is visualized, and in the midst of it stands the artist wearing an Eskimo fur-strip coat through which she gains the same coloration as the canine musicians, as if she almost had become the personification of their barking. In the primitive reality of Bettles, Auer pronounces her existence outside the realm of urbanized Western Europe and the regimentation of industry. One of the largest paintings she had created up to this

# Comparative illustrations

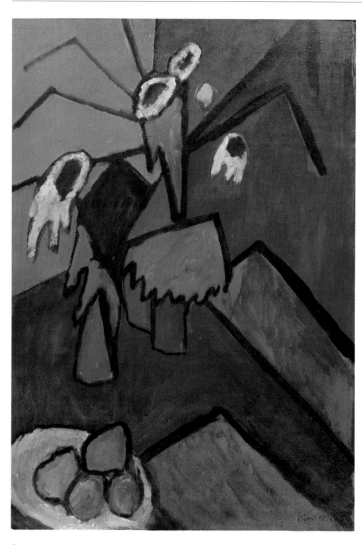

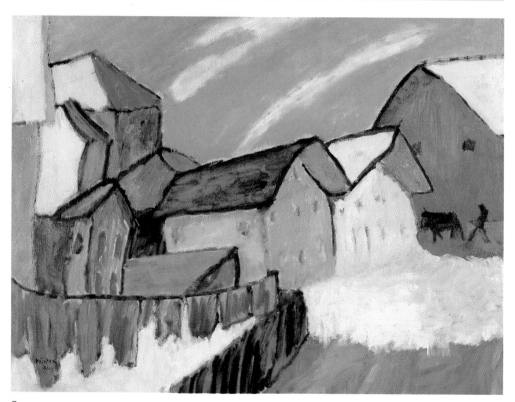

2
Gabriele Münter
Village Street in Winter, 1911. Oil on canvas
Civic Gallery in Lenbach House, Munich, Federal
Republic of Germany

1
Gabriele Münter
Still Life with Sunflowers, 1910. Oil on cardboard
Private Collection, Federal Republic of Germany

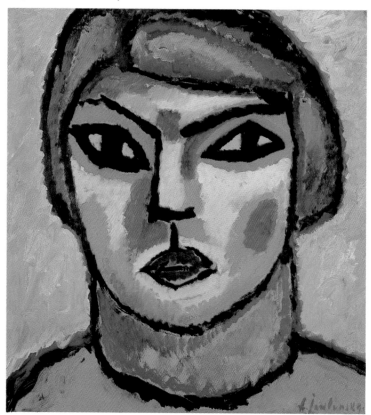

3
Alexej Jawlensky
Maturity, about 1912. Oil on canvas
Civic Gallery in Lenbach House, Munich, Federal
Republic of Germany

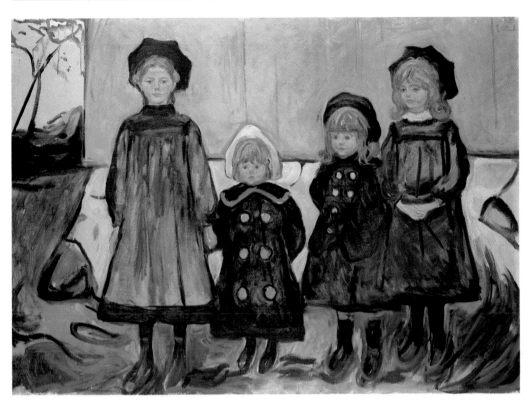

4
Edvard Munch
Four Girls from Aasgaardstrand, 1902. Oil on canvas
State Gallery, Stuttgart, Federal Republic of Germany

5
August Macke
Sunny Path, 1913. Oil on canvas
Macke Memorial Estate, Bonn, Federal Republic of
Germany

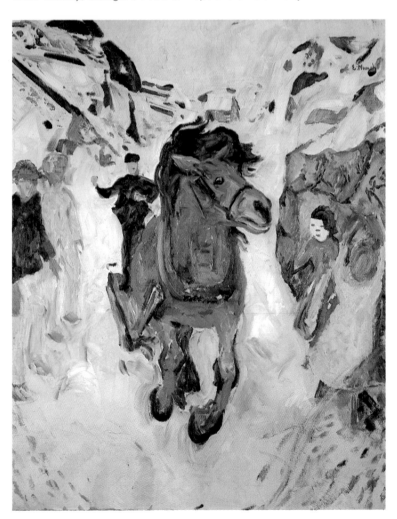

6
Edvard Munch
Gallopping Horse, 1912. Oil on canvas
Munch Museum, Oslo, Norway

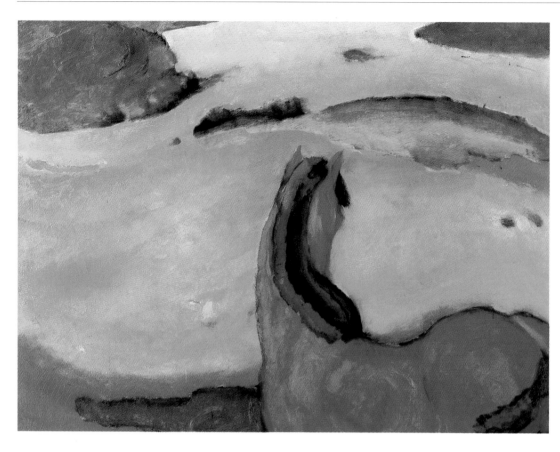

7
Franz Marc
Horse in a Landscape, 1910. Oil on canvas
Folkwang Museum, Essen, Federal Republic of
Germany

8
Ida Bock
Bouquet of Flowers with Pewter Jug, 1964
Collection Eisenmann, Böblingen, Federal Republic
of Germany

# Oeuvre catalogue

1
Funeral Procession
1964 · oil on cardboard
50 by 40 cm
Collection Eisenmann

2
The Party Dress (Woman with Hat)
1965 · oil on cardboard
60 by 50 cm
Collection Eisenmann

3
Chestnut Blossom
1966 · oil on cardboard
50 by 40 cm
Collection Eisenmann

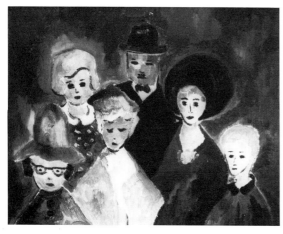

4
Family H.
1966 · oil on cardboard
29.5 by 39.5 cm
Collection Eisenmann

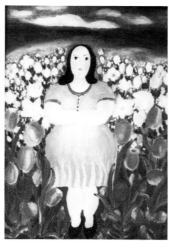

5
Spring – Woman in Flowered Meadow
1967 · oil on cardboard
40 by 30 cm
Collection Eisenmann

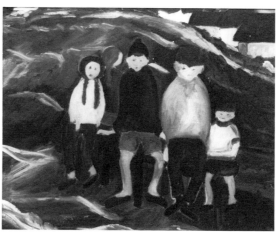

6
Children at the Sea
1967 · oil on cardboard
50 by 60 cm
Private Collection

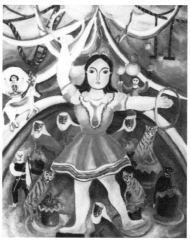

7
Circus Scene
1967 · oil on cardboard
60 by 50 cm
Collection Eisenmann

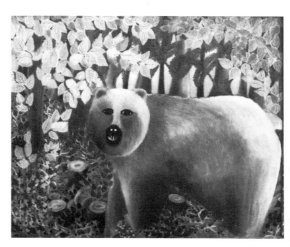

8
Bear in Autumn
1967 · oil on cardboard
40 by 50 cm
Private Collection

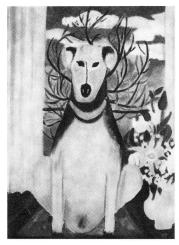

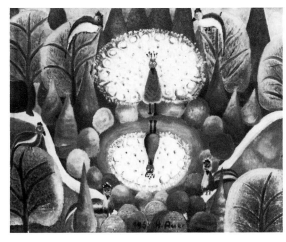

9
Benno at the Window
1968 · oil on cardboard
40 by 30 cm
Private Collection

13
The Peacock and his Wives
1968 · oil on cardboard
40 by 50 cm
Private Collection

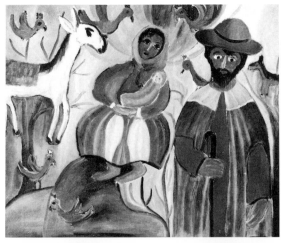

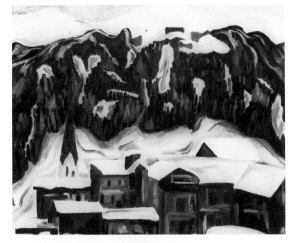

10
Holy Family
1968 · oil on cardboard
50 by 60 cm
Collection Eisenmann

14
Davos in Winter
about 1968
oil on cardboard
50 by 60 cm
Private Collection

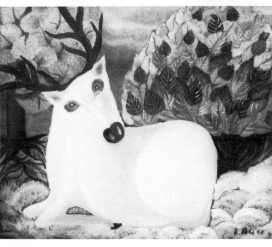

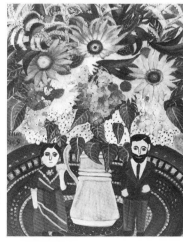

11
Dying Elk
about 1968 · oil on cardboard
40 by 50 cm
Collection Eisenmann

15
Happy Birthday
1969 · oil on cardboard
60 by 50 cm
Collection Eisenmann

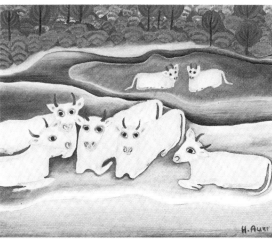

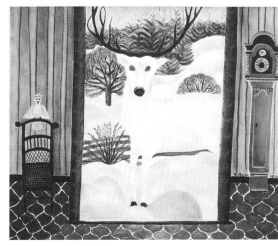

12
Cows at the Tanja River
1968 · oil on canvas
50 by 60 cm
Collection Eisenmann

16
The White Stag
1970 · oil on canvas
50 by 60 cm
Collection Eisenmann

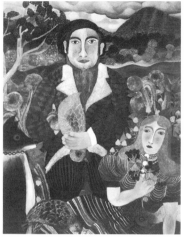

17
Summer in the North
1971 · oil on cardboard
90 by 75 cm
Property of the Artist

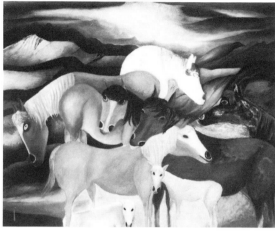

21
Horses
1972 · oil on canvas
50 by 60 cm
Private Collection

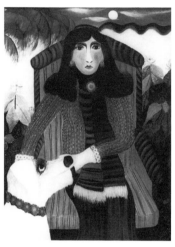

18
At the White Wall
1971 · oil on cardboard
80 by 60 cm
Collection Eisenmann

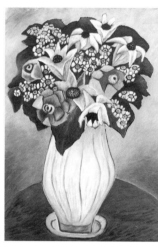

22
Still Life, Flowers
1972 · oil on canvas
70 by 50 cm
Private Collection

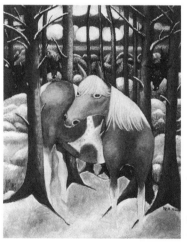

19
The Morning when the White Wolf Came
1972 · oil on cardboard
50 by 40 cm
Collection Eisenmann

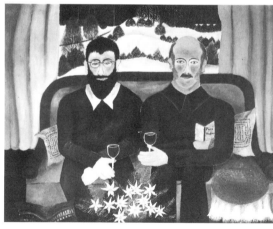

23
Two Gentlemen
1973 · oil on canvas
50 by 65 cm
Property of the Artist

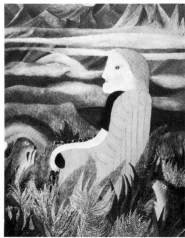

20
At the Matanuska River
1972 · oil on cardboard
50 by 40 cm
Collection Eisenmann

24
Homage to Painting
1973 · oil on cardboard
70 by 60 cm
Private Collection

25
Having Outlived Themselves
1973 · oil on cardboard
60 by 50 cm
Collection Eisenmann

26
My Father
1973 · oil on cardboard
50 by 40 cm
Property of the Artist

27
Hoarfrost at the Ratzenberg
1974 · oil on cardboard
40 by 50 cm
Private Collection

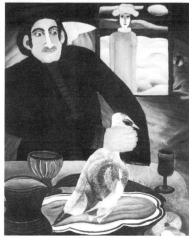

28
Mr. Kortoma
1974 · oil on cardboard
60 by 50 cm
Private Collection

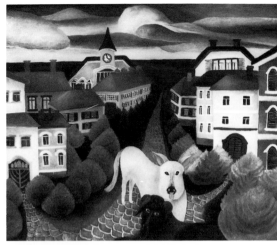

29
Dogs in the City
1974 · oil on cardboard
50 by 60 cm
Private Collection

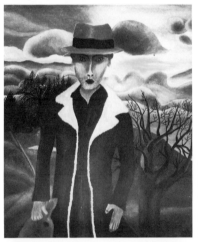

30
Solitary Figure
1974 · oil on cardboard
60 by 50 cm
Private Collection

31
Vase of Flowers on a Blue Cloth
1974 · oil on canvas
50 by 40 cm
Collection Eisenmann

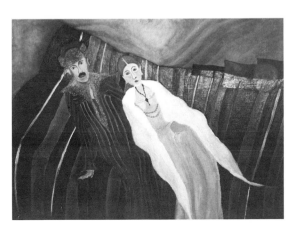

32
New Year's Eve Visit
1974 · oil on cardboard
40 by 60 cm
Private Collection

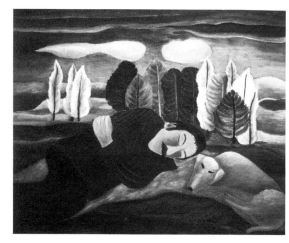

33
Break-Time I
1975 · oil on cardboard
50 by 70 cm
Private Collection

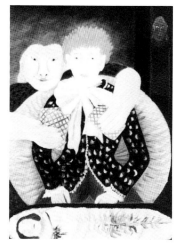

37
While Laying Cards II
1975 · oil on cardboard
64 by 48 cm
Private Collection

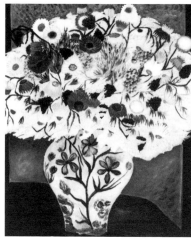

34
Bouquet of Flowers
1975 · oil on canvas
60 by 50 cm
Private Collection

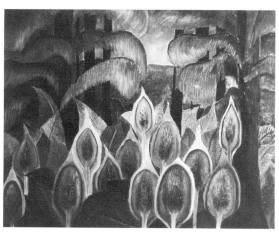

38
In the Woods
1975 · oil on cardboard
40 by 50 cm
Private Collection

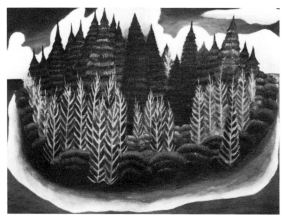

35
Island
1975 · oil on cardboard
40 by 50 cm
Private Collection

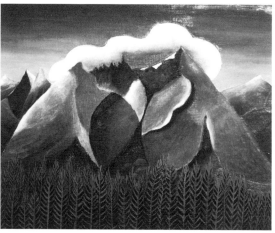

39
Mountains in Alaska
1975 · oil on cardboard
40 by 50 cm
Private Collection

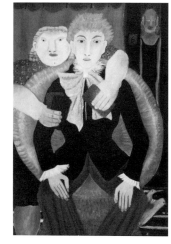

36
While Laying Cards I
1975 · oil on cardboard
60 by 40 cm
Private Collection

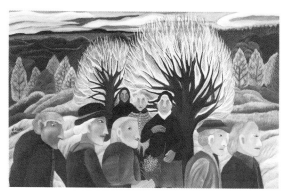

40
All Soul's Day
1975 · oil on canvas
79 by 105 cm
Private Collection

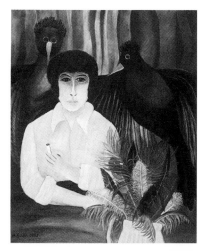

41
Self Portrait
1975 · oil on cardboard
60 by 50 cm
Collection Eisenmann

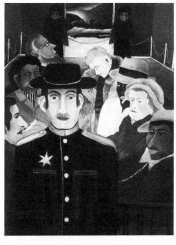

45
Before Take Off
1975 · oil on cardboard
70 by 55 cm
Private Collection

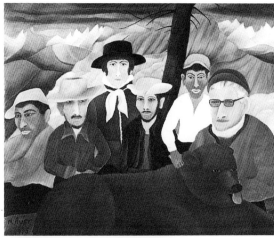

42
The Big Catch
1975 · oil on cardboard
70 by 80 cm
Collection Eisenmann

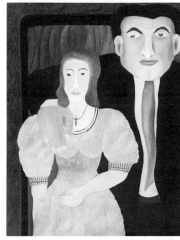

46
The Protector
1976 · oil on canvas
70 by 55 cm
Collection Eisenmann

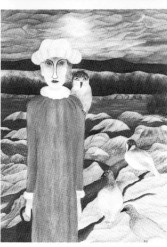

43
Mrs. Kortoma
1975 · oil on canvas
66 by 50 cm
Collection Eisenmann

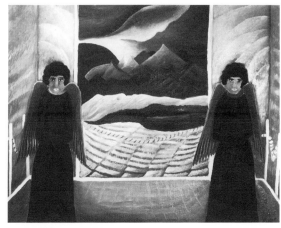

47
Exit
1976 · oil on canvas
60 by 75 cm
Private Collection

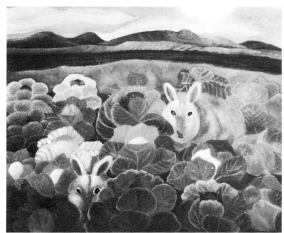

44
Hares in the Cabbage Patch
1975 · oil on canvas
50 by 60 cm
Private Collection

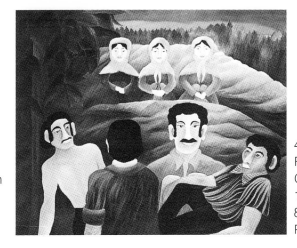

48
Foreign Laborers' Sunday
Outing
1976 · oil on canvas
85 by 105 cm
Private Collection

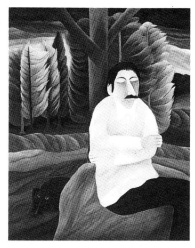

49
Break-Time II
1976 · oil on canvas
105 by 85 cm
Private Collection

53
The Dogs of Bettles
1976 · oil on canvas
80 by 95 cm
Collection Eisenmann

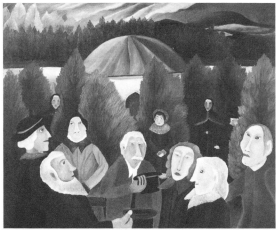

50
Saying Good-Bye
1976 · oil on canvas
75 by 90 cm
Private Collection

54
Porcupine Villa
1977 · oil on canvas
50 by 60 cm
Property of the Artist

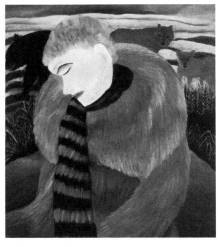

51
Sleep in Alaska
1976 · oil on cardboard
50 by 40 cm
Private Collection

55
Benno II
1977 · oil on canvas
50 by 60 cm
Private Collection

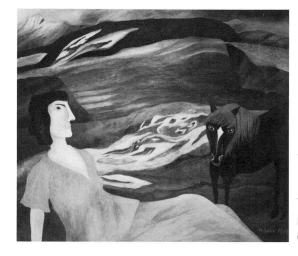

52
Benno
1976 · oil on canvas
75 by 90 cm
Collection Eisenmann

56
Breaking Camp
1977 · oil on canvas
75 by 90 cm
Böblingen Municipal
Collection

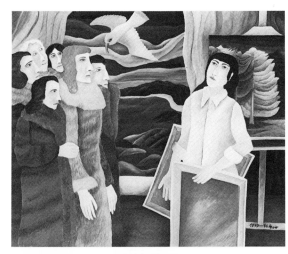

57
Visit in the Atelier
1977 · oil on canvas
105 by 125 cm
Private Collection

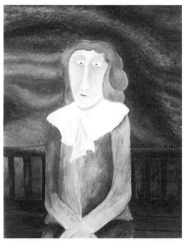

58
The Housekeeper
1977 · oil on canvas
50 by 40 cm
Collection Eisenmann

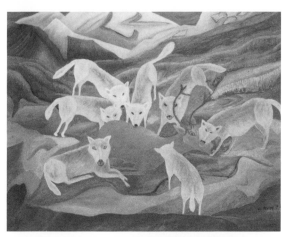

59
Autumn in Alaska
1977 · oil on canvas
60 by 70 cm
Private Collection

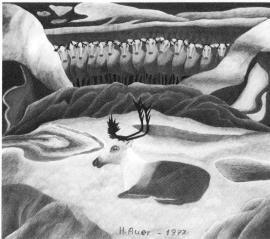

60
The Big Caribou
1977 · oil on canvas
75 by 90 cm
Collection Eisenmann

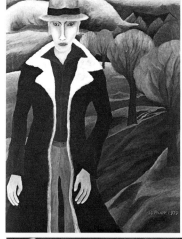

61
At the Edge
1977 · oil on canvas
88 by 68 cm
Private Collection

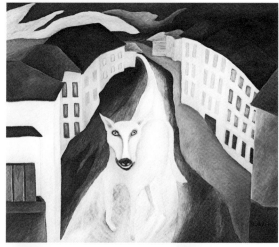

62
North Station Street
1977 · oil on canvas
60 by 70 cm
Collection Eisenmann

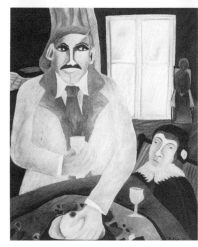

63
Mr. Kortoma has a Party
1977 · oil on canvas
90 by 75 cm
Böblingen Municipal Collection

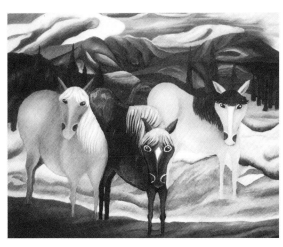

64
Horses near the River
1977 · oil on canvas
70 by 80 cm
Collection Eisenmann

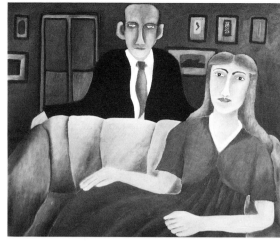

65
Art Dealer Franz R. with Katey
1977 · oil on canvas
50 by 60 cm
Private Collection

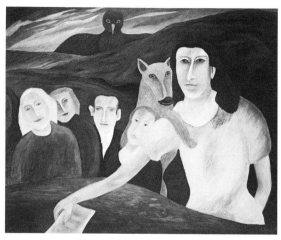

69
The Barrier
1978 · oil on canvas
85 by 105 cm
Private Collection

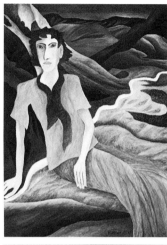

66
Goldstream
1977 · oil on canvas
93 by 68 cm
Private Collection

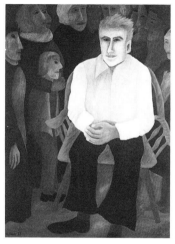

70
Voices
1978 · oil on canvas
120 by 90 cm
Property of the Artist

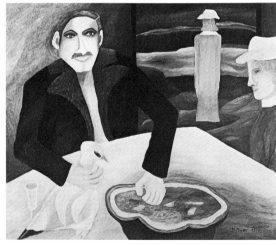

67
Mr. Kortoma with White
Grouse
1977 · oil on canvas
80 by 95 cm
Private Collection

71
Whales in the Bay
1978 · oil on canvas
85 by 105 cm
Private Collection

68
The Friendly Foxes
1977 · oil on canvas
80 by 65 cm
Private Collection

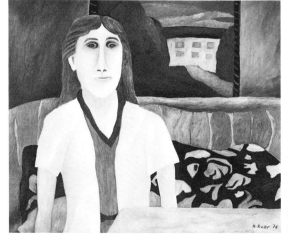

72
The Visit
1978 · oil on canvas
65 by 80 cm
Collection Eisenmann

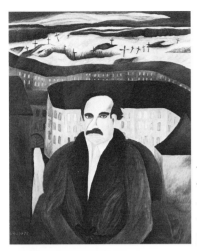

73
The Tyrant
1978 · oil on canvas
105 by 85 cm
Recklinghausen Civic Museum

77
Near the River
1978 · oil on canvas
50 by 60 cm
Private Collection

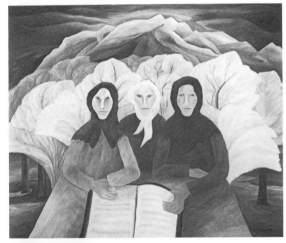

74
Three Old Ladies
1978 · oil on canvas
105 by 125 cm
Private Collection

78
Lady with Polar Fox
1978 · oil on canvas
60 by 50 cm
Private Collection

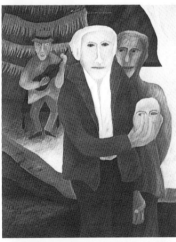

75
The Mask
1978 · oil on canvas
80 by 63 cm
Property of the Artist

79
Death in Alaska
1978 · oil on canvas
90 by 120 cm
Collection Eisenmann

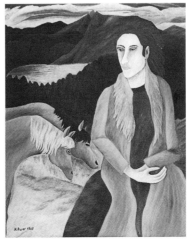

76
The Guardian
1978 · oil on canvas
60 by 70 cm
Private Collection

80
Encounter
1978 · oil on canvas
95 by 80 cm
Collection Eisenmann

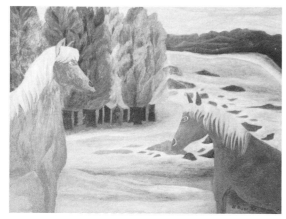

81
Two Horses
1978 · oil on canvas
60 by 80 cm
Private Collection

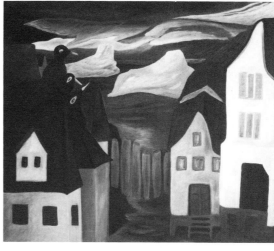

85
Houses at the Ocean Shore I
1979 · oil on canvas
60 by 70 cm
Private Collection

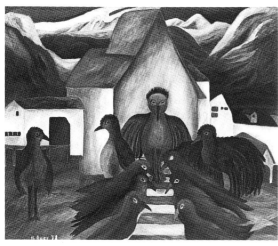

82
The Old Shipyard in
Petersburg
1978 · oil on canvas
75 by 90 cm
Private Collection

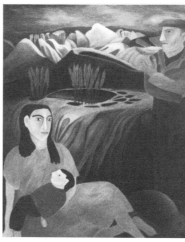

86
A Family
1979 · oil on canvas
90 by 75 cm
Private Collection

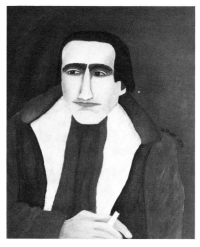

83
Young Man
1978 · oil on canvas
50 by 60 cm
Private Collection

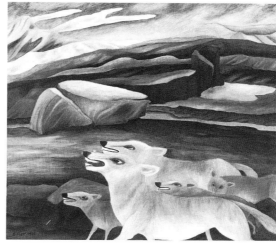

87
The Wolves
1979 · oil on canvas
80 by 95 cm
Private Collection

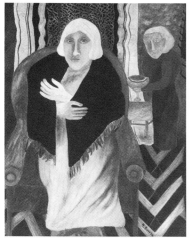

84
The Consul's Wife
1978 · oil on canvas
90 by 75 cm
Property of the Artist

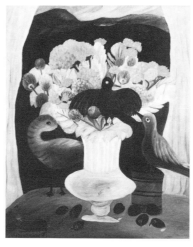

88
Still Life with Rowan Tree Flowers
1979 · oil on canvas
70 by 60 cm
Private Collection

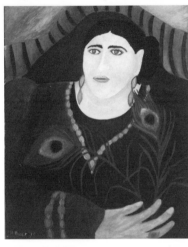

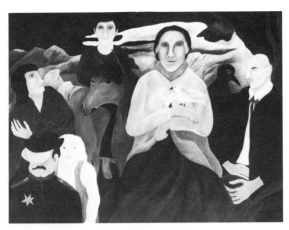

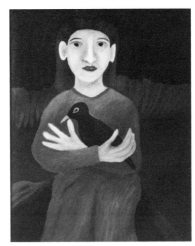

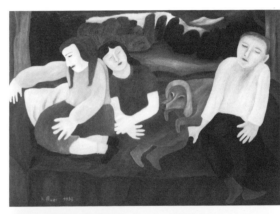

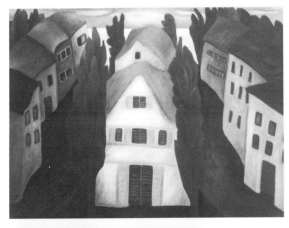

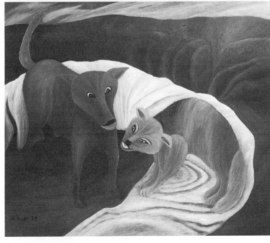

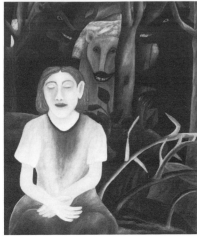

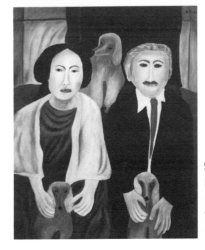

89
Grandmother
1979 · oil on canvas
105 by 140 cm
Property of the Artist

90
Mrs. Charlotte Z.
1979 · oil on canvas
50 by 40 cm
Private Collection

91
Houses at the Shore II
1979 · oil on canvas
60 by 80 cm
Property of the Artist

92
In the Woods
1979 · oil on canvas
60 by 70 cm
Private Collection

93
Little Girl
1979 · oil on canvas
50 by 40 cm
Private Collection

94
Tired Children
1979 · oil on canvas
70 by 90 cm
Private Collection

95
Dog and Cat
60 by 70 cm
1979 · oil on canvas
Private Collection

96
Married Couple with Poodles
1979 · oil on canvas
70 by 60 cm
Private Collection

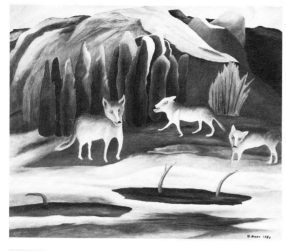

97
Wolf Country
1980 · oil on canvas
90 by 105 cm
Private Collection

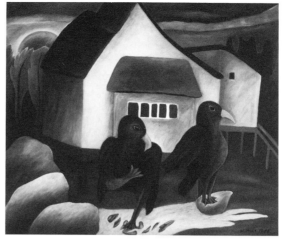

101
Waiting for Nightfall
1980 · oil on canvas
80 by 95 cm
Private Collection

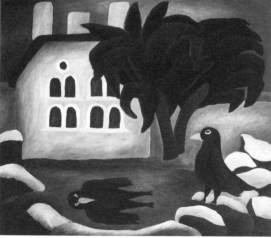

98
The Sleepwalker
1980 · oil on canvas
125 by 105 cm
Württemberg State Museum, Stuttgart

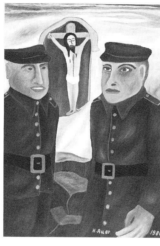

102
Border Station
1980 · oil on canvas
70 by 50 cm
Property of the Artist

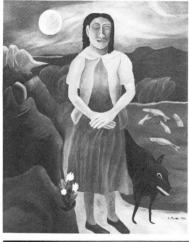

99
Reflection
1980 · oil on canvas
60 by 70 cm
Private Collection

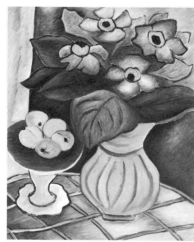

103
Vase of Flowers and Bowl of Fruit, Still Life
1980 · oil on canvas
60 by 50 cm
Private Collection

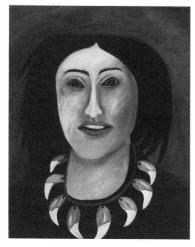

100
Woman with Necklace of Grizzly Teeth
1980 · oil on canvas
50 by 40 cm
Private Collection

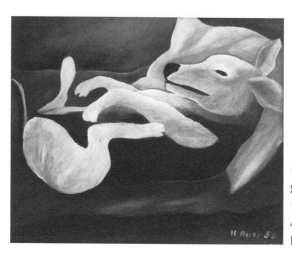

104
Sleeping Dog
1980 · oil on canvas
40 by 50 cm
Private Collection

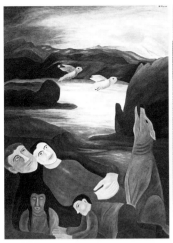
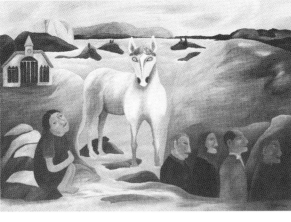
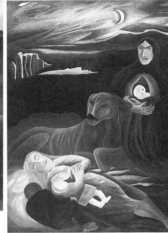

105
Morning, Noon, Evening (triptych)
1980 · oil on canvas
Collection Eisenmann
left panel: 140 by 105 cm
center panel: 120 by 170 cm
right panel: 140 by 105 cm

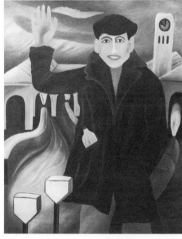

106
Main Train Station
1980 · oil on canvas
105 by 90 cm
Property of the Artist

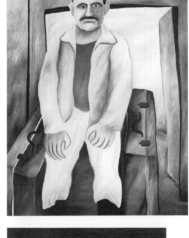

109
Man with Suitcases
1981 · oil on canvas
105 by 90 cm
Property of the Artist

107
Bowl of Fruits
1980 · oil on canvas
50 by 60 cm
Private Collection

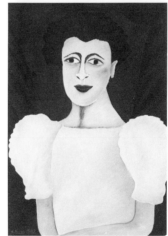

110
Lady in a White Blouse
1981 · oil on canvas
70 by 50 cm
Private Collection

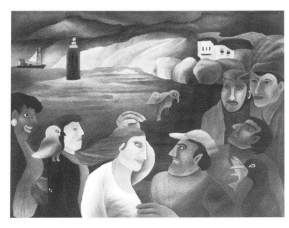

108
At the Sea
1980 · oil on canvas
90 by 120 cm
Private Collection

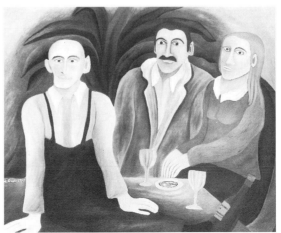

111
Television Viewers
1981 · oil on canvas
90 by 105 cm
Collection Eisenmann

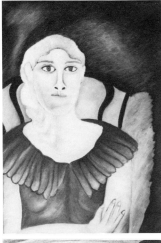

112
Lady with Hair drawn in a Bun
1981 · oil on canvas
70 by 50 cm
Private Collection

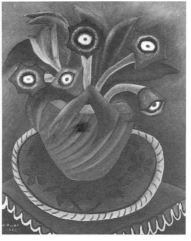

116
Blue Blossoms
1981 · oil on canvas
60 by 50 cm
Private Collection

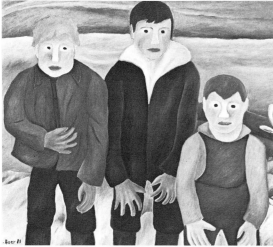

113
Siblings
1981 · oil on canvas
70 by 80 cm
Private Collection

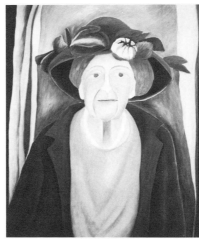

117
Deluge
1981 · oil on canvas
80 by 60 cm
Property of the Artist

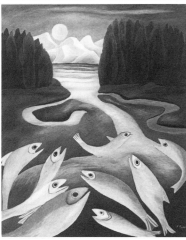

114
Wedding of the Salmon
1981 · oil on canvas
90 by 79 cm
Private Collection

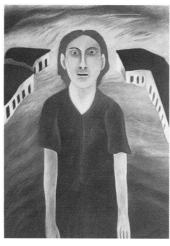

118
Madame the President
1981 · oil on canvas
65 by 55 cm
Private Collection

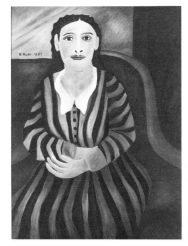

115
The Beautiful Lady M.
1981 · oil on canvas
80 by 60 cm
Private Collection

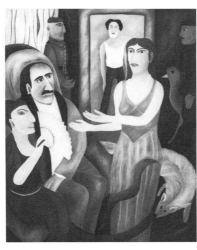

119
Group picture with Snake
1981 · oil on canvas
125 by 105 cm
Collection Eisenmann

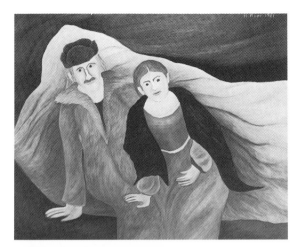

120
Leaning Couple
1981 · oil on canvas
80 by 95 cm
Private Collection

124
Monica
1982 · oil on canvas
60 by 50 cm
Property of the Artist

121
Flowers in a Gray Vase
1981 · oil on canvas
70 by 50 cm
Private Collection

125
After the Dance (Salomé)
1982 · oil on canvas
95 by 80 cm
Property of the Artist

122
Gray Dog
1982 · oil on canvas
55 by 84 cm
Private Collection

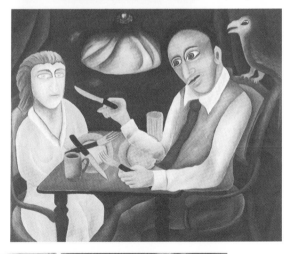

126
Tabletalk
1982 · oil on canvas
80 by 95 cm
Private Collection

123
Alaska Festival (triptych)
1982 · oil on canvas
Collection Eisenmann
left panel: 120 by 90 cm
center panel: 120 by 170 cm
right panel: 120 by 90 cm

127
Mrs. Morrison Plots Revenge
1982 · oil on canvas
70 by 50 cm
Property of the Artist

128
Still Life of Flowers
1982 · oil on canvas
80 by 60 cm
Private Collection

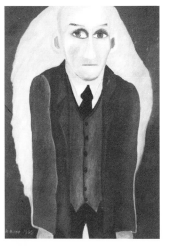

129
A Man in a Thunderstorm
1982 · oil on canvas
70 by 50 cm
Private Collection

131
A Dog, a Cat and a Bird
1983 · oil on canvas
70 by 85 cm
Property of the Artist

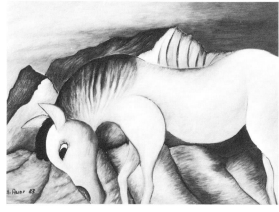

132
Small White Horse
1983 · oil on canvas
60 by 70 cm
Private Collection

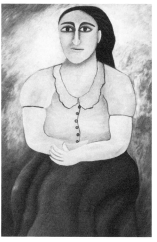

133
Italian Woman
1983 · oil on canvas
110 by 70 cm
Private Collection

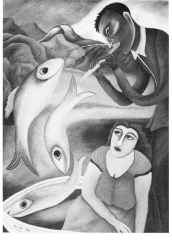

130
The Power of Music (triptych)
1983 · oil on canvas
Property of the Artist
left panel: 140 by 105 cm
center panel: 140 by 170 cm
right panel: 140 by 105 cm

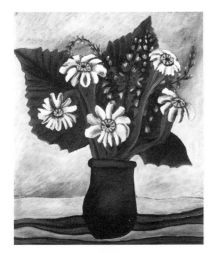

134
Shasta Daisies
1983 · oil on canvas
60 by 50 cm
Private Collection

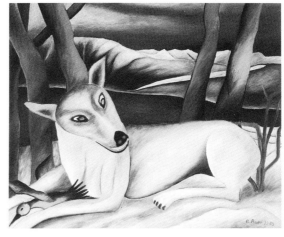

138
Wolf in Winter
1983 · oil on canvas
75 by 90 cm
Private Collection

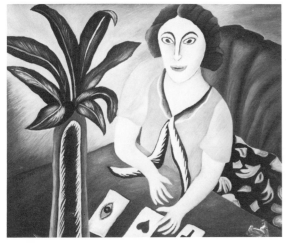

135
An Ace, a Heart and a Club
1983 · oil on canvas
75 by 90 cm
Private Collection

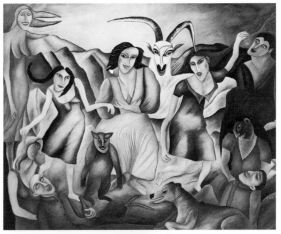

139
Witches' Sabbath
(Walpurgis Night)
1984 · oil on canvas
200 by 250 cm
Property of the Artist

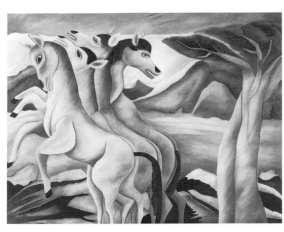

136
A Golden Day
1983 · oil on canvas
105 by 140 cm
Private Collection

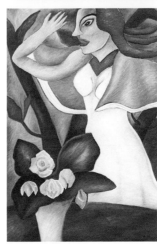

140
Hurrying Angel
1984 · oil on canvas
100 by 70 cm
Private Collection

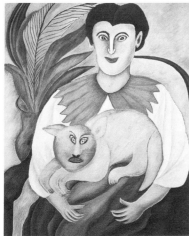

137
Woman with Yellow Cat
1983 · oil on canvas
90 by 75 cm
Property of the Artist

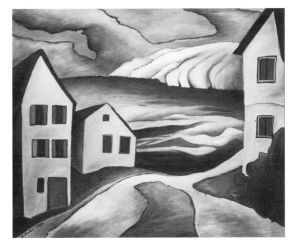

141
In the North
1984 · oil on canvas
75 by 90 cm
Private Collection

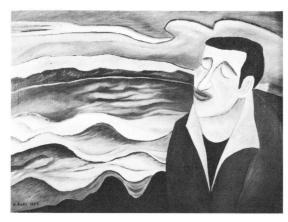

142
The Murderer and the Ocean
1984 · oil on canvas
70 by 100 cm
Private Collection

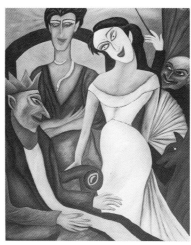

146
Salomé Dancing in front of the King
1984 · oil on canvas
125 by 105 cm
Property of the Artist

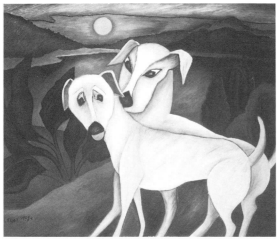

143
Windo loves Wanda
1984 · oil on canvas
75 by 90 cm
Property of the Artist

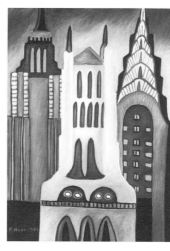

147
Cathedrals of New York
1984 · oil on canvas
80 by 60 cm
Property of the Artist

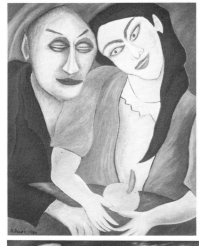

144
The Guarded Object
1984 · oil on canvas
70 by 60 cm
Property of the Artist

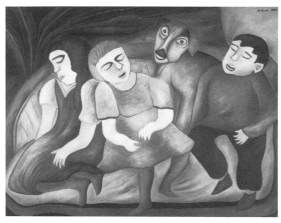

148
Sleeping Children
1985 · oil on canvas
90 by 120 cm
Private Collection

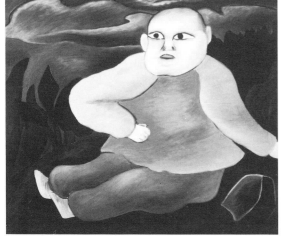

145
Cain
1984 · oil on canvas
60 by 70 cm
Private Collection

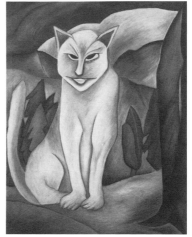

149
Great Yellow Cat
1985 · oil on canvas
95 by 80 cm
Private Collection

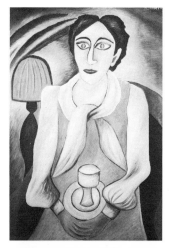

150
A Lady, Waiting
1984 · oil on canvas
100 by 70 cm
Property of the Artist

154
"Forward", Still Life with
Ship's Figurehead and
King Crab
1985 · oil on canvas
70 by 100 cm
Property of the Artist

151
Puppy
1984 · oil on canvas
75 by 90 cm
Private Collection

155
After the Fall
1985 · oil on canvas
120 by 90 cm
Property of the Artist

152
Easy Chair for Windo
1985 · oil on canvas
80 by 95 cm
Private Collection

156
Dog on Blue Rug
1985 · oil on canvas
75 by 90 cm
Property of the Artist

153
Still Life of Fish
1985 · oil on canvas
65 by 60 cm
Private Collection

157
Little Girl with Dog
1985 · oil on canvas
90 by 75 cm
Private Collection

158
Still Life with Cat and
Ears of Corn
1985 · oil on canvas
60 by 80 cm
Property of the Artist

162
The Magic Flute
1985 · oil on canvas
105 by 85 cm
Property of the Artist

159
Still Life with Hunting Trophies
1985 · oil on canvas
90 by 70 cm
Property of the Artist

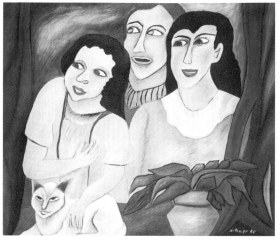

163
Three Women at the
Window
1985 · oil on canvas
75 by 90 cm
Property of the Artist

160
The Big Fish
1985 · oil on canvas
90 by 120 cm
Property of the Artist

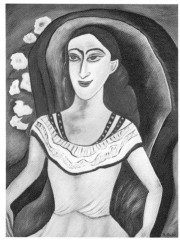

164
The Princess of Chicago
1985 · oil on canvas
90 by 70 cm
Property of the Artist

161
Garden Still Life with Dog
1985 · oil on canvas
90 by 70 cm
Property of the Artist

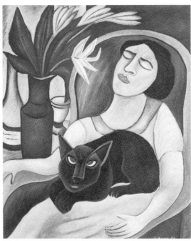

165
Nightmare
1985 · oil on canvas
90 by 75 cm
Property of the Artist

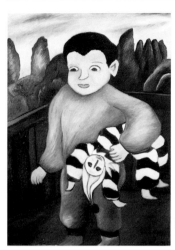

166
First Steps
1985 · oil on canvas
80 by 60 cm
Property of the Artist

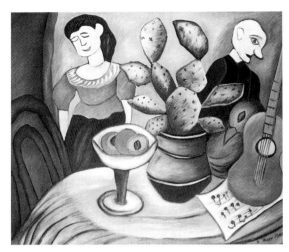

170
Still Life with Figures
1985 · oil on canvas
75 by 90 cm
Property of the Artist

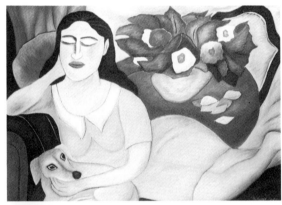

167
Lady with Dog on a Divan
1985 · oil on canvas
70 by 100 cm
Property of the Artist

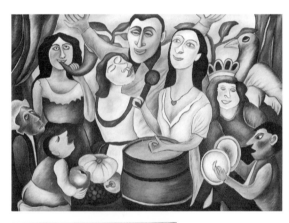

171
Rousing Welcome
1986 · oil on canvas
140 by 170 cm
Property of the Artist

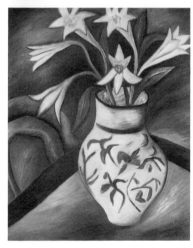

168
White Lilies
1985 · oil on canvas
70 by 60 cm
Property of the Artist

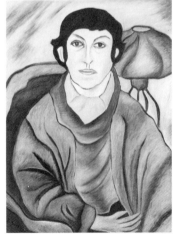

172
Self Portrait
1986 · oil on canvas
80 by 60 cm
Property of the Artist

169
Love Song, Bittersweet
1985 · oil on canvas
70 by 100 cm
Property of the Artist

173
Still Life "Afternoon of a Faun"
1986 · oil on canvas
90 by 120 cm
Property of the Artist

174
The Brass Players
1986 · oil on canvas
120 by 90 cm
Property of the Artist

178
Two Women
1986 · oil on canvas
95 by 80 cm
Property of the Artist

175
King Herod and the Mothers
1986 · oil on canvas
105 by 125 cm
Property of the Artist

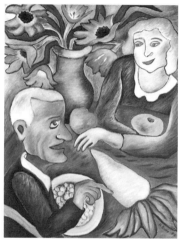

179
The Vegetarians
1986 · oil on canvas
90 by 70 cm
Property of the Artist

176
Child
1986 · oil on canvas
50 by 40 cm
Property of the Artist

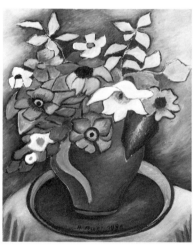

180
Still Life of Flowers "Autumn"
1986 · oil on canvas
60 by 50 cm
Property of the Artist

177
Still Life "Ash Wednesday"
1986 · oil on canvas
90 by 70 cm
Property of the Artist

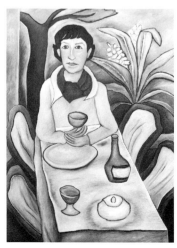

181
Dinner
1986 · oil on canvas
120 by 90 cm
Property of the Artist

# Notes

Introduction

1. The term "closed concept of art" is derived from Werner Hofmann, "Kitsch und Trivialskunst als Gebrauchskünste," *Bruchlinien. Aufsätze zur Kunst des 19. Jahrhunderts* (Munich, 1979), p. 166.

2. Although contemporary art criticism largely considers modernism as having been overtaken by post-modernism, it remains a current concept in terms of the general perception of it as being all experimental, usually nonfigurative manifestations of this century's art, and it is in this sense that I have employed it throughout this book.

3. The word avant-garde as used here is bereft of its historical specificity and, as in my use of "modernism" or "modern art," follows popular usage that largely equates it with modernism, but also sees the contemporary avant-garde as no longer opposing the art establishment, rather existing within it and being supported by the art market. The term "high art" is set against "naive art" by Juliane Roh, "Die Kunst der Naiven," *Das Kunstwerk,* 28:1 (Jan. 1975), p. 46.

4. It is symptomatic, for example, that German exhibitions of the work of naive painters have failed to be considered to any extent by German art periodicals or in recent studies of German postwar art. A similar situation exists throughout the West.

5. Ephraim Kishon, "Moderne Kunst ist reine Gaukelei und Häßlichkeit," *Die Welt am Sonntag,* 4 May 1986, p. 43.

6. Jost Hermand, "Die restaurierte 'Moderne'. Zum Problem des Stilwandels in der bildenden Kunst der Bundesrepublik Deutschland," in F. Möbius, ed., *Stil und Gesellschaft* (Dresden, 1984), p. 294.

7. Wassily Kandinsky, *Concerning the Spiritual in Art* (New York, 1947), p. 127; letter to Arnold Schönberg, dated 16 Nov. 1911, in J. Hahl-Koch, ed., *Arnold Schönberg, Wassily Kandinsky: Briefe, Bilder und Dokumente,* 2d ed. (Munich, 1983), p. 35; W. K., "Über die Formfrage," in *Der Blaue Reiter,* K. Lankheit, ed. (Munich, 1984), p. 172 ff.

8. Kandinsky, "Formfrage," p. 171 ff., and Letter to Schönberg, dated 6 Feb. 1912, *Schönberg-Kandinsky,* p. 25.

9. Kandinsky, *Concerning the Spiritual,* p. 127.

10. See Reinhold Heller, "'A Swan Only Sings at the Moment it Disappears': Jean Dubufett and Art at the Edge of Non-Art," in exh. cat. *Jean Dubufett: Forty Years of His Art* (Chicago: University of Chicago, David and Alfred Smart Gallery, 1984), p. 21 ff.

11. Jean Dubufett, "Anticultural Positions," *Arts Magazine* 53 (April 1979), p. 156 ff.

Chapter 1

1. *Der Blaue Reiter,* pp. 318 and 169

2. Ibid., p. 169 ff.

3. The facts of Gauguin's biography are derived from Robert Goldwater, *Paul Gauguin* (New York, 1972).

4. Käthe Kollwitz, *Aus Tagebüchern und Briefen,* Berlin, 1959, p. 159.

Chapter 2

1. Leopold Zahn, in *Das Kunstwerk* II:5/6 (1948), p. 57.

2. Robert Motherwell, "The Modern Painter's World," *Dyn,* VI (1944). Reprinted in Barbara Rose, ed., *Readings in American Art, 1900–1975* (New York 1975), p. 105.

3. Jackson Pollock, in *Arts and Architecture,* 1944. Reprinted in Rose (op. cit.), p. 123.

4. Konrad Adenauer, in Gordon Craig, *The Germans* (New York, 1982), p. 46.

5. Werner Haftmann, "Vorwort," *Catalogue of dokumenta II,* Cassel, 1959 (Cologne, 1959), p. 23.

6. *Ibid.,* p. 17.

7. Wilhelm Hausenstein, *"Was bedeutet die moderne Kunst"* (Munich, 1949), in Wilhelm Hausenstein, *Die Kunst in diesem Augenblick. Aufsätze und Tagebuchblätter aus 50 Jahren,* (Munich: Prestel, 1960), pp. 284–286.

8. "Blech und Bluff und Jutesäcke," *Der Stern,* XI:36 (9 Sept. 1958).

9. Paul Maenz, *Die 50er Jahre. Formen eines Jahrzehnts* (Cologne, 1984), p. 93.

10. Werner Haftmann, "Maß und Form in der deutschen modernen Malerei," in Hans Steffen, ed., *Der deutsche Expressionismus. Formen und Gestalten,* 2d ed. (Göttingen, 1970), p. 249.

11. Gerhard Grohs, "Zur Soziologie der bildenden Künste in der Bundesrepublik," in Hans Steffen, ed., *Die Gesellschaft in der Bundesrepublik. Analysen,* Part II (Göttingen, 1971), p. 52.

12. Georges Schmits, "Situation de la peinture naive," *Information d'histoire de l'art,* XX:1 (Jan.–Feb. 1975), p. 38.

13. Juliane Roh, "Die Kunst der Naiven," *Das Kunstwerk,* XXVIII:1 (Jan. 1975), p. 46.

14. Lucy Lippard. Six years: *The Dematerialization of the Art Object* (New York, 1973).

15. Robert Morris, "Notes on Sculpture, Part 4: Beyond Objects," *Artforum* (April 1969). Reprinted in Rose, op. cit., p. 214.

16. George Maciunas, Letter to Tomas Schmit (1969), as cited by Wolfgang Max Faust and Gerd de Vries, *Hunger nach Bildern. Deutsche Malerei der Gegenwart* (Cologne, 1982), pp. 80–81.

17. Schmits, (op. cit.), p. 38.

18. Nikola Michailow, "Zur Begriffsbestimmung der Laienmalerei," *Zeitschrift für Kunstgeschichte IV* (1935), p. 291.

19. René d'Harnoncourt, "Naive Meister," in *Das naive Bild der Welt.* Staatliche Kunsthalle Baden-Baden (1961), p. 19.

20. Henri Rousseau, Letter to André Dupont, 1910, as cited by Carolyn Lanchner and William Rubin, "Henri Rousseau and Modernism," in *Henri Rousseau* (New York: Museum of Modern Art, 1985), p. 35.

21. Wassily Kandinsky, "Über die Formfrage," in *Der Blaue Reiter,* pp. 168–169.

22. Michailow (op. cit.), p. 296.

23. Erik H. Erikson, *Identität und Lebensrhythmus* (Frankfurt a. M. 1969), p. 129.

24. Karl Jaspers, *Wohin treibt die Bundesrepublik? Tatsachen, Gefahren, Chancen* (Munich, 1966), pp. 177–178.

25. Compare the bibliography in Werner Weidenfeld, ed., *Die Identität der Deutschen. Fragen, Positionen, Perspektiven* (Munich: Carl Hanser, 1983).

Chapter 3

1. Wilhelm Uhde, *Five Primitive Painters,* R. Thompson, tr. (New York, 1949), p. 12.

2. Ibid., p. 14.

3. *C. D. Friedrich in Briefen und Bekenntnissen,* S. Hinz, ed. (Munich, 1968), p. 83.

4. Ibid., p. 92.

5. Franz Marc, *Schriften,* K. Lankheit, ed. (Cologne, 1978), p. 98.

6. Ibid., p. 99.

7. Cited by Curt Glaser, *Edvard Munch,* 3d ed. (Berlin, 1922), p. 192.

8. Ernest Borneman, *Das Patriarchat. Ursprung und Zukunft unseres Gesellschaftssystems* (Frankfurt a. M., 1975), pp. 518–521.

9. Paul Klee, *Tagebücher 1898–1918* (Cologne, 1957), p. 187.

10. Richard Peter, "Untamed," in Ernest Gruening, ed., *An Alaskan Reader, 1867–1967* (New York, 1966), p. 439 ff.

11. Henry Gaunett, in Ibid., p. 267 ff.

12. Hans Otto Meissner, *Bezaubernde Wildnis,* as translated in *Reader,* p. 242.

Chapter 4

1. Yevgeny Zamyatin, "The North," in *The Dragon: Fifteen Stories* (Chicago, 1966), p. 95 ff.

2. *Reader,* p. 439.

# Index